The New York Art Review

*The Illustrated
Art Explorer's Guide
to the City's Museums
and Galleries*

Les Krantz, *Editor*

Foreword by
LEO CASTELLI

MACMILLAN PUBLISHING CO., INC., New York
COLLIER MACMILLAN PUBLISHERS, London

Les Krantz
Editor & Publisher

Associate Editor: Karen Kodner, *Contributing Editors:* Lee Sievan, Barbara Flug Colin, *Manuscript Editor:* Randi Sherman, *Research:* Marjorie G. Krantz, *Cover Photograph:* Erika Stone, *Typography:* Siemens Communications Graphics

Macmillan Publishing Co., Inc.
866 Third Avenue, New York, N.Y. 10022
Collier Macmillan Canada, Inc.

Library of Congress Catalog Card Number: 82-73113
ISBN 0-02-566630-4

10 9 8 7 6 5 4 3 2 1

Printed and bound in The United States of America

Colorplates printed in The United States of America

To Annette—

who took me to my first museum,

introduced me to New York,

and lots more.

Contents

The reader may find the sales gallery or museum exhibiting any of the artists found in this volume by consulting the appropriate page number. Some galleries and museums exhibit various artists on a one-time basis or as part of rotating exhibits, thus a phone call is recommended for verification.

Foreword

New York's charisma and the world's fascination with the city are almost unimaginable. When it comes to the visual arts, I don't believe that most people realize just what New York means. It is much more than the great cultural center of America. It *is* America—a veritable focal point where all converges. Because New York is so incredibly open, it is easier to feel comfortable here than in just about any city in the United States. In fact, the city never seemed foreign to me, even when I first arrived here, just before World War Two. Almost immediately, I felt I was in my element.

When I came here from France, and my native Italy, it was a revelation to experience a totally open forum. Though I was young in spirit, as well as experience, I was hardly a stranger to the art world; after all, I had recently opened a gallery with Rene Drouin in Paris, which had to be abandoned because of the War. But in New York, I sensed that everything was different. I was amazed to see how seriously modern art had been analyzed, studied, and shown here, especially at the Museum of Modern Art, thanks to the outstanding leadership of its director, Alfred Barr, Jr.

In Paris where I had been living, much attention had been focused on Picasso, Braque and Miro, but there was little understanding of some important historical phenomena, namely the development of abstraction in the works of Kandinsky and Mondrian. In spite of my involvement with the art world, I had not really been aware of what was going on at that time in contemporary art. I had an inkling, of course, about what had happened in France, and the many important artists who had worked there. But France was rather exclusive about the artists and the art which converged in Paris. There was little interest in developments outside of France: German Expressionism, *De Stijl* in Holland, Russian Constructivism, these movements were hardly perceived. Even Surrealism was largely ignored. Strangely enough, I was actually living in Europe, but I had to come to New York to understand what was happening on the Continent.

At the same time in America a new art was beginning to develop. At the start of the War a number of important European artists came here. Among them were Duchamp, Leger, and Mondrian. New York affected their work, while their presence here stimulated and encouraged American artists. That is when things really seemed to take off here. The Museum of Modern Art, undoubtedly the greatest museum in the world when it comes to handling and exhibiting new art, also played an important role in preparing the climate for the extraordinary blossoming of American art. So did Peggy Guggenheim by showing younger American artists in her gallery like de Kooning, Pollock and Rothko, along with some of the Europeans. And, of course, there is a clear connection with European art. All of art history builds on itself, and everything that happened in Europe—from the Impressionists to the Cubists and Futurists—laid the ground-work for a more modern approach to art. And think of all the innovations that took place in Europe while the First Generation of the New York School was young and learning to paint. Then, too, many of the protagonists were European-born or -educated, though their art was uniquely American.

With all this happening in the background, I arrived and settled in New York. When I was discharged from the American army in 1946, there was considerable activity in the arts, but no single direction seemed clear. Of the artists who would eventually be well known, Arshile Gorky was especially exciting. His work was quite mature, even at that time. De Kooning and Baziotes were also doing some very good work, but the others—Rothko, Pollock, Kline and the rest—were just

beginning. I began to watch their work and to get to know many of the individuals who would later be known as the First Generation of Abstract Expressionists. We would get together at the Cedar Bar, or The Club, which was formed by the artists to have lectures and discussions of their work; in the summer we would meet in East Hampton. We were a very cohesive group back in those Tenth Street days. These associations represented my real education in contemporary art. In Europe my knowledge was spotty, but in New York I was a witness as it all was happening.

One focal point of the early days was the Ninth Street Show in 1951. Conrad Marca-Relli, de Kooning, Kline and I, as well as a few other artists, organized the show in an empty storefront on Ninth Street. A few of the artists were more mature and a bit better known than the others, but none of them was quite accepted by the establishment yet. What became clear to me as a result of this show was that some very important developments were taking place in American art; not just the Abstract Expressionist movement, as important as it was, but much more. Rauschenberg who was the youngest artist in the Ninth Street show, for example, was an incredible innovator, and he was just in his twenties.

In 1957, when I finally opened a gallery in New York, I showed Rauschenberg in a group show, and also Jasper Johns, another incredibly original young man. John's flag and his target were totally new ideas. Though the influence of Duchamp and Dada was quite obvious, what they both were doing was completely new. Along with the color field painters—Noland, Louis, Frankenthaler—these two artists dominated the art of the late fifties and early sixties. Another, whose profound originality could be seen even when he was very young, was Frank Stella. His work in a way was related to the color field painters, but was—at that time—also very close in spirit to the work of Donald Judd, Dan Flavin and Robert Morris, the so-called Minimalists, who joined the gallery in the sixties.

By the time we reached the sixties, it was clear that some very important developments had taken place. When there are so many currents and cross-currents, a few artists become a focus for what is going on. Those artists come up with "implausible innovations", as art critic Max Kosloff once put it. I also must give credit to noted art critic and historian Leo Steinberg for this revelation. The lesson is, of course, that all innovations must seem improbable, otherwise they are predictable and not very interesting.

Rauschenberg's work is a prime example. Even going back to the early fifties when he had a show of totally white paintings at Betty Parsons' gallery during the height of Abstract Expressionism, it was obvious that he was a great innovator. His Paris show in 1960 at the Cordier Gallery, which Ileana Sonnabend helped to organize, made it possible to evaluate the influence of a major American artist on an international scale. And by 1964, when Rauschenberg won the International Grand Prize for Painting at the Venice Biennale, New York became generally recognized as the world's true center for contemporary art.

Having witnessed all this, I became very ambitious to find out what the next cycle might bring, for I was quite certain that American art would not simply stagnate and that these cycles of creativity would continue. The big question was who the main protagonists would be, and, of course, what shape their art was to take. I could not believe that there would be a gap. In the light of all the innovations which were taking place in New York and throughout America, it would be totally outrageous for such a thing to happen. But the next developments in art seemed even more outrageous to some people than the idea of things coming to a standstill.

Pop Art, as it came to be known, was one of the most controversial phenomena of the decade, not just in the arts, but in Western culture. The Pop artists used images made popular by the American mass

media, which, not so coincidentally, are based here in New York where the movement reached its fullest development. Like the mass media itself, it spread throughout the world like wildfire. In the beginning, the art world was outraged. Many critics, in fact, said it wasn't art at all. But this was an art that the public could respond to; millions of individuals were as much concerned with *enjoying* the images of Lichtenstein, Oldenburg and Rosenquist, as understanding them. The name of Andy Warhol was a household word. Pop Art was a great triumph because it reached so many people in such a positive way. The international art world soon acknowledged that these artists were worth noticing, and their work is now, of course, very much admired.

But many artists, whose work the public finds more difficult, have made major contributions as well. Conceptual artists of the seventies, including artists like Joseph Kosuth, Douglas Heubler and Robert Barry, or sculptors like Bruce Nauman and Richard Serra, had something important to say.

Recently, and rather suddenly, a new movement has taken place. Figuration has reemerged, but with an expressionistic approach to it. Unlike most art movements of the twentieth century, this one is not necessarily centered in any one country; rather, it is developing simultaneously in both Europe and America. It is something we will all be watching very closely to see where it takes us.

Clearly, part of the enjoyment of art is following the developing styles, looking for innovations, and enjoying and understanding the past ones. I have been fortunate enough to live during an unbelievably exciting period of art history and to be active in one of the great cultural centers of the world. Nowhere has the pursuit of the arts been more stimulating, more exhilarating or more intense than in New York. Whether it has been the result of the art, the artists, the exhibiting institutions or the people who support all these things, I don't believe that the visual arts could have developed quite the way they did anywhere but in this extraordinary city—New York.

Les Krantz's *New York Art Review* is about all these things—the museums, the galleries, the art and the artists. I hope you will share my enthusiasm and, if you visit them, they will give you as much pleasure as they have given me over the years.

Leo Castelli

Museums and Public Art Spaces

American Craft Museum I American Craft Council 44 W. 53rd Street
New York, NY 10019 (212) 397-0630 Tuesday-Saturday: 10-5; Sunday
& holidays: 11-5

American Craft Museum II International Paper Plaza 77 W. 45th St.
New York, NY 10036 (212) 397-0605 Monday-Friday: 10-5:30

The American Craft Council opened Museum I in 1956 in a modern four-
story building located directly across from its own headquarters in order
to establish the nation's first national exhbition center for craftspersons.
The Museum, together with the Council, is an important source of
information as well as a showplace for the growing crafts movement.

The American Craft Museum II opened in May 1982 at International
Paper Plaza, under the sponsorhips of The International Paper Company
and International Paper Company Foundation. The 3,500-square-foot
gallery of Museum II doubles the previous amount of space, allowing for
greater depth of presentations.

The director advocates flexibility in order to keep pace with new inno-
vations in crafts. Past exhibitions presented by the Museum reflect its
unique character as well as its fresh approach to art. Traditional craft
forms as well as newer, experimental works in all media are shown,
ranging from functional to personal statements in glass, traditional
weaving to three-dimensional works in fiber, and functional pottery to
sculptural ceramics.

Exhibitions have included "For the Tabletop," "Plastic as Plastic,"
"Felting," "The New American Quilt" and "Making Paper." Thematic
shows are often based on a single object in order to stimulate awareness
of the object's many forms and functions. These imaginative exhibits,
such as "Homage to the Bag," "The Door," "Cookies and Breads: The
Baker's Art," and "The Great American Foot," have held wide appeal for
both the general public and craftspersons. One-person retrospectives
have filled the galleries with Dorothy Liebes' fiber art, Wharton
Esherick's handcrafted furniture, and the sculptural ceramics of Peter
Voulkos, among others. For the past twenty years, lesser-known crafts-
persons throughout the country have been given an opportunity to dis-
play their works in a series of competitions known as "Young
Americans." In addition, various competitions are offered, divided by
media categories of fiber, wood, plastic, leather, clay, glass and enamel.

Through traveling craft exhibitions, consultation services and
community-based activities, the Museum's programs are extended
nationwide. Other resources are made available in conjunction with the
American Craft Council. As the largest craft resource center in the
country, the Council offers slides and films documenting major exhibi-
tions presented at the Museum and at museums around the country.

programs

9

Asia House

Asia House Gallery 725 Park Ave. New York, NY 10021 (212) 288-6400 Tuesday-Saturday: 10-5; Thursday: 10-8:30; Sunday: 12-5 Christmas & New Year's Day: closed Admission: by donation

The offices, programs and collections of the Asia House Society are now housed in an elegant building with a rose-hued granite exterior and red sandstone interior. Objects from the Mr. and Mrs. John D. Rockefeller III permanent collection are rotated in the cherrywood-lined Rockefeller Gallery, so that the entire collection may be viewed over a two-year period. Indian and Southeast Asian stone sculptures are placed in the lobby and in the second-floor Arthur Ross Gallery. Three to four temporary exhibitions are offered each year in the ground-floor C.V. Starr Gallery, focusing on the traditional arts of Asia. Exhibitions have included sculptures from Thailand, Japanese screen paintings, Southeast Asian ceramics, ancient Chinese bronzes and the arts of Iran's Sasanian Dynasty. Masters such as China's Wen Cheng-Ming, who is a painter of the Ming dynasty, and Japan's Buson, an eighteenth-century scholar-painter, have also been featured.

Brooklyn Children's Museum

Brooklyn Children's Museum 145 Brooklyn Ave. (Saint Mark's Ave.), Brooklyn, NY 11213 (212) 735-4400 Monday, Wednesday, Thursday, Friday: 1-5; Saturday, Sunday, holidays, school vacations: 10-5 Admission: free

Established in 1899, the Museum was the first in the world constructed specifically for children. The entire Museum is decorated in hi-tech style, with exposed pipes and beams and huge industrial windows. The vestibule was once a 1907 trolley kiosk, which opens into a tunnel made of corrugated drainage culverts, lit by a neon rainbow. Exit points from the tunnel lead to the various exhibit areas.

The exhibits, which utilize over 50,000 objects, are designed to teach cultural history, natural history and technology. They are arranged by the four elements: earth, air, water and fire, each with its accompanying "lessons." There are many small exhibits tucked away throughout the Museum, such as a case of dolls at ground level, or a window that displays African masks. Two huge, clear plastic jungle gyms are meant to represent the molecular structure of a soap bubble. The many teaching collections and participatory activities create an atmosphere of fun that is dedicated to learning.

By subway, take the #2 line to Kingston Avenue, then A to Kingston/ Throop. By car, take the Manhattan Bridge to Flatbush Avenue, then to Eastern Parkway. Turn left onto New York Avenue, then right onto Saint Marks Avenue to Brooklyn Avenue. Nearby street parking.

Brooklyn Museum

Brooklyn Museum Eastern Parkway at Washington Ave., New York, NY 11238 (212) 638-5000 Wednesday-Saturday: 10-5; Sunday: 12-5; Holidays: 1-5 Admission: suggested donation $2.00, students $1.00 Members, senior citizens and children free

The Museum began in 1823 as an apprentice library formed by the village fathers "to shield young men from evil associations, and to encourage improvement during leisure hours by reading and conversation." Two years later, General Lafayette laid the cornerstone of the library's own building. Activities expanded to include a large range of interests, such as chemistry, music, art and machinery; even French lessons were available. The library, which eventually became known as the Brooklyn Museum, wanted to be "a museum with everything for everyone," and it hoped in the ensuing years to become the embodiment of cultural life in Brooklyn.

The Museum's permanent holdings now include the famed Department of Egyptian Art, which contains one of the best collections in the western hemisphere. An installation on the third floor also includes rare examples of the ancient arts of Greece and Mesopotamia.

The main-floor galleries are devoted to the arts of Africa, Oceania and

Porcelain Dejeuner, Imperiale de Sevres (France 1813). Cooper-Hewitt Museum.

Linen Needlelace Flounce, ordered by Napoleon for Empress Josephine (France, early nineteenth century). Cooper-Hewitt Museum.

New World cultures. In addition, there are many annual special exhibitions.

The second floor houses Oriental galleries and the arts of Islam and of the Indian East. In the Print Department, the collection of 40,000 prints and drawings is especially strong in nineteenth- and early twentieth-century European and American work, highlighted by important examples of the fifteenth, sixteenth and seventeenth centuries.

On the fourth floor are the American and European decorative arts—pewter, silver, ceramics and glass—and the series of twenty-five authentic, completely furnished, early American rooms from Colonial times through the nineteenth century. The rooms range from the historic Jan Martense Schenck House of 1675 to the magnificent Rockefeller Room preserved from an 1884 New York brownstone.

The fifth floor houses a comprehensive survey of American paintings and sculpture from the eighteenth century to the present, fine examples of French Impressionism and Post-Impressionism as well as some earlier European masters, and a gallery of watercolors from the Museum's collection.

The Frieda Schiff Warburg Sculpture Garden at the rear of the Museum preserves nineteenth-century architectural ornaments saved from demolished buildings in and around New York City.

There are two libraries in the Museum. The Art Reference Library is open to the public Wednesday through Friday from 1:00 to 5:00. The Wilbour Egyptological Library, one of the most important libraries of its kind in the world, is open by appointment. Making full use of the Museum's collections and libraries, the Brooklyn Museum Art School in the north wing of the building offers courses in painting and sculpture.

Concerts, lectures and films are held on Saturday and Sunday afternoons. In addition, there are many special programs for children and adults.

To reach the Brooklyn Museum by subway: Broadway-7th Avenue IRT Express to Eastern Parkway Museum stop. By car from Manhattan: cross the Brooklyn Bridge, drive straight ahead to Boerum Place, turn left at Atlantic Avenue, then right at Washington Avenue to Eastern Parkway. Parking is available at the rear of the building.

Center for Inter-American Relations

Center for Inter-American Relations 680 Park Ave., New York, NY 10021 (212)249-8950 Tuesday-Sunday: 12-6

The Center seeks to develop better understanding in the United States of the cultures and societies of Latin America, the Caribbean and Canada. Its headquarters, a landmark town house, is the setting for a wide variety of programs, which include activities in art, music and literature.

Each year, several major exhibitions are held in the Center's art gallery. Works range in subject matter from pre-Columbian to colonial and contemporary art, and involve painting, sculpture, photography, textiles and decorative arts.

A large retrospective exhibition of works by Mexican photographer Manuel Alvarez Bravo was recently held. Pioneer photographers of Brazil from 1840 to 1920, were featured in another show at the Center. In a future exhibit, three Latin American artists, John Castles (Colombia), Raquel Rabinovich (Argentina) and Ricardo Regazzoni (Mexico) will construct environmental sculptures from prefabricated material in view of the public.

China House

China House Gallery (China Institute of America) 125 E. 65th St., New York, NY 10021 (212) 744-8181 Monday-Friday: 10-5; Saturday: 11-5 Sunday: 2-5 February, June, mid-October: closed Admission: free

This is one of the few American museums devoted exclusively to Chinese art. It occupies one small, cabinet-lined room on the first floor of its parent organization, the China Institute of America. China House was the first institution in America to exhibit I-Hsing ware, the little-known, rare Chinese ceramics which are remarkable for their natural clay color,

simple design and elegant execution.

The gallery features two exhibits a year—one from mid-October through January and the other from mid-March through May. They focus on themes or on outstanding, but often little-known, institutional Chinese art collections such as that of the Newark Museum of Art. Theme shows included Chinese porcelains in European mounts, the first exhibition ever devoted to the penchant, especially in eighteenth-century France, for altering Chinese ceramics to fit Western tastes, and paintings by the "friends" of Wen-Cheng-ming, one of the four great masters of the Ming dynasty. Exhibits cover a broad spectrum, ranging from bamboo carving, one of the more important of China's minor arts, to calligraphy, China's premier art form. An exhibit from the Yale University Art Gallery displayed a rare bronze pole top from the Shang dynasty, a sampling from Yale's collection of Ch'ang-sha ceramics, and a selection of objects from a scholar's study. Also included were paintings by Wang Mien, one of the greatest ink plum masters, and by Chu Lu, who is renowned for his bamboo paintings.

The Cloisters

The Cloisters Fort Tryon Park, New York, NY 10040 (212) 923-3700
Tuesday-Saturday: 10-4:45; Sunday and holidays: 1-4:45;
May-September: 12-4:45 Admission: Pay as you wish: $4.00 suggested for adults, $2.00 for students and senior citizens

This special branch of the Metropolitan Museum of Art stands at the northernmost point of Manhattan and towers over the Hudson River. The building and land were donated to the city in 1930 by John D. Rockefeller, Jr. and the museum was opened as a monument to medieval art in 1938. A modern structure is combined with sections from five medieval monasteries, a Romanesque chapel, a twelfth-century Spanish apse, and a chapter house from the same period. Recorded medieval music sets an appropriate mood each day for the visitor's tour. Special concerts are often held, but one must inquire in advance for times and dates. For those interested a complete escorted tour of the museum is offered every Wednesday.

By car from Manhattan, take the Henry Hudson Parkway north to the first exist after the George Washington Bridge. The Madison Avenue number 4 bus goes to the door of the museum. By subway, take the Eighth Avenue "A" train to 190th Street. Be sure to exit by the elevator and take the number 4 bus to the museum. If weather permits, a walk from the subway stop through the park is most enjoyable.

The starting point of a museum tour is the Octagonal Entrance Hall directly below the large tower. The bookstore is located off to the side where information and orientation materials can be obtained.

The museum spans the periods from 31 A.D., when Constantine ruled as the first Christian emperor, to the beginning of the Renaissance, which started in the fifteenth century in Italy and the sixteenth century in northern Europe. To trace the development of the stylistic changes during this time span, it is suggested that the museum be viewed in chronological order beginning with the Romanesque period and ending with the late Gothic style.

Pole-top, bronze, Late Shang Dynasty (China, Yin-hsu period, 14th-12th century B.C.). China House Gallery.

The Romanesque Hall contains several doorways depicting the development of the Romanesque and Gothic styles, which were important architecutal elements representing the spiritual motif of many church entranceways of the medieval period. The entrance doorway illustrates the heavy, rounded Romanesque motifs recalling the majestic architecture of ancient Rome. Other portals include the thirteenth-century doorway from Reugny, France, which illustrates the transition to the Gothic style. The magnificent Moutiers-Saint-Jean doorway is typical of the high Gothic with its brilliantly carved sculpture. The portal lions dating from the early thirteenth century are believed to come from northern Italy, where lions were frequently integrated into portal architecture of many Romanesque churches. The Spanish Arlanza frescoes, dating from 1220, portray fantastic animals suggestive of portal sculpture.

13

The Fuentiduena Chapel is from the Church of San Martin in the region of Segovia near Madrid. The Cloisters has combined a modern structure with the mid-twelfth-century apse, which is on loan from Spain. Included in the chapel is the Tredo's Fresco, a work of the Pedret Master, recalling Byzantine mosaics due to its stylization of figures and the usage of color. The San Baudelio de Berlanga frescoes date from the twelfth century and are powerful in their narrative quality. Among the other objects in the chapel is a twelfth-century crucifix, which illustrates the Romanesque simplicity and directness in carving.

The Saint-Guilhem Cloister is made up of capitals and columns of the Romanesque and Gothic styles. The capitals, dating from 1206, are adorned with floral patterns and medieval themes. They are believed to come from an addition of the Abbey of Saint-Guilhem-le-Desert near Montpelier, a Benedictine Abbey founded in 809. The fountain in the center of the cloister is believed to have been carved in the late eleventh century. The corbels portray ten grotesque, yet humorous, figures that are used to support the ribs and cornices over the cloister walks.

The Langon Chapel incorporates stone walls from the twelfth-century church of Notre-Dame-du-Bourg near Bordeaux. The capitals on the columns have no religious significance, but reveal simple faces that bring to mind Greek atlantes and caryatids. This Romanesque chapel also contains a rare wooden sculpture of the enthroned Virgin, which was originally polychromed. The sturdy iron-bound doors were the church's protection against thieves.

The twelfth-century chapter house from Pontaut was dismantled from the abbey in Gascony and reconstructed. The floors and vaults represent the only restorations. This room, used by the monks for their daily morning meeting, is typical of Romanesque architecture in that the walls are uneven in length and do not form perfect right angles.

The Romanesque Cuxa Cloister contains about half of the columns and other elements from southern France's important Benedictine monastery, Saint-Michel-de-Cuxa. The capitals are mixed in treatment, ranging from the simple to the ornate. The marble used for reconstruction comes from the Languedoc provence where the original Cuxa stones were quarried. The Frias doorway from the early thirteenth century is actually eighty stone carvings arranged in their original order during the Middle Ages.

The Nine Heroes Tapestry Room contains one of two sets of fourteenth-century tapestries. The other set is the Apocalypse tapestries at Angers. The set originally consisted of three tapestries, but were cut up and dispersed during the years. The museum has been able to collect about two-thirds of the original set with five of the heroes having been recovered. The nine heroes include the three pagans: Hector, Alexander and Julius Caesar; the three Hebrews: David, Joshua and Judas Maccabeus; and the three Christians: Arthur, Charlemagne and Godfrey of Bouillon.

The Early Gothic Hall reflects changes in the architectural motif as well as in the portrayal of the figures in contrast to the Romanesque style. The more naturalistic, graceful image that came out of the thirteenth century moves toward a more mannered, stylized elegance in the four-teenth century. The windows, for example, are pointed instead of rounded and allow for more natural light. The gallery houses a thir-teenth-century limestone statue of the Virgin, believed to have come from the destroyed choir screen of the Strasbourg Cathedral. A four-teenth-century statue of the Virgin and child is also in this gallery. Both of these are extraordinarily preserved and show more humanistic, re-laxed features than previous works.

The Gothic Chapel suggests features from churches in Carcassonne and Monsempron. Stained-glass French panels depict the prophet Isaiah and Saint Mary Magdalene. The three central double lancet windows are glazed with Austrian stained glass from St. Leonhard in Lavanthal, dating from about 1340. St. Bartholomew, St. John the Evangelist and two scenes of St. Martin dividing his coat with a beggar are illustrated. Tomb monuments from the thirteenth and fourteenth centuries typically reflect

the serenity and beauty of the carvings of this period.

The capitals of the nearby Bonnefont Cloister were in part extracted from the abbet of Bonnefont-en-Comminges in southern France. The court garden flanked by the cloister arcades is suggestive of many gardens depicted in paintings and tapestries of the period, but not based on any known model.

The Trie Cloister contains capitals from the destroyed Convent of Trie, not far from Toulouse. Believed to date from between 1484 and 1490, they are placed in approximate sequential order of the biblical scenes which they illustrate. Coats of arms of the local families also appear on capitals, showing a secularization of the arts in the late Gothic period. The fountain in the garden is made of two parts dating from the late fifteenth to the early sixteenth century.

The Glass Gallery contains 75 pieces of stained glass from the fifteenth to the early sixteenth centuries. The glass roundels were inset in leaded panels of clear glass, commonly used in secular buildings. The elaborately carved Abbeville Woodwork comes from the courtyard of the House of Francis I. The Treasury consists of three rooms which contain precious small-scale objects. The hundreds of objects on display include the twelfth-century ivory Bury St. Edmunds Cross, twelfth-century Mosan goldsmith work, reliquaries, ivories and illuminated manuscripts highlighted by the *Belles Heures* of the Duke of Berry by the Limbourg Brothers.

Glass Gallery

In the Boppard Room, six glass panels from the church of the Carmelite Convent at Boppard in Germany make up the largest collection of late Gothic stained glass from a single monument in the United States. The Spanish alabaster retable from the fifteenth century is also found here along with the limestone doorway, exemplifying the flamboyant Gothic style.

The Hall of the Unicorn Tapestries contains the most precious treasures from the Middle Ages. These Franco-Flemish tapestries incorporate a strong sense of beauty, color and naturalism. They tell the story of the hunt and capture of the unicorn, a theme which symbolizes courtship and marriage and has various religious connotations as well.

Wallpaper printed from wood blocks, William Morris (England, designed 1876, reprinted 1934). Cooper-Hewitt Museum.

Among the tapestries one finds in the Burgos Tapestry Hall is the *Glorification of Charles VIII,* a Flemish tapestry dating from about 1490. This same room also contains two magnificent silver-gilted ewers dating from 1500 and made for the German Master of the Order of Teutonic Knights.

The Campin Room gets its name from the *Merode Altarpiece* by the Flemish master, Robert Campin. All of the furnishings in the room are similar to those depicted in the Campin altarpiece.

The Late Gothic Hall contains a timbered ceiling taken from old Connecticut buildings. The fifteenth-century windows come from the refectory of the convent of the Dominicans at Sens. The paschal candlestick found here was used for the celebration of the Easter festival. It is made of painted and gilded wood and rises to a height of six feet, five inches.

The Froville Arcade, located on the exterior along the upper driveway, comes from a fifteenth-century cloister that originally was a Benedictine priory in Fromville. The nine pointed, cusped arches are grouped in threes and separated by buttresses. Treated as a series of windows, these arches demonstrate how the Gothic style differs from the elaborate arcades that were common in the Romanesque and early Gothic periods.

Cooper-Hewitt

Cooper-Hewitt Museum, the Smithsonian Institution's National Museum of Design 2 E. 91st St., New York, NY 10028 (212) 860-6868 Tuesday: 10-9; Wednesday-Saturday: 10-5; Sunday: 12-5 Admission: adults, $1.50, senior citizens and children under 12 free, Tuesday after 5 P.M., free

Although the Museum officially opened in 1976, its history dates back to 1859 when Peter Cooper opened the Cooper Union for the Advancement of Science and Art. It was an institution consisting of a free school, library and lecture forum that was available to the needy without regard

for race, creed, color or sex. Intending to include a museum of "art, science, and nature," he provided space for such a museum in his original building plans. Late in the century, Cooper's granddaughters decided to establish the Cooper Union Museum for the Arts of Decoration and began to amass a collection.

collections

Within a few years, important private collections were purchased or acquired as gifts. Later acquisitions continued to maintain a high level of quality, so that today the Museum is considered one of the foremost repositories of decorative arts and design in the world. The holdings encompass objects from all parts of the world and every historical period, spanning more than 3,000 years. Included are drawings, prints, wall-paper, textiles, ceramics, glass, furniture, woodwork, metalwork and jewelry. Also covered is every conceivable category of design—architecture, urban and industrial planning, advertising, fashion, interiors and home furnishings.

From the beginning, the Museum's collection was assembled with the singular purpose of providing visual information for the study of design. Objects from the collection are organized in curatorial departments by medium and technique rather than by culture, period or historical chronology. The Library, developed to complement the collection, provides the most comprehensive and readily accessible reference materials on design in the United States. Combined with a picture archive and research library of more than two million items, Cooper-Hewitt has become an important resource for scholars, students and designers from all parts of the world.

When the trustees of Cooper Union decided to discontinue the Museum in 1963, the collection was entrusted to the Smithsonian Institution. The name was subsequently changed to Cooper-Hewitt Museum, the Smithsonian Institution's National Museum of Design. In 1972 the Carnegie Corporation deeded the Carnegie Mansion to the Smithsonian as a new home for the Cooper-Hewitt Museum.

The Museum's holdings are divided into three departmental units. Especially outstanding is the drawings and prints collection, which is the largest in the United States, consisting of over 90,000 items. It includes eighteenth- and nineteenth-century Italian and French designs for textiles, theaters, ornaments and architecture; furniture and objects of all kinds; American wood engravings; and North European woodcuts and engravings by Albrecht Durer, Lucas van Leyden and Rembrandt. A sizable group of nineteenth-century American drawings includes many by Winslow Homer, Frederick Church and Thomas Moran.

decorative arts

The decorative arts collection has significant holdings of earthenware, stoneware, porcelain, metalwork, furniture, lacquer and glass. The evolution of ceramics from antiquity to the present, for instance, may be traced in the interrelated collection of European porcelain, Oriental stoneware, and porcelain prototypes. The glass objects are of great scope and fine quality, featuring ancient glass, medieval Middle Eastern examples, and European objects from the seventeenth century to the present. Twentieth-century European and American art glass is included as well as stained and leaded glass panels of the thirteenth through the sixteenth centuries. The diversity in metalwork can be seen in steel and ironwork on one hand, and silver and jewelry on the other.

The textile collection embraces a broad range of woven, printed and dyed fabrics. An outstanding segment is a group of Egyptian, Islamic, Mediterranean and Near Eastern textiles from the third through the fifteenth centuries. Embroidery is well represented in this collection by a group of men's waistcoats from the eighteenth and nineteenth centuries and by a sizable group of samplers from European countries and America. The lace collection is considered to be among the world's finest.

Each of the curatorial departments received numerous donations over the past several years that have strengthened the collections significantly. The Decorative Arts Department received a Sevres porcelain *dejeuner* (coffee service), that bears the monogram of Napoleon on the

cover of its leather carrying case. The Textile Department was given a length of brocaded dress silk woven in Spitalfields in the 1740s. The Drawings and Prints Department received a rare and important set of books, *The Works in Architecture* by Robert and James Adam, that was published in England between 1773 and 1822. It includes three elephant folios of engraved plates accompanied by a rich text that outlines the design philosophies of the Adam Brothers.

Thematic exhbitions have been offered regularly since the opening of the Museum. In keeping with the implied purpose of the Museum as the Smithsonian Institution's National Museum of Design, the exhibitions always focus on some aspect of design. Since its opening in 1976, the Museum has mounted numerous exhibitions covering a wide range of subjects. Notable among them are "The Royal Pavillion at Brighton," "Andrea Palladio," "MA, Space-Time in Japan," "The Oceanliner: Speed, Style, Symbol," "Electroworks," "Gardens of Delight" and "Puppets: Art and Entertainment." The exhibitions have been considered provocative and have received favorable press review. Excellence in design has appropriately become the hallmark of the Cooper-Hewitt exhibit installations.

Continuing to carryout the original aims of the founders, the Museum has introduced interesting and varied programs. They include workshops, weekend seminars, lecture series, activities for children, performing arts and a special project for Museum professionals. In addition, a Master of Arts Degree in History of Decorative Arts is offered in collaboration with Parsons School of Design/The New School.

Design for a Villa, ink and watercolor on paper (Italy, 1675). Cooper-Hewitt Museum.

Drawing Center

The Drawing Center 137 Greene St., New York, NY 10012 (212) 982-5266 Monday-Saturday: 11-6; Wednesday: 11-8 Admission: fee optional

Opened in January 1977, this not-for-profit institution is dedicated to the exhibition and study of drawings, defined as "any unique works on paper." Five shows a year emphasize drawings of aesthetic importance or popular interest which are not represented in regular museum programs. Contemporary artists' drawings that are not ordinarily presented commercially can also be seen. These include architectural, industrial, cinematic, theatrical and dance designs, musical manuscripts, sketchbooks and paper models.

The Center offers innovative services to the artist, scholar, collector and public alike to encourage an appreciation of drawing as a major art form. Lectures, films, readings and symposiums are offered in conjunction with exhibitions in which artists, critics, collectors, curators and art historians participate. Paper conservation workshops, designed to teach care and conservation of drawings, prints and photographs, are held twice a year. Checklists are available for each show. A scholarly catalogue is published annually. Work-study and internship programs with several universities are in progress. In a viewing program, in which portfolios of unaffiliated artists are reviewed, advice is given to a great number of artists on their exhibition and conservation possibilities. Resumes and slides of artists' works, kept in the Center's growing reference volumes, are consulted by museum curators, art dealers, collectors and editors.

The Drawing Center's exhibition program consists of four group shows a year of emerging artists plus one scholarly or thematic exhibition. Recent scholarly exhibitions included "Sculptors' Drawings over Six Centuries," "Visionary Drawings of Architecture and Planning," and "Musical Manuscripts."

Fashion Institute

Fashion Institute of Technology, Shirley Goodman Resource Center and Design Laboratory 227 W. 27th St., New York, NY 10001 (212) 760-7709 Tuesday: 10-9; Wednesday-Saturday: 10-5

In the early days of World War I, when American merchants and designers were cut off from the markets of Europe, the Brooklyn Museum established a design research laboratory. This successful project was extended to include many schools in the New York area. With a view to enlarging the services of the laboratory, the trustees of the Brooklyn Museum and the Fashion Institute of Technology agreed to change its location to the new F.I.T. campus where young people are preparing for careers in the home furnishing and apparel industries.

The Fashion Institute's present building, completed in 1975, has an impressive, wide entrance, fine galleries and well-designed archival rooms for gowns and accessories. It also has facilities for restoration and preservation. It is an oasis of delight and visual enchantment in the old overcrowded streets of the Garment Center in the vicinity of Seventh Avenue, renamed Fashion Avenue.

The Design Laboratory is today an integral part of the Shirley Goodman Resource Center, the largest research facility of its kind in the world. On seven floors covering the block between 26th and 27th Streets are exhibition galleries, offices, classrooms and individual study rooms. A textile collection of more than three million indexed swatches is also housed here, along with approximately one and a quarter million costumes and accessories of dress dating from the eighteenth century to the present. A comprehensive library of books and periodicals may also be found.

Since 1976, the exhibitions at F.I.T. have been true works of art. "Paul Poiret, King of Fashion" included seventy-six works from 1907 through 1925, many of them borrowed from museum collections. In the extraordinary installation, all details of the period surrounded the clothed mannequins, such as accessories, furnishings, backgrounds, garden areas, paintings and even soft music characteristic of the period. The galleries

were completely transformed, sight and sound, into the Pre-World War I era and the 1920s.

In "The Look," costumes and accessories from 1765 to the present, were selected from the collections at F.I.T. to recreate the changes in fashion, posture, hair styles and make-up as influenced by a wide variety of factors—politics, economics and popular culture.

Other ambitious exhibitions have included "Givenchi: A 30-Year Retrospective;" "Louise Dahl-Wolfe," a photographic retrospective of her brilliant work for *Harper's Bazaar*; a remarkable collection of costumes, artifacts, uniforms and other items donated by Adele Simpson to the Resource Center; three hundred years of design presented in "American Style;" and "The Glory of the Gods," featuring religious robes and artifacts from around the world. There was also a frontier fashion exhibit entitled "The Opening of the West from the Gold Rush to the Pipe Line."

The Frick

The Frick Collection 1 E. 70th St., New York, NY 10021 (212) 288-0700 Tuesday-Saturday: 10-6; Sunday: 1-6 June-August: Monday & Tuesday: closed Admission: Weekdays and Saturday: $1.00 Sunday: $2.00; students and senior citizens 50c.

This outstanding collection is housed in the former residence of Henry Clay Frick, the Pittsburgh coke and steel industrialist. Built in 1913-14, it was designed by American architect Thomas Hastings in a style reminiscent of domestic European architecture of the eighteenth century. The rooms are decorated in the style of English and French interiors of the same period. After certain alterations and additions were made to the residence, it was opened to the public in 1935. A further extension and garden were completed in 1977.

During Frick's lifetime, the house contained the works of art he collected over a period of forty years. He bequeathed them to a board of trustees empowered to make the collection, along with his house, a center for the study of art and kindred subjects. Among the numerous works were 131 paintings. Since that time, some forty additional paintings have been acquired by the trustees, mostly with funds from an endowment by Frick.

From an early age, Frick was interested in art, and his acquisitions show a progressive development of interest and taste. After initially collecting Salon pictures and paintings of the Barbizon school, he purchased his first work by an old master around the turn of the century, and in the next decade acquired many more of the outstanding paintings which established the character of the collection on view today.

collections

Works of art in The Frick Collection are arranged flexibly to retain the atmosphere of a private home. The rooms have been turned into galleries and contain the finest examples of Italian Renaissance and eighteenth-century French furniture, as well as Italian bronzes and French and Chinese porcelains.

The Boucher Room exhibits eight panels by Francois Boucher representing the Arts and Sciences and some eighteenth-century French furniture. The Fragonard Room shows *The Progress of Love,* a series of canvases painted by Jean Honore Fragonard for Madame du Barry; Jean Antoine Houdon's marble bust of the Comtesse du Cayla; and additional examples of eighteenth-century furniture. The Enamel Room is occupied by Piero della Francesca's *Saint Simon,* Duccio's *Temptation of Christ,* Jan van Eyck's *Virgin and Child* and sixteenth-century painted enamels from Limoges.

Renaissance paintings

Renaissance paintings in the collection feature works by Giovanni Bellini, Bronzino, Fra Filippo Lippi, Titian and Veronese, among others. French paintings include those of Jean-Baptiste Simeon Chardin, Claude Lorrain, Camille Corot, Jacques-Louis David, Edgar Degas, Jean-Auguste Dominique Ingres, Charles-Francoise Daubigny, Edouard Manet, Jean-Francoise Millet, Claude Monet and Pierre-Auguste Renoir. English paintings are also well represented and include works by John Constable, Thomas Gainsborough, William Hogarth, Sir Thomas

Lawrence, Joseph M.W. Turner, Sir Joshua Reynolds and George Romney. Dutch and Flemish paintings are represented by Pieter Bruegel I, Sir Anthony van Dyck, Frans Hals, Meindert Hobbema, Rembrandt, Jan Vermeer and others. Spanish painters include Francisco de Goya, Diego Velazquez and El Greco. There are portraits by the American painters Gilbert Stuart and James A.M. Whistler, as well as the famous portrait of *Sir Thomas More* by Hans Holbein the Younger.

From October until the end of May, illustrated lectures are given on Thursday, Friday and Saturday afternoons. An introductory lecture is presented at 11:00 a.m. Tuesday through Friday during the lecture season. Chamber music concerts are also presented on Sundays fall through spring. A limited number of tickets are available by mail.

Goethe House

Goethe House New York 1014 Fifth Ave., New York, NY 10028 (212) 744-8310 Tuesday & Thursday: 11-7; Wednesday, Friday, Saturday: 12-5

Goethe House is one of the many branches of the Munich-based Goethe Institute for the promotion of international cultural cooperation. It is housed in an elegant Beaux-Arts town house, originally designed by Welch, Smith & Provot and completed in 1907. Goethe House organizes cultural and scientific programs in cooperation with American institutions, such as theaters, film clubs, museums, galleries, art centers, concert halls and universities.

Exhibitions have included the prints and drawings of Emil Orlik; and holograms, paintings and drawings by Dieter Jung. Thirty-nine posters from the Galeria Klihm of Munich represented a kaleidoscopic view of exhibitions held there from 1950 to 1970. Posters by Laszlo Moholy-Nagy, Herbert Bayer, Otto Dix and Karl Hofer, and those by renowned designers using their works, were included. In another exhibition, copies of *Simplicissimus* showed the art of Germany's most influential satire magazine from 1896 to 1944.

Goethe House sponsored an exhibition of nineteenth-century German stage designs from the collection of the Theater Museum in Munich, which was shown at the Cooper-Hewitt Museum. In cooperation with the International Center of Photography in New York, it held an exhibit of one hundred years of photography from 1840 to 1940, which included the works of Heinrich Kuhn and Hugo Erfurth among many others. One-person retrospective exhibits included a show of works by Erich Salomon as well as lithographs, silk screens and other prints by Joseph Beuys. Recently exhibited were rare miniatures and paintings from the Goethe era upon the 150th birthday of Goethe.

Guggenheim Museum

The Solomon R. Guggenheim Museum 1071 Fifth Ave., New York, NY 10000 (212) 860-1300 Tuesday: 11-8; Wednesday-Sunday: 11-5 Admission: adults $2.00, students and senior citizens $1.25; Tuesday 5-8 free. For information regarding hours and special exhibitions call (212) 860-1313.

The Museum is a non-profit organization dedicated to showing significant twentieth-century painting and sculpture. It is well known for its ambitious exhibitions and retrospectives, which present the full spectrum of modern art from the Impressionists to established contemporaries. The Museum hold the largest group of works by Wassily Kandinsky in the United States as well as the largest number of sculptures by Constantin Brancusi in New York. The ongoing development of new gallery space favors permanent display for the Museum's more than 4,000 fine works.

transportation

The Museum is located on "Museum Mile" (at 89th Street). By bus, take the Metropolitan Transit #4 uptown on Madison Avenue or downtown on Fifth Avenue. By subway, take the IRT express 4 or 5, or local 6, stopping at Lexington Avenue and 86th Street.

In 1943 Solomon R. Guggenheim commissioned the American architect Frank Lloyd Wright to design an original building to house contemporary art. Guggenheim approved the plans before his death in

Miniatures from the Goethe Era (1775-1830). Goethe House.

Pablo Picasso, *Pitcher and Bowl of Fruit* (1931), 51" x 64", oil on canvas. Guggenheim Museum.

1949, construction began in 1957, and the controversial building was completed in 1959, shortly after Wright's death. The unique structure was referred to be some as a "giant snail" and by others, such as architect Philip Johnson, as "the most beautiful building in New York."

Wright himself thought the building represented the first advance in the direction of organic architecture in New York and constructed it of materials consistent with its setting adjacent to Central Park. He specified the use of as much natural light as possible inside the building and emphasized natural colors such as beige and brown.

the building

The structure has been likened to sculpture. Cast in concrete, its spiral shape is formed by a grand cantilevered ramp that curves unbroken from the ground to the dome almost 100 feet above. The building's circular form is repeated in the shape of the galleries, the auditorium, the elevators and in the decorative motifs on the floor and in the sidewalls in front of the museum. The ground-floor area provides a multipurpose space that can accommodate large-scale sculpture, special events and sizable crowds. Above the groundfloor where the ramp begins, the museum resembles a chambered nautilus, with seventy-four niche-like bays for the display of works of art. Underneath the galleries is the auditorium, and adjacent to them is the administration building with offices for the museum staff.

Guggenheim began his art collection with works by old masters, without pursuing any particular direction. In the mid-1920s, circumstances changed his course when he met and commissioned his portrait to a young German artist, Baronness Hilda Rebay. Rebay had exhibited with avant-garde groups in Germany from 1914 to 1920 and associated with artists such as Sonia Delaunay, Albert Gleizes, Fernand Leger, Chagall and Wassily Kandinsky. Guggenheim, who was introduced to her circle and converted by her enthusiasm for avant-garde art, began to accumulate works by these artists until the walls of his Plaza apartment were overrun. As the fame of his collection grew, he occasionally availed his home to the art world and began lending out for exhibitions. Soon Guggenheim took office space at Carnegie Hall and appointed Rebay as the custodian of the collection, which was converted in 1937 into a foundation and empowered to operate as a museum.

James Johnson Sweeney, internationally known art critic and a former director at the Museum of Modern Art, took over the directorship upon Rebay's retirement. Sweeney proceeded to show successive selections from the collection as quickly as they could be prepared for exhibition. The original collection was enlarged by the purchase of the estate of Karl Nierendorf in 1948, which included works by Oskar Kokoschka, Paul Klee, Chagall, Lyonel Feininger and Ernst Kirchner. Further acquisitions brought in sculpture by Constantin Brancusi, Alberto Giacometti, Alexander Archipenko, Alexander Calder, Raymond Duchamp-Villon, Aristide Maillol, Henry Moore and Max Ernst. A major painting purchase in 1954 was Cezanne's *The Clockmaker.* Arrangements were also made for the purchase of works by Braque, Miro, Picasso and key examples by Americans Franz Kline, Jackson Pollock, Willem de Kooning, Stuart Davis and many younger artists.

abstractionist paintings

Many of the finest and most famous paintings and sculpture in the collection, long relegated to storage for lack of exhibition space, are now installed in a new gallery that runs off the fourth ramp of the Museum's spiral, in an area previously devoted to offices and the conservation studio. The new installation places primary emphasis upon pioneer abstractionists Kandinsky, Klee, Leger, Delaunay and Mondrian, among others, initially collected by the Guggenheim's predecessor, the Museum of Non-Objective Painting. Subsequently acquired paintings and sculpture by Alexej Jawlensky, Franz Kupka, Marcel Duchamp, Francis Picabia, Alexander Archipenko, Constantin Brancusi and others are also placed on permanent view.

The Museum recently participated in an unprecedented exchange of masterworks with The Museum of Modern Art. In this way, it acquired its first important painting by Henri Matisse, as well as a major work by

Picasso, which strengthens the sequence of his paintings already in the collection. Picasso's *Pitcher and Bowl of Fruit* (1931) is one of the rare paintings in which a "stained-glass" style is followed consistently. Matisse's *Italian Woman* (1916) is a three-quarter portrait of the Italian model Laurette, which is characterized as one of the artist's sternest and most arresting works. In return, the Guggenheim gave to the Museum of Modern Art two works of 1914 by Wassily Kandinsky which, with MOMA's own two works, complete the celebrated *Four Seasons* ensemble.

Thannhauser Collection

A selected part of the Justin K. Thannhauser Collection, a modern art treasure, is permanently integrated into the Guggenheim's masterpieces of the figurative trend of late nineteenth- and early twentieth-century art. Consisting of seventy-five paintings and sculptures, it is strong in a group of Impressionist and Post-Impressionist masterpieces that antedate the Museum's original holdings, and thus serves as a historical background for the collection.

The exhibition program includes eight to twelve shows each year. It consists of loan exhibitions and exhibitions drawn from the museum's permanent collection of nearly 3,000 paintings, sculpture and works on paper from the nineteenth and twentieth centuries. The group and one-person shows feature established modern masters as well as artists currently involved in experimental approaches.

From the time of his appointment in 1961, Thomas N. Messer and his staff have proceeded with the staging of large retrospectives that survey the work of such established masters of modern art as Kandinsky, Klee, Munch, Schiele, Calder, Brancusi, Mondrian, Miro, Ernst, Dubuffet, Giacometti and Maillol. Comprehensive exhibitions of the work of more contemporary artists have been accorded to Francis Bacon, Philip Guston, David Smith, Morris Louis, Joseph Cornell, Julius Bissier, and Roy Lichtenstein. Most recently, the Museum has mounted one-person exhibitions of the work of Kenneth Noland, Willem de Kooning, Mark Rothko and Joseph Beuys, as well as group shows that present diverse aesthetic perspectives.

Recent exhibitions have included "The New York School: Four Decades, Guggenheim Museum Collection and Major Loans," which reflected the range and depth of the Museum's postwar collection of American art; "Italian Art Now," featuring seven contemporary Italian artists; a retrospective of abstract expressionist Jack Tworkov; and "Kandinsky in Munich: 1986-1914," the first of three biannual exhibitions to examine Kandinsky's oeuvre. Others were a presentation of outstanding American art of the 1950s and 1960s from the permanent collection; "Seven Photorealists from New York Collections," featuring thirty-five paintings and works on paper; a survey of European and American Abstract Expressionism; and major retrospectives of Jean Dubuffet and Arshile Gorky.

The Museum has inaugurated a Collection Decentralization Program, which enables American museums to borrow works on a long-term basis from the Guggenheim's permanent collection. Ten museums from around the country have been selected for the 1982-1987 program, the first of its kind. Loans will last from six months to two years and each museum will initiate educational programs to complement the borrowed works.

special events

The Museum sponsors special events and offers various education programs. Films are shown and lectures are given by the Museum staff and visiting authorities. Performing arts events, films and lectures are also occasionally scheduled. Poetry readings, sponsored by the Academy of American Poets, are given on selected evenings. In addition, the Guggenheim presents performances in conjunction with major exhibitions. The premiere of Kandinsky's one-act color opera, "The Yellow Sound," was recently staged by the Museum in order to augment viewer appreciation of the first of three major Kandinsky exhibitions. Russian constructivist theater was performed in relation to an exhibition of Russian avant-garde art at the Museum.

Taped tours by Museum curators are available for rent at the admission desk for special exhibitions as well as for the Justin K. Thannhauser Collection. There is a Museum building tour in addition to recorded architectural tours in English, French and German. Informative guided tours by docents for adult groups are available by appointment.

A cafe, located between the main gallery and the administration building, is open from 11:00 to 4:30, Wednesday through Sunday and holidays, and Tuesday from 11:00 to 5:30. Light lunches and refreshment are served, and an outdoor terrace is open from late spring until early fall.

membership

The Museum maintains a membership program known as the Society of Associates. Annual dues are $250 for a family membership and $125 for a junior membership for those under thirty-five. Privileges of membership include invitations to private openings, complimentary catalogues, free admission to the Museum, free use of recorded tours, bookstore discounts, use of the Museum reference library, special events for members only and courtesies extended by major museums abroad. In addition, individuals may become members for $25 and receive free admission and special discounts. For further information, call the membership office at (212) 860-1354.

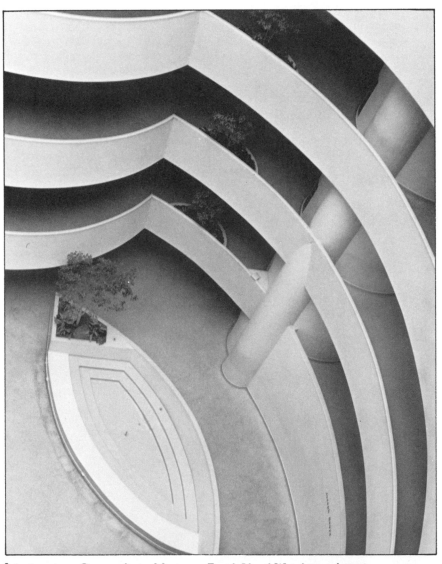

Interior view, Guggenheim Museum. Frank Lloyd Wright, architect.

The Hispanic Society of America Broadway between 155th and 156th
Sts., New York, NY 10032 (212) 926-2234 Tuesday-Saturday: 10-4;
Sunday: 1-4 Admission: free

With one of the largest Hispanic populations in North America, New York
is the home of a fine museum representing the cultures of the Iberian
Peninsula. The holdings span prehistoric times to the present day and
include paintings, sculpture and decorative art. The original collection
was founded in 1904 by Archer M. Huntington as a free museum and
reference library. Over the years the Society has assembled thousands of
manuscripts and over 100,000 books, thus making this institution an
important research center for Spanish and Portugese history and
literature, as well as art.

The main building opened in 1908 and the north building was added
in 1930. The courtyard of the main building is decorated in terra cotta in
classic Spanish Renaissance fashion. Inside are numerous display cases
filled with archaeological artifacts and ancient ceramics, and excellent
collections of Hispano-Moresque bowls and fifteenth-century mudejar
silk. This building also houses rare art treasures such as El Greco's *Pieta*
from the late sixteenth century, which dramatically portrays Christ
embraced by Mary and the Magdalene. Velazquez's *Portrait of a Little
Girl* from the seventeenth century depicts a young child and sensitively
captures the innocence of her youth and budding beauty. Other works
ranging from Luis de Morales to Francisco de Goya hang throughout the
galleries.

The South Exhibition Room resembles a Spanish chapel and is lined
with paintings and art objects from the fifteenth to the seventeenth
centuries. Here one finds an exquisite retable signed by Pere
Espalargues and dated 1490. The Sorolla Room is lined with large and
colorful mural-like paintings of Joaquin Sorolla y Bastida. These majestic
works depict the gay costumes and fiestas of regional Spain.

There is an impressive inventory of publications discussing and illus-
trating the Society's vast permanent collections. Further information may
be obtained by writing or calling the Society.

Transportation to the Society: by bus, take the Fifth Avenue bus *transportation*
number 4 or 5 to West 155th Street and Broadway; by subway, take the
Eighth Avenue Washington Heights local train to West 155th Street and
proceed two blocks east. West side IRT riders may take a local train to
157th Street and Broadway.

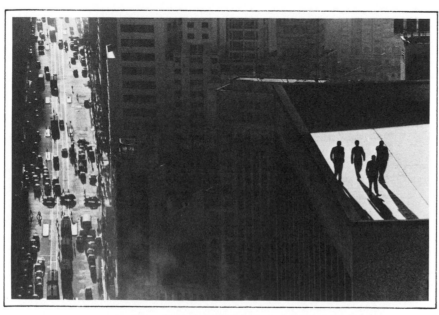

Rene Burri, *Sao Paulo, Brazil* (*1960*). International Center of Photography.

Institute for Art and Urban Resources

The Institute for Art and Urban Resources, Inc. Project Studios One 46-01 21st St., Long Island, NY 11101 (212) 784-2084 Thursday-Sunday: 1-6

This non-profit organization was initially involved in salvaging abandoned buildings for artists' workspaces and exhibitions. It subsequently established two permanent exhibition and workspace centers: Project Studios One (P.S.1) in Long Island and the Clocktower in Manhattan (See downtown gallery review).

P.S. 1, housed in a nineteenth-century school building that was slated for demolition, provides low-cost studios to artists as well as exhibition facilities of 25,000 square feet. The size and relaxed atmosphere of P.S. 1, which is the largest alternative space in North America, affords artists an opportunity to utilize the building's raw interior space to maximum advantage. The Clocktower, on the other hand, is designed for in-depth, one-person exhibitions, which often feature works of artists whose careers are just emerging. Studio space is also available at The Clocktower.

Since the inaugural exhibition at P.S. 1 in 1976, works by over 1,000 artists have been shown at both centers. Exhibitions, which are organized by artists, art critics and museum curators, feature contemporary art by living artists.

The Institute has an exhibition center, special projects rooms and a multidisciplinary program, which includes curated shows in the areas of fashion, architecture, music/sound, poetry/literature, video, film and photography.

International Center of Photography

International Center of Photography 1130 Fifth Ave., New York, NY 10028 (212) 860-1777 Tuesday: 11-8; Wednesday-Sunday: 11-5 Admission: adults $2.00; students and senior citizens $1.00

Established in 1974 as an independent, not-for-profit institution, the Center is New York City's only museum of photography. It maintains conservation programs, collections and a comprehensive educational photographic facility. It also provides an exchange of information and ideas, as well as a meeting place for the photographic community and public.

The Center is housed in the Willard Straight Mansion, a Neo-Georgian landmark building completed in 1915. Its refined elegance and fourteen-foot ceilings on the first and second floors furnish an impressive setting for exhibitions. The third floor has three seminar rooms, resource and library rooms, and staff offices. The basement is occupied by darkrooms, print finishing rooms and a student exhibition gallery. Day-and-night activity in the building includes workshops, lectures, seminars and a diverse program of changing exhibitions.

exhibitions

The one-person and group shows during the Center's first seven years cover a wide spectrum of photographic expression and experimentation by over 1,000 photographers. Among those represented are Lewis W. Hine, Robert Capa, Clarence White, Philippe Halsman, George Hoyningen-Huene, Jacob A. Riis, Weegee and Martin Munkacsi. Contemporary masters have included Henri Cartier-Bresson, Andreas Feininger, Bruce Davidson, Burk Uzzle, Alfred Eisenstaedt, Berenice Abbott, Frederick Sommer, Roland Freeman and Gordon Parks. Photographers who are emerging as serious artists, with a substantial body of work and unique point of view, form the basis for the Center's "Insights Series," exhibiting works of Judith Turner, Paul Diamond, Pierre Boogaerts, Lynn Davis and Robert Mapplethorpe.

Group shows have included "Paris/Magnum; Photographs 1935-1981;" "Recollections: Ten Women of Photography;" "Double Take: A Comparative Look at Photographs and Photography of the Fifties: An American Perspective." Historical surveys have covered "The Grand Tour: Mid-Nineteenth Century Photographs from the Leonard Peil Collection" and "Treasures of the Royal Photographic Society." Sociological studies, "Robert Flaherty: Photographer/Filmmaker," "The

Inuit 1910-1922," and "The Last and First Eskimos: Photographs by Alex Harris." International exhibitions included "Japan: A Self Portrait," "Fotografia Polska," and "When Words Fail; German Photography from its Origins through the Avant-Garde 1840-1940."

Aware of significant new directions in photography, the Center installed exhibitions showing technological breakthroughs. Such shows have included "Holography '75, The First Decade;" the experimental work of the emerging Los Angeles photographers, "In Just Seconds: A Polaroid Color Survey;" and "Gjon Mili: Photographs and Recollections."

Color photography, a medium rarely included in museum shows until recently, has been recognized from the start in Center exhibitions such as Ernst Haas' "An American Experience;" "American Images: New Work by Twenty American Photographers;" and "The New Color: A Decade of Color Photography."

The Traveling Exhibitions Program has circulated Center shows throughout the world, approximately twenty exhibitions shown in ninety cities.

In November 1979, the Center appointed a curator to catalogue and to develop the permanent collection. The study room, which may be used in conjunction with the resource library, gives students and scholars access to the Center's archives of photographs, correspondence, reference materials and memorabilia of eminent photographers. Although the Center's core collection emphasizes the documentary tradition, future acquisitions will extend its scope to include the full historical and aesthetic range of photographic expression.

Gordon Parks, *Muhammad Ali* (from "Moments without Proper Names"). International Center of Photography.

Japan House

Japan House Gallery 333 E. 47th St., New York, NY 10017 (212) 832-1155 Monday-Thursday: 11-5; Friday: 11-7:30

Built by Junzo Yoshimura in 1971, the museum is approached by a court-yard filled with greenery. It is the only American museum devoted exclusively to Japanese art. Priority is given to works not shown in New York before, with a balance of avant-garde and popular and early and contemporary art. Scholar-curators play a critical role in the development of the exhibitions and in the preparation of catalogs which complement the visual material.

Recent exhibitions have included one thousand years of Japanese art (650-1650) from the Cleveland Museum, music notation on paper in Japan, early Buddist art from Japan, treasures of Asian art from the Idemitsu Collection, and works on paper by twentieth-century artist Shiko Munakata.

Jewish Museum

The Jewish Museum 1109 Fifth Ave., New York, NY 10028 (212) 868-1888 Monday-Thursday: 12-5; Sunday & Jewish holidays: 11-6 Fridays and Saturdays: closed Admission: adults $2.00, children (6-16) and students with valid ID $1.00, senior citizens pay as you wish, members free. Call to confirm your visit.

The Library of the Jewish Theological Seminary of America was the first home of The Jewish Museum. From its beginning in 1904, the collection grew substantially with donations and gifts, a fact necessitating a far larger exhibition space. In 1947, Mrs. Felix M. Warburg donated her home at 1109 Fifth Avenue as the permanent location of the Museum. The Warburg mansion was expanded in 1963 by the addition of a new building, the gift of Mr. and Mrs. Albert List.

The Jewish Museum is the main repository in the United States for art and artifacts representing the Jewish heritage. Rare ceremonial objects and works of art are restored in the Museum's conservation departments and shown in the galleries on a rotating basis. The collection of ceremonial art is the largest in the United States and one of the most important in the world. Most of the Judaic holdings were donated by patron and art collector Harry G. Friedman. In addition to Friedman's numerous gifts, there are the Rose and Benjamin Mintz collection that

includes Eastern European art, the Samuel Friedenberg collection of plaques and medals and the Harry J. Stein-Friedenburg collection of coins from the Holy Land that date from the sixth century B.C. to the present.

Among the outstanding holdings of the Jewish Museum are Palestinian pottery from the Iron and Bronze Ages, a brilliantly colored mosaic wall believed to be part of an entrance to a sixteenth-century Persian synagogue, a sizable assemblage of contemporary art, and an important collection of Jewish textiles. Loan exhibitions of Judaica are circulated among many institutions throughout the United States. The Museum also represents works by important contemporary artists in changing exhibitions. An important archaeology collection has been donated to the Jewish Museum by Mr. and Mrs. Max Katner and will form a major component of the new permanent installation of biblical archaeology, "Israel in Antiquity."

exhibitions

In its present building, the Jewish Museum has offered an average of seven exhibitions each year. They have included both thematic and one-person shows of works by contemporary artists. Important thematic exhibitions were "MASADA: A Struggle for Freedom" (an archaeological exhibition), "Lower East Side—Portrait of American Life," "Jerusalem—City of Mankind" (a photographic interpretation), and "Fabric of Jewish Life: Textiles from the Jewish Museum Collection." One-person shows included the work of Jewish artists Jankel Adler, Yaacov Agam, Ben Zion, Roman Vishniac, Max Ernst, Arnold Friedman, Camille Pisarro, Larry Rivers and Ben Shahn. Recent exhibitions have included the acclaimed and enormously popular "Kafka-Prague," a display of documents and photographs recreating the mood of Franz Kafka's native city. The exhibition was originally compiled for Beth Hatefutsoth, the Nahum Goldmann Museum of the Jewish diaspora in Tel Aviv, and is circulating nationally. Other recent exhibitions include "Paintings of Moritz Oppenheim: Jewish Life in 19th-Century Germany" and "J. James Tissot: Biblical Paintings." In addition, there will soon be a new permanent archaeological installation, "Israel in Antiquity."

Museum programs include lectures, films, walking tours, courses on Jewish art and children's events. Guided tours are given by specially trained docents. Participants in the Tobe Pasher Workshop for Silversmiths have created contemporary Jewish ceremonial objects, many of which are currently on display. Some 17,000 students benefit by the Museum's school programs each year.

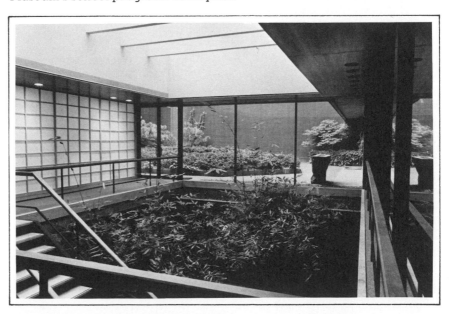

Courtyard at Japan House Gallery. Building by Junzo Yoshimura.

The Metropolitan Museum of Art Fifth Ave. and 82nd St., New York,
NY 10028 (212) 855-5500: general telephone; 535-7710: recorded
information Tuesday: 10-8:45; Wednesday-Saturday: 10-4:45; Sunday
11-4:45 Admission: pay as desired; suggested fee $2.00; senior citizens
free

The Metropolitan Museum is one of the great cultural institutions of the
world and the largest of its kind in the western hemisphere. The
Museum's holdings comprise over three million of the finest existing art
treasures from ancient through contemporary times. Until recently, only
a fraction of the Museum's holdings was accessible to the public, due to
space and design limitations precipitated by the constant growth in
acquisitions. Several new wings have now been added, including the
Michael C. Rockefeller Collection of Primitive Art, the Temple of Dendur
and the American Wing. With the Museum's extensive renovation
program nearly completed, most of the vast collections can now be
viewed in their entirety.

The Museum serves as an outstanding educational complex. The
special exhibitions change frequently and are advertised to the public by
huge, colorful banners that flap above the main Fifth Avenue entrance.
In addition, there are many diverse concerts, tours and other cultural
programs offered by the Museum. The educational and interpretive
material in the new galleries uses a variety of techniques to meet the
information needs of visitors. Orientation areas with maps and charts
provide a general introduction to collections, and specific and detailed
information is available in video discs, audiotours, and brochures and
other printed materials. A wide-ranging program of special educational
and community programs including films, gallery talks, and activities for
young people is underway.

The Museum is located on Fifth Avenue between 80th and 85th Streets, *transportation*
with the main entrance found at 82nd Street. For those traveling by car, a
public parking garage is available adjacent to the Museum on 80th
Street.

The most convenient subway line is the IRT, Lexington Avenue Line,
number 4 or 6 (express or local), stopping at the 86th Street and
Lexington Avenue Station, which is just a short walk from the Museum.

Buses stop regularly directly in front of the Museum on Fifth Avenue,
heading downtown, or one block east on Madison Avenue in the uptown
direction. A crosstown bus line also travels along 79th Street for those
traveling east or west.

Originally founded in 1870 and housed in temporary quarters, the
Museum moved to its present location ten years later. The initial struc-
ture, now housing the Medieval Collection, was designed by Calvert
Vaux on land belonging to New York City. The constant growth of the
Museum's collection has necessitated multiple additions to the original
building, with a long history of architects involved in the ongoing expan-
sion. The Renaissance facade designed by renowned sculptor Richard
Hunt has been incorporated into a monumental neoclassical structure,
reconstructed as part of the comprehensive plan that has created several
new wings. The result is better access from Central Park, since for years
the entire physical orientation of the Museum was towards its Fifth
Avenue facade. Upon entering the Great Hall, one of the grandest
interiors in New York, one can find many helpful services: two free-of-
charge checkrooms flanking either side of the doors, a circular informa-
tion desk where questions can be answered and various brochures ob-
tained, and a number of interesting shops.

The museum shops found just right of the entrance include the book- *shops*
store, which stocks both Museum publications and catalogues as well as
general art books, and postcard shop, which carries color and black-
and-white reproductions. On the left is a gift shop that features beautiful
reproductions of collection pieces and a large selection of stationery and
boxed Christmas cards. This shop, which has become a very popular
source of Christmas gifts, publishes a fine catalogue of available repro-
ductions each winter. The poster shop is located downstairs on the

ground-floor level, adjacent to the Junior Museum, where there also is a gift shop just for children.

For those who wish to enjoy the Museum on a frequent and regular basis, there is a worthwhile membership program. Members' privileges include preview shows, lectures, special activities and mailings of many museum publications. Members also receive free admission to the Museum, free issues of the illustrated Bulletin, the bi-monthly Calendar, an annual garden party at the Cloisters, special activities for members' children and discounts on many publications and purchases. There are special plans available to individuals, families and students. Detailed information is available at the circular information desk in the Great Hall. The Grace Rainey Rogers Auditorium is the site of numerous concerts and lectures which are open to the public in accordance with published schedules available either at the information desk or in the Calendar/News. This and other museum information may be obtained at (212) 879-5512.

The Fountain Restaurant and Bar is located in the south wing on the ground floor of the building. During luncheon hours, one can dine around the pool with sculpture by Milles, or enjoy afternoon coffee or cocktails. On Tuesday evenings dinner is available. The Snack Bar, located on the ground floor of the Junior Museum wing, is open daily for lunch.

Temple of Dendur, (Egypt, first century B.C.). Metropolitan Museum of Art.

lectures & tours

Informative gallery talks and introductory tours of the Museum are offered on a continual basis at no charge, as are films and lectures in the Rainey Auditorium. Special Sunday programs include a variety of events. Use of the reading room in the European paintings galleries is also free, as well as special exhibits in the orientation galleries. Recorded tours may be rented for specific collections.

The Thomas J. Watson Library boasts the largest and most comprehensive collection of material on art and archeology in the western hemisphere. Although it is basically for the use of the curatorial staff, it is also available to graduate students with identification cards, visiting scholars and researchers.

The Photograph and Slide Library has an enormous collection of slides which may be rented for lectures, and an equally great number of black-and-white photographs and color prints, which are available for study. Photographs of objects in the Museum's collections can be purchased. These services are all available to the general public.

The Museum offers many free courses, events, apprentice programs, and both work-study and independent study programs for high school students.

Junior Museum

The Junior Museum, located in the lower level, is an exciting introduction to the world of art for youths of all ages and backgrounds. The permanent display invites children to participate in special educational exhibits where they can examine and understand basic principles and properties of the various art media and their places in the history of art. Free talks, tours, treasure hunts, art workshops, craft demonstrations and films are available. Also included in the Junior Museum wing are the auditorium, studio, art library, gift shop and snack bar.

The Metropolitan Museum's outreach programs include regular exhibitions in the special Community Programs Gallery on the lower level, as well as presentations in mobile museums. Visiting lecturers are often dispatched and technical assistance and advice offered to the community.

The basic curatorial departments of the Museum are located as follows: *departments*

American Wing—multi-level, all floors
Ancient Near Eastern Art—second floor
Arms and Armor—main floor
Costume Institute—ground floor
Drawings, Prints and Photographs—second floor
Egyptian Art—main floor
 Temple of Dendur—second floor
European Paintings—second floor
Far Eastern Art—second floor
Greek and Roman Art—main and second floors
Islamic Art—second floor
Lehman Collection—main floor
Medieval Art—main floor and Cloisters, Fort Tryon Park
Musical Instruments—second floor
Primitive Art—Rockefeller Wing
Sculpture and Decorative Arts
 Ceramics, Glasswork and Metalwork—ground floor
 Period Rooms, Furniture, and Arts—main floor
Twentieth Century Art—second floor

Generous endowments and gifts by private individuals and families throughout the past years, as well as purchases by the Museum itself, have contributed to an enormously vast collection. As a result, much of it is loaned in the form of traveling exhibitions and cultural exchanges with other museums, both in the United States and abroad.

The Museum's wealth of art and art objects is spectacular in its range and value, providing something for every art taste regardless of the period or style of interest. Following is a brief description and highlight of each of the curatorial departments.

The Museum has what is today considered the finest and most comprehensive collection of American art in existence. The collection of paintings, sculpture, drawings and watercolors constitute the largest body of works of their kind. Holdings in furniture, silver, ceramics, glass and textiles form a collection of decorative arts unsurpassed in quality. The department owns more than 3,000 works of fine art, ranging from the earliest Colonial portraits to the twentieth century's famous Ash Can school. Included are works from the Hudson River school of painters, American Impressionists, American Realists and nineteenth-century sculptors. The decorative arts collection reflects the history of America by exhibiting American arts in their original context. Ceramics, clocks, glass, silver and textiles are displayed with the appropriate furniture in the period rooms. Visitors can explore stylistic transitions from the Chippendale, Colonial, Empire, Federal, Pennsylvania German, Queen Anne and Shaker periods, among others. *collections*

Although American paintings and sculpture have been part of the Museum's holdings since its founding in 1870, there has never been any permanent gallery for their display. Much sculpture has been in storage, and the period rooms and decorative arts galleries were off from public view when construction on the new building began. Now the new American Wing consists of a spacious, glass-enclosed sculpture garden court and a three-floor structure built around the old multi-level American Wing. *American paintings and sculpture*

The masonry, steel and glass structure to the west and north of the original building houses galleries for paintings, sculpture, decorative arts and architectural elements, and it also provides space for temporary exhibitions. When fully installed, a series of period rooms with original woodwork and furnishings will offer an unequalled view of American history and domestic life from the late seventeenth to the early twentieth

century. The new wing embraces an area of 150,000 square feet, roughly six times the size of the old wing, and when completely installed, can make the entire collection of American art accessible to the public.

The collections of paintings, sculpture, decorative arts and architectural elements are installed chronologically as much as possible. The earliest material on the top floors proceeds in time down to the latest material on the first floor of the new wing. Most of the period rooms dating from the end of the seventeenth century through the beginning of the nineteenth are housed in the original American Wing section. The earliest rooms of the early Colonial period (1630-1730) can be found on the third floor; rooms of the late Colonial period (1730-90) are located on the second floor; and rooms from the early Federal period (1790-1825) are on the first floor.

The second floor and mezzanine of the new building contain the Joan Whitney Payson Galleries, in which paintings and sculpture of the eighteenth and nineteenth centuries are displayed. The eighteenth-century period rooms and two galleries of decorative arts are located on this floor. Late nineteenth- and early-twentieth-century Realist paintings and sculpture are exhibited on the mezzanine level of the new building. There is also a special exhibition gallery on this level, where folk art was the first installation. Decorative arts and period rooms of the nineteenth and early twentieth centuries are located on the first floor of the new building. The Erving and Joyce Wolf Gallery for special exhibitions is also on this floor.

Engelhard Court

The Charles Engelhard Court contains a selection of sculpture and important architectural elements of the nineteenth and early twentieth centuries. On display is the original facade of the United States Branch Bank, which occupies the entire north end of the Court. A pair of cast-iron staircases, designed by Louis H. Sullivan in 1893 for the Chicago Stock Exchange Building, flanks the Tiffany loggia. These staircases provide public access to the second-floor balcony of the Engelhard Court, where a selection of silver, pewter, glass and ceramics is displayed.

The decorative arts installations are so complex that some will open at a time later than the first phase of the reinstallation of the American collection in the new wing. Important new acquisitions, consisting of additional period rooms and decorative arts dating from 1825 to 1915, will be installed during the second phase. The study-storage areas on the mezzanine will open at the completion of the third phase. These areas will contain all paintings, sculpture, decorative arts, textiles and miniatures not chosen for display, but vital for study purposes.

*ancient
Near Eastern
collections*

The opening of the new Raymond and Beverly Sackler Gallery for Assyrian art marks the first phase in the reinstallation of the Museum's entire collection of Near Eastern art, considered one of the finest in artistic quality in the United States. When completely installed, the collection will occupy most of the galleries on the second floor between the Great Hall and the existing Islamic galleries. The antiquities range in date from 6000 B.C. up to the time of the Arab conquest in 626 A.D. They include artifacts from the eastern Mediterranean coast in the west to Afghanistan in the east, and from Turkey and southern Russia to the north to the Persian Gulf and Arabia in the south. Pottery, sculpture, seals, jewelry, bronzes, weapons and metalworks are among the pieces on display.

Ancient Assyria first achieved greatness in the ninth century B.C. when the powerful King Assurnasirpal II conquered adjacent lands. Assurnasirpal's capital at Nimrud has been the site of extensive excavations. The Museum's superb stone reliefs from the King's palace are once again on view with the opening of the Sackler Gallery, as are two massive stone sculptures that once flanked the palace's entrance and a fine collection of ivory carvings from Nimrud. The arrangement of objects gives the appearance of the original palace setting. Maps and photographs describe the site in antiquity as well as during the excavations, and graphic panels provide information on the significance of the motifs and colors used in the sculpture.

Established in 1960, the collection of arms and armor is one of the largest and most comprehensive in the world, with examples dating back to the time of the Vikings. The pieces, which are masterpieces of protection and ornament, were produced in great workshops throughout Europe and the Near and Far East in the fifteenth through the seventeenth centuries. Many of the more than 15,000 pieces, including suits of armor and swords, were once worn by renowned kings and heroes.

The viewing area is attractively and imaginatively organized around the central Equestrian Court displaying a group of armored horsemen on their mounts. The side galleries contain accompanying weaponry, helmets and arms.

Now considered the "action spot" of the Museum, the Costume Institute has glamorous special exhibitions such as "Women of Style," "Vanity Fair" and "Russian Costumes."

Organized in 1937 by Irene Lewisohn as a separate museum under another roof, it preserved and exhibited examples of clothing from all countries serving both the theatre and the clothing industries. It was integrated with the Museum's galleries in 1960 and thus greatly increased its activities and expanded its collection. Because of such rapid growth, the new Costume Institute facilities were opened in 1971 and were installed in ten galleries for special temporary exhibits. Three storerooms are used to house the permanent collection of more than 17,000 pieces. Private study rooms for researchers and designers, a library and several other work-oriented rooms comprise the remainder of the department.

The permanent collection is extensive and includes regional and period costumes, royal clothing, society styles and theater fashions designed by outstanding European and American couturiers up through the present time.

Funded heavily by New York's fashion industry as well as by the City of New York, the Costume Institute also is supported in part by a festive annual "Party of the Year."

The new exhibition area contains works from the Departments of Drawings and of Prints and Photographs in three galleries that open from a vestibule. They may be reached from the Andre Mayer galleries on the second floor. The two departments together have fifty percent more gallery space than was previously available, a fact that allows far greater flexibility in exhibiting the diverse collections. The inaugural exhibition, "The Painterly Print: Monotypes from the Seventeenth to the Twentieth Centuries," surveyed the history of a popular print making process.

The fragile nature of the 3,000 works in the Department of Drawings requires temporary exhibits on a frequently changing basis. The Museum's collection of drawings—technically defined as any notation by an artist in pen, ink, chalk, pastel, pencil and watercolor—is extensive, representing almost every national school. Works include a great number of French and Italian drawings and the largest group of drawings by Francisco de Goya outside of the Prado Museum, as well as many masterpieces by Dutch and Flemish artists. Interested students and scholars may make an advance appointment for viewing selected drawings.

The Department of Prints and Photographs was formed in 1916 to trace the development of the history of printmaking. Prints, drawings, illustrated books, posters, silhouettes and trade cards are exhibited on a revolving basis. All techniques are shown, ranging from lithographs and etchings to engravings and woodcuts. The well-known Italian Renaissance masters Pollaiulo, Mantegna, and Caravaggio are represented, as are works by German master Albrecht Durer, Rembrandt, Claude Lorraine, William Hogarth, and Goya.

The Museum's collection of ancient Egyptian art is one of the world's finest and most comprehensive, comprising almost 45,000 objects from prehistoric Egypt through the Byzantine occupation during the reign of Emperor Justinian. The architectural elements, sculpture, reliefs, funerary objects and religious, personal and domestic artifacts reflect the

The Buli Master, Zaire, Luba-Hemba Stool: standing caryatid, 24" high, soft wood. Metropolitan Museum of Art.

prints and photographs

33

Rubens, *Self-Portrait with Wife and Child,* Metropolitan Museum of Art.

daily life and aesthetic values of the ancient Egyptians throughout the thirty centuries of their civilization. The department contains some of the most valuable excavated material outside the Cairo Museum, and much of its wealth is derived from ongoing excavations that continue to unearth many priceless objects.

The entirety of the vast collection is now on display and accessible in the new, completely refurbished galleries that cover about an acre of Museum space. The collection is arranged chronologically, providing for the integration of all the material of a particular period. An innovative concept is the use of large walk-in cases, which allow groups of varied objects without the barriers of individual glass cases.

The full reconstruction of the Temple of Dendur in the Sackler Wing adds an imposing full-scale environment to the collection. It has been carefully reassembled to appear as it did on the banks of the Nile in the first century B.C., simulating the temple site with a reflecting pool, a wharf, courts, foundation walls and a hillside of stone.

Established in 1886, the Department of European Paintings originally included only a few hundred works. Since that time the collection has increased enormously. The national schools represented are: Italian— Primitives and fifteenth through eighteenth centuries; Dutch—concentrating on works of seventeenth-century masters, with a strong representation of Rembrandt; French—seventeenth through late nineteenth centuries, with special galleries for Camille Corot, the Impressionists, and the Post-Impressionists; Flemish and German—fifteenth through seventeenth centuries; Spanish—El Greco, Diego Velazquez, Bartolome Estaban Murillo, Jose Ribera and Goya; and English—eighteenth and nineteenth centuries.

European painting

The new Andre Meyer Galleries for nineteenth-century European paintings and sculpture recently opened, enabling the Museum to show the great bulk of its holdings in this area, one of the richest such collections in the world. The 24,000 square feet more than triples the space formerly available. Thirteen galleries surrounding a large central gallery look south over Central Park and let in much natural light.

The intent of the installation design is that works by single artists can be shown together. There is now a gallery containing twenty-one paintings by Gustave Courbet, another devoted to nineteen paintings by Camille Corot and others containing representative groups of pictures by Jean Francois Millet, Honore Daumier, Theodore Rousseau, and Charles Francois Daubigny.

The central gallery houses the Museum's magnificent collection of Impressionist and Post-Impressionist paintings, many of which have not been shown in years. The collection includes twenty-one pictures by Edouard Manet, twenty-eight by Claude Monet, fifteen by Pierre Auguste Renoir, and nineteen by Paul Cezanne. A special feature display is the Museum's well-known series of works by Vincent van Gogh. The three galleries devoted to Edgar Degas contain all of the Museum's paintings and a large selection of the pastels. In addition, the Museum owns an almost complete series of bronze casts from the models of Degas; most of these are shown, in conjunction with the related paintings and pastels. With the added component of natural light, the paintings appear differently each time they are seen, a fact especially important for the Impressionists.

The Moon Goddess Ch'ang O, (China, c. 1510), Ink and colors on paper. Metropolitan Museum of Art.

The Museum's holdings in Far Eastern art date from the second century B.C. to the nineteenth century. They include paintings, sculpture, murals and objects from China, Japan, Korea, India and Southeast Asia. The openings of the Astor Chinese Garden Court, Ming Furniture Room and Douglas Dillon Galleries mark the completion of the first phase of the Museum's reinstallation of its collection of Far Eastern art.

Far Eastern collections

The Astor Court is a reconstruction of a Ming-dynasty courtyard, modeled on an existing courtyard in Soochow, China. Its assembly at the Museum by a team of skilled craftsmen from Soochow, who used traditional tools and techniques, represents the first permanent cultural exchange between the United States and the Peoples Republic of China.

The courtyard unites the adjoining galleries for Chinese paintings and highlights the themes of nature and the contemplative life found in many of the paintings. Set against the north end of the courtyard is the Ming Furniture Room, where the Museums's collection of domestic hardwood furniture of the Ming period is displayed.

Chinese paintings

The Douglas Dillon Galleries are devoted primarily to the display of the Museum's collection of Chinese paintings spanning four dynasties: the Sung, Yuan, Ming and Ch'ing. The paintings are shown on a rotating basis, and the galleries occasionally are used for special exhibitions from other collections. The completion of the permanent galleries for Far Eastern art permits a large number of new acquisitions to go on view for the first time. The second stage will be the installation of the Japanese galleries. Eventually the galleries for the art of ancient China, Korea, India and Southeast Asia will be completed.

The major portion of the medieval collection of the Metropolitan is housed in a special museum created forty-five years ago, the Cloisters, in Fort Tryon Park. (See separate listing.)

The entire collection is made up of more than 4,000 objects dating from the fourth through the sixteenth centuries, beginning with the recognition of Christianity by Constantine and ending with the fall of Constantinople to the Turks in 1453.

All of the main periods of medieval art are represented by the department: early Christian, Byzantine, migration, pre-Romanesque, Romanesque and Gothic. The collection surpasses any other outside of Europe, showing strength in ivories, sculpture, tapestries and enamels of the highest quality.

musical instruments

In 1889, Mrs. John Crosby Brown donated a collection of instruments from all over the world to the Museum, making possible the establishment of the Musical Instruments Department. Over a period of thirty years she was able to gather unique specimens representative of specific times and countries, which together comprise the richest and most extensive collection of its kind in the world. Since that time, the Museum has increased the original number from 3,000 to 4,000 instruments, thus illustrating the growth of music and musical instrumentation. The collection stresses both the aesthetic value of the instruments as unique works of art, as well as their function as tools for creating sound.

Found in the collection are string instruments, richly decorated keyboards such as the original Italian pianoforte of 1729, chamber organs, guitars, zithers and lutes from the seventeenth century, and Flemish double virginals. The pieces come from major cultures originating in Africa, America (native Indian), Japan, the Near East, North Africa, South America, the South Pacific, Southeast Asia and Tibet. Many of them are in actual working order today.

Rockefeller Wing

The new Michael C. Rockefeller Wing, a 42,000-square-foot exhibition space devoted to the art of Africa, the Pacific Islands, Precolumbia, and Native America, is located at the south end of the Museum. It contains over 1,500 objects that span 3,000 years, three continents, and many islands, including sculpture of wood, stone and terracotta, articles of precious and semiprecious stone, objects of gold and silver and textiles.

The new wing unites the collection of the former Museum of Primitive Art, founded by Nelson A. Rockefeller in 1954 and donated to the Metropolitan in 1978. The wing is named in memory of Nelson Rockefeller's son Michael, a student of the art and culture of New Guinea, who died in 1961 while on a collecting expedition. Among the most spectacular objects in the wing are the nine twenty-foot-high memorial poles of Asmat, collected by Michael Rockefeller.

The gallery space is divided about equally among the three major sections. The African section includes about 500 objects from the diverse traditional cultures of sub-Saharan Africa. Many of the works are elements in rituals and ceremonies, ranging from classic bronze portrait heads from Benin to expressionistic wood masks of Congo villagers. Besides the many wooden figures and masks, the collection includes household objects and ornaments of terracotta, gold, silver and stone. In

addition, there are refined sculptures from the Guinea Coast, bronzes and ivories from Benin, bold works from Cameroon, naturalistic art of the western Guinea Coast and small ivories from Zaire.

The area known as Oceania includes Australia and the large island groups of Melanesia, Micronesia and Polynesia. The artistic traditions of Oceania are quite diverse, ranging from near abstraction to intricately patterned decoration, and from naturalistic portraiture to inventive figures of emotional intensity. Objects include small utensils for daily use, articles of personal adornment, ritual objects, large-scale wood carvings and masks.

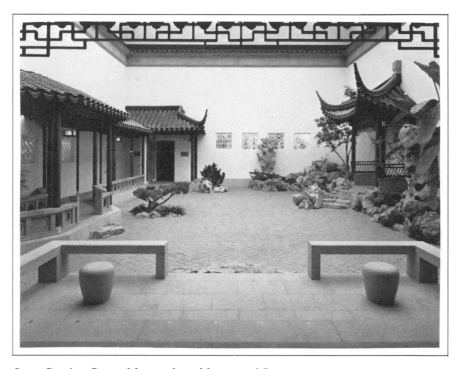

Astor Garden Court. Metropolitan Museum of Art.

The Native American and Precolumbian art holdings include stone and ceramic sculpture, precious objects of gold, silver and jade, wood carvings, textiles and feather hangings that represent 3,000 years of evolving culture in the Americas. Ancient Mexican art from all major periods is included. Another area of strength is the art of ancient Peru. Fine examples of North American Indian art from the Eskimo, Eastern Woodlands and Plains cultures round out the collection.

Created in 1907, the Department of Sculpture and Decorative Arts, which was formerly the Western European Arts Department, is one of the largest departments in the Museum. It is comprised of entire rooms from palaces and famous houses, period furniture, decorative arts and sculpture ranging in time from the Renaissance to the twentieth century in Europe. Ceramics, clocks, glass, metalwork, tapestries and textiles are among the decorative arts on display in rooms and galleries. Among the countries represented are England, France, Italy, Spain and Switzerland. Each room is authentically decorated with original period furnishings. *decorative arts*

Established in 1970, the Twentieth Century Art Department offers a sampling of the finest contemporary art, with revolving exhibitions as well as permanent installations. The collection, which features works from 1900 on, traces the modern art movement beginning with Picasso's Cubist paintings. Its strength lies in postwar American art, and most specifically, in works by New York Abstract Expressionists Jackson Pollock, Franz Kline, Willem de Kooning and others. *contemporary collections*

Museum of American Folk Art

Museum of American Folk Art 49 W. 53rd St., New York, NY 10019
(212) 581-2474 Tuesday: 10:30-8; Wednesday-Sunday: 10:30-5:30
Admission: by donation, children under twelve free; Tuesdays 5:30-8:30
free

This two-story museum, established in 1963, shares the block with the American Craft Museum I and the Museum of Modern Art. The extensive permanent collection is shown in portions in temporary exhibitions. Four or five shows are mounted each year, most of them thematic, featuring hooked rugs, painted or decorated furniture or regional painting, for example. Other shows are based on an image or motif, such as "the all-American dog." The small second-floor gallery specializes in work executed by self-taught artists, dating from the 1650s to the present. Weathervanes, papier-mache pull toys, and Appalachian walking canes are among the American artifacts on display.

Occasionally the gallery will take an in-depth look at a single artist such as Erastus Salisbury Field, a portraitist of the mid-nineteenth century who is also well known for his series on the Garden of Eden. Group shows feature works of major folk artists, such as contemporary landscape painter Mattie Lou O'Kelly, portraitist Ammi Phillips and Edward Hicks, as well as works by unknown artists.

Woman's Buckskin Dress, Yankton Sioux. Museum of the American Indian.

Museum of the American Indian—Heye Foundation 155 St. and Broadway, New York, NY 10032 (212) 283-2420 Tuesday-Saturday: 10-5; Sunday: 1-5 Admission: adults $1.50, students and senior citizens 75c

The Museum is devoted to the collection, preservation, study and exhibition of all things connected with the anthropology of the aboriginal peoples of North, Central and South America. It was founded in 1916 by George G. Heye, an ardent collector who first began to assemble items from Indian societies at the turn of the century, and is now the largest of its kind in the world.

The scope of artifacts on the three exhibition floors is vast, running from Alaska to Chile and from the Paleo-Indian period to the present. Among the many items displayed are beautifully quilted and beaded clothing of the Plains Indians, colorful featherwork of the forest peoples of South America, magnificent Aztec sculpture and Northwest Coast potlatch ceremonial objects. The personal possessions of great Indian leaders like Sitting Bull, Red Cloud, Crazy Horse and Geronimo are also exhibited. The modern-style paintings of Indian artist R.C. Gorman are on view, as well as the works of acclaimed Hopi artist Fred Kabotie. Over one thousand paintings are held in the permanent collection, with a concentration on the American Southwest.

The Museum holds special exhibitions throughout the year. These have included a series of staged demonstrations by artists and artisans of North America; an exhibit of contemporary American Indian lithographs, etchings and serigraphs; a major exhibition of Indian silver jewelry from the eighteenth and nineteenth centuries; and early silverwork pieces that illustrate Indian silversmith techniques. Traveling exhibitions have gone to Peking, Mexico City and the American Museum of Natural History. A collection of over 42,000 black-and-white negatives is maintained by the Museum. The library, which contains 40,000 publications that cover all phases of Indian life, is accessible to the public.

Museum of the City of New York Fifth Ave. at 103rd St., New York, NY 10029 (212) 534-1672 Tuesday-Saturday: 10-5; Sunday: 1-5 Admission: free

Founded in 1923, the Museum first housed its collection in Gracie Mansion, a stately Colonial Georgian structure completed in 1932. The spaciously designed building has high ceilings, wide corridors and an impressive rotunda at the entrance, where a circular staircase leads to the upper floors. Of the Museum's six floors, five are open to the public and house permanent and changing exhibits, while the other floor is used for executive offices and archives.

The Museum's service to the community ranges from the preservation of the cultural contributions of the city's ancestors to engaging in new ways of meeting the diverse needs and interests of the community. The latter was most notable when the new Theatre Museum opened in March 1982 in the Minskoff Theatre Arcade at 1515 Broadway (212/944-7161). Contributing to the revitalization of the theatre district, the new satellite museum makes one of the world's largest theatre collections accessible on a continuing basis. The premier exhibition, "An Actor's Life," designed by set designer David Mitchell, is a collection of letters, photographs, posters, three-dimensional objects, paintings and sculpture extolling the actor's talents and survival skills. A sound and light show describing famous costumes is narrated by Gary Merrill. Helen Hayes reminisces about her life as an actress in a twenty-minute videotape in the audio-visual gallery.

The permanent exhibits include antique fire engines, puppets from around the world and silver works by Dutch, English and early New York silversmiths. The toys displayed include dolls and doll houses from the late eighteenth century to the present. The Duncan Phyfe drawing room is filled with furniture by this famous New York cabinet maker. Other exhibits document the rise of the Dutch nation in the sixteenth century and

Indian and Dutch life in New Amsterdam beginning in 1624. A life-sized replica of a Dutch fort is featured. The history of New York after the English takeover in 1664 is depicted, illustrated with furniture, dioramas, prints, costumes and portraits, which include two of George Washington by Gilbert Stuart. The Alexander Hamilton Collection includes Hamilton's desk, furniture and portraits of Mr. and Mrs. Hamilton by John Trumbull and Ralph Earl.

Of special interest to New Yorkers are the J. Clarence Davies Collection of paintings, prints, maps and documents relating to New York City history; as well as a series of dioramas telling the story of communications from the first postal rider to Boston in 1673 through the present day. Memorabilia showing the historical rise of the New York Stock Exchange and the growth of Wall Street; and a history of the Port of New York from 1524 to the present are also noteworthy. Presently closed for renovation are the John D. Rockefeller rooms, which include a bedroom and dressing room removed in their entirety from the Rockefeller home at 4 West 54th Street.

There is a superb collection of over 10,000 photographs made by Byron at the turn of the century, and postcards of many of these pictures are available at the gift shop. One of the most fascinating gifts which the Museum recently received is a collection of 174 pen-and-ink sketches, in addition to some in pencil and watercolor, made by Reginald Marsh in preparation for his creation of the panels in the Rotunda of the U.S. Customs House. In 1937 Marsh completed the eight panels, which represent the successive stages of the arrival of an ocean liner in the Port of New York. The preliminary sketches, which were given to the Museum by his widow, Felicia Mayer Marsh, uniquely document the step-by-step development of each panel from initial conception through completion.

A multimedia, audiovisual exhibition, "The Big Apple," traces the growth of New York City from 1524 to the present. The installation, on the Museum's main floor, which continues through 1984, features a ten-foot tall, gleaming red apple which opens into three screens that flash pictures, dates and maps during the twenty-minute dramatic presentation. Historically pertinent three-dimensional objects are spotlighted during the narrative. They include the cannon and charred timbers of a ship sunk off the tip of Manhattan Island in 1613, a hand-pumped fire engine that helped save the city in the fire of 1835, and the last remaining Broadway horsecar. The audience may inspect all the objects during an intermission.

The Education Department has established a program of special tours for physically and mentally handicapped groups. Museum tours in English and Spanish, weekend courses for children and adults, Saturday activities for children and Sunday free concerts for adults are among the numerous services offered. The popular outreach program, A Museum Comes To You, was inaugurated in 1975 as a service to schools outside New York and staffed solely by Friends of Education. More recently instituted is a program of free guided tours on Sundays following the weekly concerts.

Breech-Loading Swivel Gun, (seventeenth century, Dutch) Museum of the City of New York.

Museum of Holography

Museum of Holography 11 Mercer St., New York, NY 10013 (212) 925-0526 September-May: Wednesday-Sunday: 12-6; Thursday: 12-9 Summer: Wednesday-Sunday: 12-6 Admission: adults $2.50, students with current ID $2.00, children under 12 and senior citizens $1.00

The Museum is located in a landmark cast-iron building in SoHo, New York City's downtown art district. It houses a permanent collection of art holograms, a permanent exhibition presenting the scientific history of holography, special exhibitions by holographic artists, daily screenings of films about holography and a bookstore.

Holography is a photographic technique that uses a laser beam to project a ghostly image that appears to float in empty space and move as the observer passes by. It is difficult to describe a hologram to someone who has never seen one. You can explain the mechanics, but never verbally convey the feeling or aesthetic quality.

There are two permanent exhibitions and one area featuring new works every three to four months. Commissioned holographic portraits of well-known New Yorkers, such as William F. Buckley, Andy Warhol, Arthur Ashe and Big Bird, are now installed in the Contemporary Portrait Gallery as a permanent exhbition. Other exhibits have included projected light installations by British artist Andrew Pepper; "Stereal-ities," recent stereograms in assemblages by Connecticut sculptor/holographer Aaron Kurzen; and "In Perspective," showing the history of the technical advances in holography. "A.I.R. '81" was the Museum's Artist-in-Residence exhibition, showing works created in the Museum's Dennis Gabor Holography Laboratory in 1981.

The Museum's exhibitions are complemented by educational films and videotapes, a permanent historic collection, tours and a reference library. During the winter the Museum offers Thursday evening lectures about holography. Additionally, the Museum publishes *Holosphere*, the field's leading technological newsletter. The Museum bookstore offers holographic pendants, holographic limited edition plates, books and other "holo-products."

Museum of Modern Art 18 W. 54th St. until mid-1983; thereafter, 11 W. 53rd St., New York, NY 10019 (212) 708-9500 Monday, Tuesday, Friday, Saturday, Sunday: 11-6; Thursday: 11-9; Wednesday closed Admission: $3.00, full-time students with current ID $2.00, children and senior citizens $1.00; Tuesdays: pay as desired; special student-group rates (telephone 708-9685)

A major expansion and renovation project during 1982 and part of 1983 will significantly increase gallery space and provide new and substantially improved visitor services. Construction of a new West Wing and renovation of the existing North Wing has been completed. Renovation of the main building, the East Wing, and the Garden Wing is currently under way. During this second stage, the Museum's collections and exhibitions are on view in temporary quarters on two floors of the new West Wing.

The Museum was founded in 1929 by Lillie P. Bliss, Mrs. Cornelius Sullivan, and Abby Aldrich Rockefeller to establish a permanent public museum to acquire collections of the best modern works of art and to encourage and develop the study of modern arts and their applications. The founders intended to aid the public's enjoyment and understanding of the visual arts of our time. The growth of the Museum in space, distinguished collections and range of activities is evidence of the fulfillment of this goal.

As a national and international resource center, the Museum serves a public many times larger than its local one. Exhibitions are circulated throughout the United States and the world, and thousands of bookings for films from the Museum's collection are made by museums, universities and high schools nationwide.

The Museum owes much of its success to its first director, the late Alfred H. Barr, Jr. In 1929, Barr planned a multidepartmental institution with the painting and sculpture collection at the core, but with later additions of the Departments of Drawings, Prints and Illustrated Books, Film, Architecture, Design, and Photography. A survey of the floor plan of the fully expanded Museum will reveal its extraordinary diversification and show why it is widely considered to be the greatest collection of modern art in the world.

Until mid-1983:

the collections

On the lower level a selection of masterworks is installed in ten new galleries. Over 100 major works are on view, dating from the 1880s to the present, and grouped chronologically to give a sense of history and continuity, beginning with Post-Impressionism of the late nineteenth century and continuing through the great movements of the twentieth century— Cubism, Expressionism, Futurism, Constructivism, Dada, Surrealism, Abstract Expressionism and developments from the 1950s to the present. Selections from the collections of architecture and design, and photography are installed in several smaller galleries.

41

The ground floor is reserved for temporary shows until the expanded space is inaugurated. These have included an exhibition of Giorgio de Chirico, the second in a series on The Work of Atget, and a retrospective of the work of American sculptress Louise Bourgeois.
From mid-1983:

Temporary exhbitions will be shown on the lower level of the new West Wing and in the ground floor galleries. The permanent collections will be reinstalled in designated galleries in the new West Wing and in the renovated main building.

Since the Museum's inaugural show of paintings by Paul Cezanne, Paul Gauguin, Georges Seurat and Vincent van Gogh, the mounting of major exhibitions has been an important goal of the Museum. Outstanding exhibitions of recent years have included "Cezanne: The Late Work;" "Mirrors and Windows: American Photography since 1960;" "Transformations in Modern Architecture;" "Art of the Twenties;" "Pablo Picasso: A Retrospective;" and "Joseph Cornell."

Department of Films

The Department of Film is unique among the curatorial departments both for its services and its vigorous exhibition schedule. The general public and a large community of students and professionals look upon the Museum as a center for the study and exhibition of film. The Film Library was formed in 1935 to trace, catalogue, assemble, exhibit and circulate films. The first international film archive, it constitutes the archival collection of about 10,000 films, and remains a leader in the cross-cataloguing of archives throughout the world. Preservation of films from chemical disintegration has been a top priority of the film department in the last decade. The Film Study Center is a research facility for scholars, critics and other members of the film community, and the Circulating Film Program serves over 4,000 educational institutions yearly.

With roughly thirty screenings weekly both in the 460-seat Roy and Niuta Titus Auditorium (reopening in mid-1983) and the new 225-seat Titus Auditorium, the Department of Film strives to maintain a balance between continuing programs and special exhibitions. Continuing programs include "Films From the Archive," "Cineprobe," devoted to the personal and independent filmmaker who is present at the screening to discuss the work; "What's Happening?," recent films of social or political import; and "Projects: Video," which follows the development of video as a medium for artistic communication. Special exhibitions, many of which tour the nation's film societies and museums, offer retrospectives of national cinemas and entire studios, and careers of directors, writers, producers and actors. Developments in the fields of animation and documentary are also featured in the shows.

Until mid-1983, Museum stores are located at 37 West 53rd Street and in the 54th Street lobby. Thereafer, the Lobby Museum Shop will be relocated in the new and expanded lobby on 53rd Sreet. The stores offer a variety of books, cards, posters, furniture, reproductions, slides, design objects and gifts, including hand-crafted jewelry. Museum restaurants after mid-1983 will be located in the East Wing overlooking the Abby Aldrich Rockefeller Sculpture Garden.

library

Each Museum department has study facilities for qualified students. The library is available by appointment to members and qualified scholars. Since the Museum has been considered from the beginning a study center for the modern visual arts, its library is now regarded as the world's finest collection of printed material relating to modern art. In 1940 the Department of Photography was established with a basic collection and reference library. Today, the photography collection and other collections in the Museum function as libraries.

Gallery talks relating to the permanent collection are held on weekdays at 12:30 (except Wednesdays), and on Thursday evenings at 5:30 and 7:00. Each month, one or more of the talks is interpreted in sign language for hearing-impaired visitors.

Special events such as symposiums, lectures, readings and films, are held throughout the year. They have included lectures on American

Pablo Picasso, *Girl Before a Mirror* (1932), oil on canvas. Museum of Modern Art.

motion-picture producer and director D.W. Griffith and on Italian Surrealist painter Giorgio de Chirico. A symposium was held in conjunction with the exhibition "New Work on Paper I," and a symposium "New York: Building Again," presented a panel of architects and critics.

There are many forms of membership in the Museum. Student membership is $15.00 annually. Resident membership and nonresident or foreign membership for those living outside the New York area is $35.00 annually. Members are entitled to free admission to Museum galleries, gallery talks and daily film programs; a 25% discount on Museum books and gift items; invitations to major exhibition previews; and access to the members' restaurant (opening mid-1983). Family and dual memberships are $50.00. Contributing memberships, which allow increased participation in Museum activities range from $100-$1,000 and are partially tax-deductible.

National Academy of Design

The National Academy of Design 1083 Fifth Ave., New York, NY 10028 (212) 369-4880 Tuesday-Sunday: 12-5

Founded in 1825 when there were neither art galleries nor art schools in New York City and very few in the country, the Academy began as a drawing society that promoted the arts and taught students. The earliest members included Rembrandt Peale, Thomas Cole and Asher B. Durand, as well as Samuel F. B. Morse as the group's first president. The Academy, which is national in scope, draws its members, students and exhibitors in the annual shows from a wide geographical area. Since 1940, the Academy has been housed in an elegant townhouse-gallery designed by Ogden Codman in 1915 and donated by Archer M. Huntington, husband of sculptor Anna V. Hyatt.

Over 3,000 paintings, approximately 3,500 prints, drawings, architectural renderings and photographs, and about 600 pieces of sculpture are held by the Academy, a rich source of American art. Nineteenth-century artists represented in the collection include Winslow Homer, Frederic Edwin Church, John Singer Sargent, John James Audubon, Thomas Eakins and Augustus Saint-Gaudens. Among twentieth-century artists are Reginald Marsh, Edwin Dickinson, Thomas Hart Benton and George Grosz. The Academy also houses one of the most extensive collections of primary source material on American art dating from its founding. This includes original documents, sketch books, letters and biographical files of all members. An extensive library containing many books written by Academy artists is accessible on a limited basis to serious students and members.

Important exhibitions of works from the collection included a selection of figure paintings and a group of landscape paintings displayed for the first time. Exhibitions featuring Abbott Thayer, Edwin Dickinson, artists' self-portraits, American still life painting, and a major show of works by Samuel F. B. Morse are scheduled. Other future exhibitions will reveal America's heritage throughout the nineteenth and twentieth centuries by drawing upon the broad holdings of the Academy.

New Museum

The New Museum 65 Fifth Ave., New York, NY 10003 (212) 741-8962 Monday, Tuesday, Thursday, Friday: 12-6; Wednesday: 12-8; Saturday: 12-5:30 August: closed Saturday

The museum was founded in 1977 by director Marcia Tucker, former curator at the Whitney Museum. Housed in the New School for Social Research but operating as a separate entity, it functions as a unique, experimental center for exhibition, information and documentation of art of the past decade. Shows focus on the work of living artists and consistently include art that has not yet received wide public exposure or critical acceptance. National in scope, the museum features works that are created outside as well as within major art centers.

Exhibitions, which include painting, sculpture, drawing, photography, video, film and performance, are presented in a critical and

scholarly context. They are forums reminiscent of the exchanges between artists and the public prevalent in New York in the late 1920s and early 1930s. Each show is accompanied by an illustrated catalog containing essays, biographies and bibliographies.

The Museum presents thematic group exhibitions: ongoing series, such as "New York/New York" and "Outside New York," designed to give exposure to the work of young, lesser-known artists; and solo exhibitions of the work of mid-career artists such as Barry Le Va, Ree Morton and John Baldessari, whose contributions have not yet been extensively examined. The Museum also offers lectures, symposiums, adult education groups and an unusual education program geared towards elementary school children.

The New York Historical Society 170 Central Park West, New York, NY 10024 (212) 873-3400 Tuesday-Friday: 11-5; Saturday: 10-5; Sunday: 1-5 Admission: Wednesday-Sunday: adults $2.00, children 75c Tuesday: discretionary fee (It is recommended that adults pay $2.00 and children 75c, but you must pay something.)

The Society was organized in 1804 to collect and preserve materials pertaining to the history of the United States, and of New York State in particular. This privately endowed organization is the second oldest historical society in America. The present building was completed in 1938, but prior to that, the Society was located in a variety of private and public buildings, the last of which was specifically designed and built for it at the corner of Eleventh Street and Second Avenue, a most fashionable section of the city in 1857. The Society houses a museum devoted to Americana, which includes a large collection of American painting, furniture and decorative arts. A fine reference library is also to be found, along with a manuscript collection covering all historical periods and a comprehensive accumulation of maps, prints and newspapers.

The work of John James Audubon has an honored place at the Society, which owns all but two of the 435 original watercolors in his famous series, *The Birds of America.* Selections from the collection are on view along with memorabilia associated with Audubon's life and a set of the famous *Elephant Folio* of engravings from the original drawings. Although Audubon prints are very familiar to the public, seeing the original watercolors is an experience in itself.

The Society has owned examples of American folk art since 1911, long before these objects and paintings were commonly recognized as art, and has since added to this collection. It now includes American household utensils, needlework, shop signs, weathervanes, earthenware jars and various utensils showing the development of lighting. Elegant examples of china, glassware, pottery and an outstanding collection of paperweights are also on display. Just behind the facade of a 1766 Connecticut house is the exhibit "A Child's World," which contains American toys and other objects to delight children.

The first floor galleries include one of New York's finest collections of silver, reflecting the history of this art form from the Colonial period to the late Victorian era in two gleaming rooms. One gallery is devoted to the sculpture of John Rogers, who depicted charming scenes of everyday nineteenth-century life.

A very impressive selection of American painting, displayed in the fourth-floor galleries features portraits and landscapes, including Charles Willson Peale's portrait of his family, Rembrandt Peale's *Thomas Jefferson*, and outstanding works by Gerrit Duykinck, Gilbert Stuart and others. A particularly fine collection of Hudson River school paintings can be seen, including Thomas Cole's *Course of the Empire* and works by Asher B. Durand, Frederic Church and Albert Bierstadt. Also on the fourth floor are fine examples of seventeenth-, eighteenth- and nineteenth-century furniture, including the Members Desk used by the first Federal Congress in 1789.

In the basement are a group of carriages used in New York during the latter part of the nineteenth century. Among them is the famous road

Constantin Brancusi,
Bird in Space (c. 1928),
54" high, Bronze.
Museum of Modern Art.

45

coach, The Pioneer, which ran between New York City and Ardsley, New York. There are a variety of old sleighs, the Beekman family coach (circa 1770) and examples of fire apparatus used by volunteer fire departments of old New York.

At the time the Society moved to Second Avenue in 1857, its collections began to grow. Assyrian reliefs were added in 1858, the Abbott Egyptian collection in 1860 and the small but choice accumulation of Anderson Egyptian antiquities a few years later. In 1907 the Society acquired the Edwin Smith Surgical Papyrus, the oldest-known scientific medical document in the world. In 1936 nearly the entire Egyptian collection of the Society was transferred to the Brooklyn Museum for an indefinte loan period and was eventually purchased by this museum.

library

The Society's Library is well known for its manuscripts, newspapers, pamphlets, prints, and 600,000 volumes. The Society owns one of the best extant collections of eighteenth-century New York newspapers beginning with *Bradford's Gazette,* New York's first newspaper. The collection of over one million manuscripts includes the papers of Horatio Gates, James Duane, Rufus King, Albert King, Albert Gallatin and James Alexander, as well as many letters by George Washington. A special room has been set aside for prints and photographs, which features thousands of engraved portraits, the Pach collection of over 700 photographs of distinguished New Yorkers from 1867-1937 and political caricatures from the first half of the nineteenth century. Also featured are architectural drawings, nineteenth-century lithographs, a mammoth collection of advertising ephemera and prints and photographs devoted largely to New York scenes. Selections from the Library's vast collection are exhibited regularly in the Library's gallery. Recent shows have included "Murder, Murder Most Foul," "George Washington in New York State" and "Tales of Christmas Past." The Library and Print Room are open to the public upon payment of a daily fee of $1.00. Hours are Tueday through Saturday from 10:00 to 5:00.

Several galleries on the first floor are set aside for the Society's active program of changing exhibitions. Approximately ten shows per year on diverse aspects of American history, drawn primarily from the Society's collections are presented to the public. Some of the recent exhibitions are "Collaboration: Artists and Architects" (eleven visionary and viable schemes produced cooperatively by prominent artists and architects); "Small Folk: A Celebration of Childhood in America" (folk art by, about and for children); and "The White Mountains: Place and Perceptions" (paintings, drawings, photographs and prints evoking a long-ago past in New Hampshire).

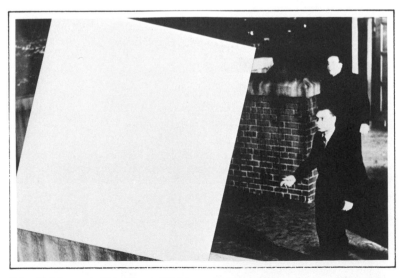

John Baldessari, *Two Stares Making a Point but Blocked by a Plane (For Malevitch)*, 24" x 36", photograph with collage. New Museum.

The New York Public Library Prints Collection Fifth Ave. and 42nd St.,
New York, NY 10018 (212) 930-0817 Monday-Saturday: 1-6 Thursday
& Sunday: closed

Located on the third floor of the main branch of the New York Public
Library, the Collection houses over 160,000 original prints and drawings
from the fifteenth century to the present. A comprehensive collection of
reference books and documentary clippings files provide literature on
the history and techniques of printmaking and on individual print-
makers. Mary Cassatt, Edouard Manet and Japanese master Utamaro are
among the artists whose works are especially well represented.

Exhibitions are on display on the third floor of the Library, where one
also finds the main reading room and architectural archives. The exhibi-
tions change every four months.

A unique collection of over 500 prints by women was acquired in 1900.
Many were executed by aristocratic ladies or members of artists' families.
Works by England's Queen Victoria are among those featured in this
collection.

Under the auspices of the Print Collection are two notable collections
of historical interest arranged chronologically: The I. N. Phelps Stokes
Collection of Historical Prints and the Eno Collection, which depicts the
development of New York City up to 1900.

The public is invited to view the exhibitions which line the halls of the
third floor. However, for admission to the Print Collection in Room 308 a
free pass must be obtained at the Office of Special Collections, Room
226.

N. Clark, Jr.,
Stoneware Jug (c. 1840-
84). New York
Historical Society.

The Pierpont Morgan Library 29 E. 36th St., New York, NY 10016
(212) 685-0610 Tuesday-Saturday: 10:30-5; Sunday: 1-5 July &
August: closed Sunday

The Library is a treasury of artistic, historical and literary collections, as
much an art museum as a research library. This double focus derives
from the fact that its founder, J. Pierpont Morgan, has consuming
interests in art as well as literature and history. Holdings include ancient
written records, medieval and Renaissance manuscripts, incunabula,
autograph manuscripts and letters, rare printed books, bookbindings,
music manuscripts and early children's books.

The Library was designed by the architectural firm of McKim, Mead & *the building*
White in the style of a Renaissance palazzo in the classical Greek
manner. The building was finished in 1906, and both its interior and
exterior have been designated as national historic landmarks. The
impressive facade, with reclining lionesses flanking the grand entrance,
gives way to one of the most sumptuous and elegant interiors. The East
and West Rooms are filled with early Italian and Flemish paintings;
ancient, medieval and Renaissance sculpture; medieval goldwork and
enamels and majolica porcelain.

J. Pierpont Morgan, who began his collection with autographs, made
such outstanding purchases as a Gutenberg Bible, one of three copies
now owned by the Library; the famous ninth-century Lindau Gospels;
four Shakespeare folios; a superb collection of Byron manuscripts; and
the original autograph manuscripts of Keat's *Endymion* and Dicken's *A
Christmas Carol.*

Morgan continued to expand his collection with books printed before
1501, many of which were from the press of England's first printer,
William Caxton; first editions of his favorite English and French authors;
a large group of manuscripts by Jane Austen, Robert Burns, Charles
Dickens, Alexander Pope, Sir Walter Scott, William Thackeray, Mark
Twain, and Emile Zola; and the earliest manuscript of Aesops' *Fables* in
Greek. J. P. Morgan, who opened the Library as a public institution in
1924, added to his father's vast collection with purchases that included a
number of Thomas Jefferson's autograph letters and manuscripts by
Balzac.

With income from generous legacies and contributions from individual

collectors, the Library has been able to add steadily to its collections. Among the more recent bequests are the William S. Glazier Collection of medieval and Renaissance manuscripts, the Elizabeth Ball Collection of early children's books, the Janos Scholz Collection of Italian drawings, the Heineman Collection (including Napoleon's love letters to his wife Josephine and the manuscript of the Theory of Relativity in Einstein's own hand), and most recently, the Oenslager Collection of theater drawings.

Although use of the collections is restricted to qualified scholars, selections from the Library's holdings are made available to the public through exhibitions. There are at least four major exhibitions and seven or eight smaller shows each year. Recent exhibitions included "William Blake," "Maurice Sendak," "Music Manuscripts of Mozart," "The Seventy-Fifth Anniversary of the Morgan Library" and "Lewis Carroll and Alice, 1832-1982."

Queens Museum

The Queens Museum New York City Building Flushing Meadow-Corona Park, Flushing, NY 11351 (212) 592-2405 Tuesday-Saturday: 10-5; Sunday: 1-5 Admission: adults $1.00, students and senior citizens 50c, members and children under 12 free Group tours available by reservation: 592-9700

From its inception in 1972, the goal of the Museum has been to bring fine art into Queens through a program of rotating exhibitions and to provide space for Borough artists and craftsmen. It also sponsors workshops, films, lectures and other special events.

The Museum is housed in the New York City Building directly in front of the Unisphere in Flushing Meadow-Corona Park, which was constructed for the 1939-40 World's Fair and was used again for the 1964-65 World's Fair. From 1946-50 the United Nations General Assembly met in this same building, and in 1947 the historic vote which created the State of Israel was cast here. In June 1980, the Queens Museum inaugurated spacious new facilities which include two main galleries for exhibitions, a modern lobby, a gift shop, expanded office and work space, a community gallery and a theatre.

The Museum has organized and mounted over seventy-five exhibitions, which have ranged in theme from highly specialized fine art presentations to exhibitions of broader cultural and historical significance. Exhibitions have included rarely seen and frequently unpublished works of art from major public and private collections, as well as works which reflect the most recent developments in contemporary art. Notable examples include "Dawn of a New Day: The New York World's Fair 1939-40," an exhibition which examined the Fair's social, cultural and historical significance; "American Hooked Rugs 1850-1957," an exhibition of fifty fine examples of this folk art tradition circulated by the Gallery Association of New York State; "Approach/Avoidance: Art in the Obsessive Idiom," an exhibition of recent works and special installations by ten American artists; and "Shipwrecked 1622: The Lost Treasure of Philip IV," the only New York showing of the spectacular treasures and artifacts recently recovered from two seventeenth-century Spanish galleons, the Nuestra Senora de Atocha and the Santa Margarita.

In addition, the Museum presents important traveling exhibitions, which might otherwise bypass the New York metropolitan area, such as "Murals Without Walls: Arshile Gorky's Aviation Murals Rediscoverd." This exhibition featured two recently rediscovered mural panels painted by Arshile Gorky in 1936 for the Newark Airport as part of a Works Progress Administration project. The Museum also exhibits works by younger, lesser-known artists and organizes an annual juried exhibition of works by professional artists who live and work in Queens.

On permanent display is the Museum's most unique and dramatic exhibit, the Panorama of the City of New York, an 18,000-square-foot, detail-perfect architectural model of the city's five boroughs on a one-inch to 100-foot scale. Originally conceived by Robert Moses for the New York City Pavilion at the 1964-65 World's Fair, the Panorama is peri-

odically updated by the Museum to reflect the city's constantly changing profile.

Supplementing the Museum's exhibition program are tours, films, lectures, workshops, special events, performances, formal art courses and free weekend drop-in workshops. The Museum's Friday special-education program is available for disabled children. The Queens Museum Community Gallery provides exhibition space for presentations by local civic and cultural groups.

"Artists Make Art," is the first in a series of recently implemented experimental participatory exhibits in the newly opened junior museum wing. The working environments of three contemporary artists are presented, and the studio spaces are filled with both art-related and mundane objects to show the unique influences on each artist. The Museum also sponsors art tours, both locally and abroad.

Membership ranges from a student/senior citizen category at $5.00 to benefactor at $1,000. Patron-membership entitles card holders to invitations to previews, free catalogues, free or reduced admission, a discount on purchases at the museum shop and box office discounts on tickets for performances of the Queens Symphony and Queens Festival productions.

transportation To reach the Queens Museum by subway take the IRT #7 line to Willets Point-Shea Stadium Station and walk across the park toward the Unisphere. By car from the Triboro Bridge or Queens Midtown Tunnel, take the Grand Central Parkway, exit at Whitestone Bridge-Northern Boulevard; keep right and follow signs to Northern Boulevard and Shea Stadium. At the bottom of the ramp make a sharp right turn and follow the signs to the New York City Building.

South Street Seaport Museum

South Street Seaport Museum 207 Front St., New York, NY 10038
(212) 766-9020 Monday-Sunday: 11-5 Admission: $3.50

Located along the East River in Lower Manhattan, just south of the Brooklyn Bridge, the Museum constitutes an eleven-block historic district that represents the legacy of New York's great nineteenth-century port. The Museum's collection includes historic ships, old brick counting houses, saloons, warehouses and hotels. Exhibitions highlight marine paintings but encompass a variety of themes. Recent shows included "Photos of Alice Austen," works by a photographer who recorded the turn of the century harbor views from her home in Staten Island; "Celebration of the Hudson," paintings, prints and objects incorporating nineteenth-century marine views; and "Preservation in Progress," an exhibit of elements that describe the steps and techniques involved in preserving historical architecture. Other presentations will cover engineering aspects of the Brooklyn Bridge for its bicentennial celebration, and works of nautical folk art. The museum's core offerings are the temporary and permanent exhibitions held in the historic buildings and on ships. The historic vessels are themselves a unique aspect of the Museum's collection. Visitors can examine nineteenth-century and turn-of-the-century ships with colorful histories, such as the Peking, the Wavertree, the Ambrose, the Lettie, the G. Howard, and the Pioneer. There are also tours, lectures, workshops and concerts that take place in the streets and buildings, on the piers and aboard the ships.

Staten Island Museum

The Staten Island Museum 75 Stuyvesant Pl., Staten Island, NY 10301
(212) 727-1135 Tuesday-Saturday: 10-5; Sunday: 2-5 Admission: free

A surprising bit of information to most New Yorkers is that one of the area's earliest museums was founded five miles out in the water on Staten Island. Originally founded as the Natural Science Association of Staten Island in 1881, an art committee formed in 1908 soon organized a collection in the old Norvell House where local artists exhibited their works from 1911 to 1918. A generous gift from D. Wallace MacDonald embellished the collection with over 800 works of art as well as numerous archaeological artifacts.

49

Works by Ezra Ames, a portrait painter of the nineteenth century; Jasper F. Cropsey, a follower of the Hudson River school; John Sloan and Albert Bricher are part of the small but impressive permanent collection. The print collection includes works by Albrecht Durer and Rembrandt along with other old master printmakers. A collection of Oriental and African art is also maintained.

The Institute has a tradition of presenting exhibitions of fine paintings, photographs, sculpture and countless artifacts from around the world. Recent exhibitions focused on art of the Renaissance, depicting classical influences in Renaissance and Baroque art; and birds in art, illustrating birds throughout history from ancient Egypt, the Mediterranean world, the Middles Ages, the Renaissance and modern times. A special centennial celebration produced two major exhibitions: "Centennial Argosy: One Hundred Works of Art," representing the Museum's collections of Western and non-Western art of all periods; and "Aspects of American Art: The Institute's Founding Years ca. 1870-1900," examining the state of art in the United States as it existed just before and after the founding of the Staten Island Institute of Arts and Sciences, of which the Staten Island Museum is an integral part. Scheduled exhibitions include "Vladimir Salamun Sculpture," the latest in an ongoing series of solo exhibitions devoted to outstanding Staten Island artists. Also scheduled is "Ceremonies and Spirits," a show featuring the art of Africa, the Pacific Islands and the Americas spanning 2,500 years, on loan from the Michael C. Rockefeller wing of the Metropolitan Museum of Art, that emphasizes the spiritual nature of primitive art and its role in daily life and rituals. A fully illustrated handbook highlighting the permanent collection has been recently published and is available for purchase.

The Museum additionally provides the general public with counsel on evaluating art objects and answers inquiries regarding art restoration. This service may be obtained by contacting the Office of the Curator of Art. An impending move to larger quarters at Snug Harbor Cultural Center will enable the Institute to display its relatively small, but important permanent collection in an appropriate setting.

Studio Museum

The Studio Museum in Harlem 44 W. 155th St. (Adam Clayton Powell Boulevard), New York, NY 10039 (212) 864-4500 Tuesday-Friday: 10-6; Saturday-Sunday: 1-6 Admission: by donation

The Museum is committed to the acquisition, interpretation and conservation of the works of Black artists. Founded in 1967, it recently moved to a building donated by the New York Bank for Savings. The collections fill the lower, street and mezzanine level floors; offices and studios are located on the fourth floor. There are three major galleries and a lower-level photography gallery and archives. A two-story center with a surrounding mezzanine provides a high-ceilinged space for monumental sculpture and large installations.

The Museum began as a gallery to exhibit the work of emerging Black artists and specially talented resident artists. The artist-in-residence program, which continues at the Museum's new location, now includes materials and a stipend in the one-year term, culminating in the exhibition of the artists' works.

Merging with the James VanDerZee Institute in the late 1970s, the Museum established a major photography department, incorporating VanDerZee's vast collection into the Museum's permanent holdings. Some of the images date back to the 1920s and provide historical documentation of Black Americans.

The permanent collection of over 180 paintings includes rare works by Romare Bearden, one of the most eminent Black artists in America. Elizabeth Catlett's prints and works by Auerbach Levy and Emanuel Hughes are also part of the permanent collection. Early craft items, nineteenth-century landscapes and many contemporary works round out the diverse holdings.

The Museum's inaugural exhibition in its new location was "Ritual and Myth: A Survey of African-American Art," which showed works by over

forty-five artists who are of African origin or who emphasize African themes. Haitian artists were represented as were American artists Romare Bearden, Aaron Douglas, Wilfredo Lam and Melvin Edwards.

Other recent exhibits have included "Images of Dignity: A Retrospective of Charles White" and "Harlem Heyday: The Photography of James VanDerZee." A show of paintings, sculpture, collage, film and photography from the permanent collection, featured both eighteenth- and nineteenth-century artists and contemporary artists. Other recent exhibits featured draped canvases by Sam Gilliam; the photography of Anthony Barboza, which includes high fashion, African landscapes and portraits; jazz photographs by Roy DeCarava; and abstract paintings by Alma Thomas. "En Route To" was a group show of three artists-in-residence: assemblagist Janet Henry and sculptors Tyrone Mitchell and Walker Jackson. There was also a three-dimensional installation by Richard Yarde that recreated the Savoy ballroom.

The Museum sponsors active educational programs and special events. There are gallery talks by living artists that relate to exhibits of their work, seminars on the various exhibition themes and an annual film festival that showcases works by independent Black filmmakers. The Museum takes a keen interest in encouraging scholarship on Black art, and solicits scholarly essays for inclusion in exhibition catalogues. The Fine Art of Collecting is an annual series of seminars to encourage collecting among Blacks, offering tours of studios and galleries, talks by gallery dealers and discussion on investments in art. In addition to the artists-in-residence program, there is a cooperative school program that hires artists to teach in Harlem schools. The new gift shop, which has a wide selection of posters and reprints, acts as a major source of income for the Museum.

Statue of Knicker-bocker (c. 1850-67). New York Historical Society.

Ukrainian Institute

Ukrainian Institute of America 2 E. 79th St., New York, NY 10021 (212) 288-8660 Tuesday-Sunday: 2-6

The Institute is housed in a six-story building designed in the style of the French Renaissance by the famous architect Stanford White. The building was purchased by William Dzus, an American philanthropic industrialist proud of his Ukrainian heritage, who transferred the rights to the Institute. His goal was to guide and develop leaders, to protect the Ukrainian culture in America, to look after Ukrainians in this country and to help them keep pace with other cultural groups. The building was recently designated a historical monument by the National Register of Historic Places.

Cultural events in the form of lectures and discussions of contemporary Ukrainian and American literature, art and economics have been initiated. A display of Ukrainian ethnographic art was jointly sponsored by the Ukrainian National Women's League of America and the Ukrainian Institute of America. Under the sponsorship of the Institute the Ukrainian Publishing Company Suchasnisy implemented a program featuring the well-known American poet, Stanley Kunitz, upon the publication of a great number of his poems in Ukrainian translation.

Shows have featured art by Alexander Archipenko and Alexis Gritchenko, as well as contemporary Ukrainian graphics and photography. Works by young Ukrainian artists are among scheduled exhibits.

Whitney Museum

Whitney Museum of American Art 945 Madison Ave., New York, NY 10000 (212) 570-3600 Tuesday: 11-8; Wednesday-Saturday: 11-6; Sunday & Holidays: 12-6 Admission: adults $2.50, senior citizens $1.25, children under twelve with adult and full-time college students with ID free; Tuesdays 5-8: free

Devoted exclusively to American art with special emphasis on the twentieth century and the work of living artists, the Whitney Museum is the product of a dream of Gertrude Vanderbilt Whitney, a sculptor and local arts patron. The Museum was actually born on Eighth Street in her

51

Alexander Calder, *The Brass Family*, 64" x 41" x 8", brass wire. Whitney Museum of Art.

Greenwich Village sculpture studio, which she converted into gallery space. Whitney believed that living American artists deserved recognition and that a new museum was very much needed to serve them. She accordingly opened what has since become one of the world's most talked-about museums.

From its beginning in 1931, the Whitney was well on its way to becoming a viable museum, owning over 600 works by American artists, which were donated by its founder. The collection was then incorporated as a "charitable trust for educational purposes." As interest in furthering the development of American art continued to grow, the Museum began to introduce new, younger artists as well as mount its historic and thematic exhibitions.

In 1954 the Museum moved uptown to West 54th Street near the Museum of Modern Art. In order to accommodate the crowds it subsequently attracted, it moved again to its present location.

The trustees, who purchased a choice piece of property on Madison Avenue at 75th Street, intended to make the soon-to-be constructed museum a work of art in its own right. Marcel Breuer, an architect, teacher and member of The Bauhaus school, was commissioned for the job. Taking a reverse approach to design, Breuer first defined "what it should not look like"—a business, an office of a place of light entertainment. He endeavored to give the building the weight of a skyscraper, the latitude of a bridge and the feel of the city. He once defined it as bringing "the vitality of the streets to the museum's structure." The building, which was completed in 1966, totally broke with traditional ideas of museum architecture. Its modern yet innovative look was truly in keeping with the spirit of its Eighth Street founder.

the building

The museum's popular exhibitions make it one of New York's busiest spots on weekends. Due to the large size of the exhibition space, waiting time is usually minimal when long lines form. The several dozen annual shows are quite diverse, ranging from one-person retrospectives and group exhibits to thematic and historical surveys.

George Bellows, *Dempsey and Firpo* (1924), 51" x 63", oil on canvas. Whitney Museum of Art.

The year 1980 marked the fiftieth anniversary of the Museum, and a year-long series of exhibitions included presentations of works by major twentieth-century American artists represented in depth in the permanent collection. They include Charles Burchfield, Alexander Calder, Stuart Davis, Gaston Lachaise, Maurice Prendergast, Charles Sheeler and John Sloan. Other anniversary exhibitions included a retrospective of paintings by Abstract Expressionist Marsden Hartley; the first exhibit to focus on selected folk artists, featuring American folk painters of three centuries; and the first permanent installation of selected major

works from the Musuem's holdings, a chronological and thematic presentation of outstanding paintings and sculptures.

Exhibition highlights in recent years have featured extensive one-person shows of works by Edward Hopper, Philip Guston and Chuck Close. "Disney Animation and Animators" reviewed, for the first time in a museum, the accomplishments of Walt Disney and the animators associated with him. A show of six artists working in clay explored in depth the achievements of the most influential ceramic sculptors to emerge in California since the mid-1950s. The eightieth-birthday tribute to Louise Nevelson presented her reassembled environmental installations which had not been seen for more than twenty years. The first major retrospective of drawings by sculptor David Smith and the first retrospective of sculptor George Segal were also notable among the wide range of exhibitions.

Biennial Exhibitions

The Whitney Biennials are invitational surveys of selected works by American artists. In 1981, 115 artists showed works in painting, sculpture, photography, film and video, many of which had not been previously exhibited. The inclusion of film and video installations in the Biennial of 1981 underscored a key development in contemporary art, that of artists' accomplishments in expanding the formats of their media within the context of an exhibition space.

The Museum's acquisition program is a vigorous one, restricted to the twentieth century with primary emphasis on the work of living artists. The most highly publicized acquisition in the recent past was the painting *Three Flags* by Jasper Johns. Two major acquisitions of works by Georgia O'Keeffe, *Flower Abstraction* and *Black and White,* came to the Museum in connection with an O'Keeffe show that presented nine of her works from the Museum's permanent collection.

Some of the shows presented at the Whitney are traveling exhibitions organized elsewhere. The Museum also has recently expanded its program to reach national and international audiences. Traveling exhibitions organized by the Museum went to thirty-five institutions in 1981, a fact resulting in the recognition of the Whitney as the most active museum devoted to American art.

allied arts

The Museum's New American Filmmakers series presents ongoing programs and environmental installations of independent film and video every day from September through June. Symposiums and panel discussions are held throughout the year to coincide with special exhibitions, such as a recent day-long examination of the career of Edward Hopper. The annual Goodson Symposium on American Art recognizes art scholarship at American universities and museums. Among performing arts events, the Museum and Composers' Showcase features artists such as Steve Reich, Sun Ra Arkestra, and the Contemporary Chamber Ensemble. Musical performances, which are presented outdoors on Sunday afternoons during the summer, have included concerts by the Phoenix Ensemble, composer Mitchell Korn, and the Tobason Trio.

A unique independent study program developed by the Museum provides grants to art history majors, allowing them to study with selected artists and critics. In addition, twelve two-hour seminars are offered to students of art and art history each semester. Gallery talks with Museum curators on Thursday afternoons are intended primarily for college students, and weekend gallery talks on Saturday and Sunday afternoons are open to the public. "Artreach" introduces American art to New York schoolchildren with a slide show presentation of works in the permanent collection, followed up by guided visits to the Museum.

Now located at the former First Precinct Police Station on Old Slip, the Downtown Branch of the Whitney Museum presents a continuous program of exhibitions and performing arts events organized by students in the independent study program. Admission is free. The branch is open Monday through Friday from 11:00 to 3:00. Performances take place on Wednesday at 12:30 and gallery talks on Tuesdays and Thursdays at 1:00.

Joan Miro, *Dutch Interior I* (1928). 36" x 28", oil on canvas. Museum of Modern Art.

The Galleries

The Downtown Galleries

By Specializations

The following list represents concentrations of a particular artistic mode and not necessarily the individual focus of the gallery.

Alternative Spaces:
Artists Space, Atlantic Gallery, Blue Mountain, Bowery Gallery, Clock Tower, Dia, 55 Mercer, First Street Gallery, Franklin Furnace, Greene Space, Henry Street Settlement, The Kitchen, SoHo Center, Ward-Nasse, West Broadway Gallery, White Columns

American:
Contemporary:
Boone, Bouckaert, Bromm, Caldwell, Castelli, Cowles, Feldman, Hoffman, Ingber, Key, Kind, Meisel, Metro Pictures, Meyer, Milliken, Nosei, Oil & Steel, O.K. Harris, Solomon, Sonnabend, Sperone Westwater Fischer, Starkman, Terrain, Thorp, Vorpal, Washburn, Weber

**Ceramic/Crafts
& Other Media:**
Castelli (Castelli-Sonnabend Tapes & Films), Cowles, Feldman, Heller, Metro Pictures, Meyer, Solomon

**European &
Other Continents:**
Contemporary:
Boone, Bromm, Castelli, Cowles, Nosei, Sonnabend, Sperone Westwater Fischer, Weber

Graphics:
Contemporary:
O.K. Harris, Starkman, Vorpal

Photography:
Ledel, Metro Pictures, Meyer, Solomon, Sonnabend

Sculpture:
Castelli, Cowles, Feldman, Oil & Steel, O.K. Harris, Solomon, Sperone Westwater Fischer, Vorpal, Washburn, Weber

By Location

SoHo

Broome
Elise Meyer	477
The Kitchen	484

Grand
Henry St. Settlement	466

Greene
Heller	71
Greene Space	105
Washburn	113
Key	130
Terrain	141
Castelli; Sperone Westwater Fischer; Weber	142

Mercer
Feldman	31
55 Mercer	55
Ledel	168
Metro Pictures	169

Prince
Alexander Milliken	98
Annina Nosei	100
SoHo Center	110-112
Ward-Nasse	

Spring
Phyllis Kind	131

Wooster
Dia	77
Blue Mountain; Bowery	121
Dia	145
Paula Cooper	155

West Broadway
First St. Gallery	386
Caldwell; OK Harris	383
Holly Solomon	392
Dia	393
Boone	417
Edward Thorp	419
Boone; Castelli; Cowles; Sonnabend; Nancy Hoffman	420
West Broadway	431
Atlantic	458
Ingber	460
Elaine Starkman	465
Vorpal	465

TriBeCa
Artists Space	95 Hudson
Harm Boukaert	100 Hudson
Hal Bromm	90 West Broadway
Clock Tower	108 Leonard
Dia	67 Vestry
Franklin Furnace	112 Franklin
Oil & Steel	157 Chambers
White Columns	325 Spring

Artists Space

Artists Space 105 Hudson St., New York, NY 10013 (212) 226-3970
Tuesday-Saturday: 11-6 August: closed

The gallery, which presents new works by unaffiliated artists, is a showcase for serious, innovative art. Artists Space holds group and individual exhibitions of painting, sculpture, drawing, mixed media, performance, film and video, which are organized by the gallery staff, guest curators and artists.

 The gallery provides a number of services to artists. The Unaffiliated Artists Slide File, containing over 1,800 New York State artists who are not represented by commercial galleries, is used by Artists Space staff, artists and art professionals. The Emergency Materials Fund and the Independent Exhibitions Program provide grants to help artists pay exhibition-related costs in alternative or other nonprofit spaces.

Atlantic Gallery

Atlantic Gallery 458 West Broadway, New York, NY 10012 (212) 228-0944 Tuesday-Sunday: 12-6 August: closed

The gallery is artist run, showing work in all styles and media by over thirty artists. There are one-person exhibits every three weeks, with a group show featuring guest artists every season.

 The one-person exhibits always feature new work by artists active in New York City. Several of the members exhibit frequently in the United States and Europe. They include Sally Brody, who paints high-color still lifes; Astrid Fitzgerald, a Swiss artist who does geometric patterns on shaped canvases; Dixie Pearlee, whose landscapes are abstract expressionist works that are at times very realistic; and Italian artist Fabrio Salvatori, who works in an abstract-symbolist manner.

 Carol Levin's watercolors are of lush landscapes of rural Long Island scenes. Rich Samuelson's paintings, using urban objects for color and form, were exhibited in a recent show titled "Painted Iron." Ceramicist Rene Murray creates fanciful figures and plates and also does tapestry. "Horsescapes," a recent exhibit of works by Naomi Plotkin, featured etchings, monotypes and paintings inspired by the theatrical show *Equus* that were done in a calligraphic and lyric style.

Blue Mountain

Blue Mountain Gallery 121 Wooster St., New York, NY 10012 (212) 226-9402 Tuesday-Sunday: 12-6 June-August: closed

Formerly the Green Mountain Gallery, the gallery is now an artist-run space. Works shown are by contemporary artists in revolving one-person exhibitions. Works are generally representational using figures, landscapes and still lifes. Lorna Ritz does large-scale, abstract oil paintings in the modernist tradition. Arthur Cohen's landscapes depict

New York City and Provincetown, Massachusetts, and Michael Chelminsky's landscapes are New England scenes. Trevor Winkfield paints on paper with invented imagery. Large oil paintings by Meg Leveson are Brooklyn cityscapes. Rudy Burckhardt paints nudes and woodlands in oil. Lucien Day's large-scale watercolors and paintings are curved surfaces encompassing wide-angle vision. Elliot Barowitz makes satirical, expressionistic paintings and prints of airplanes and cars. Clay figures, painted plaster animals in aggressive poses, and mechanical environments are sculpted by Linda Peer. The large-scale, still life-with-interior oil paintings by Jacqueline Lima deal with the curvature of visual space. Charles Kaiman paints realist still lifes. Other artist-members include John Leavey, Janet Sawyer, Nancy Gelman, Robert Godfrey, Judith Evans, Carol Paquay, Margaret Grimes, Robert Henry, Una Wilkinson, Helene Manzo, Rosemary Nacgale and Teri Bartol.

David Salle, *The Mother Tongue* (1981), 112" x 86" oil, acrylic/canvas, masonite. Mary Boone Gallery.

Mary Boone

Mary Boone 420 & 417 West Broadway, New York, NY 10012
(212) 966-2114 Tuesday-Saturday: 10-6

While many galleries closely define their art styles, Boone exhibits one which she readily admits has not yet been defined, and, in fact, has no name yet attached to it. This approach which is developing in both Europe and America comes out of the conceptual movement, ranging from the totally abstract to a combination of abstraction and figuration.

Boone has assembled a group of young pioneer artists of this evolving movement from both continents. Understanding them, she maintains, takes time and she is first to admit that it may be a decade or two before they are put into their proper historical perspective. She sees their art as a radical shift in sensibility and she is not alone in her conviction. Their art has received a considerable amount of attention not just at the gallery, but all over the world. The artists are young, dynamic and without question something is happening with their art.

Concerned with figuration are David Salle and Julian Schnabel, both who are highly expressionistic painters, at times chaotic in their approach. Salle, who often works with diptychs and triptychs, tends to be more ordered than Schnabel, using strong figures, often nudes who appear to be looking on interacting figures. Salle's use of colors is subtle, often soft on one side and powerful on the other. Schnabel's large scale canvases are extremely chaotic, at times almost violent. Their underlying narrative is challenging, though often difficult to understand.

German painter Anselm Kiefer also combines abstraction with figuration on thickly painted, chaotic canvases, many concerned with ideas from German mythology. Troy Brauntuch's figuration employs subtle photographic images, juxtaposing them to achieve conceptual complexity. Matt Mulligan is more simplistic and graphic in his approach to figuration, utilizing narrative panels. He depicts common imagery from everyday human experiences.

Abstract works are also part of the gallery's offering such as the large-scale canvases of Gary Stephan. His pieces relate to a more formal position in painting, employing a cathedral feeling by manipulating space with thickly painted solid bars. Ross Bleckner's black and white canvases depict caustic abstractions, physical to the touch as well as to the eye.

Michael McClard and Robin Winter take a somewhat subversive position to what was happening in the seventies. Their art is a product of their past films and performances. Their props evolved into subjects of their paintings which are historical and political in nature. Michael Tracy's paintings show an influence of both the Mid-Italian Renaissance and the films of Pierre Paolo Pasolini. The objects have religious overtones, insular and primitive in form.

Harm Bouckaert

Harm Bouckaert 100 Hudson, New York, NY 10013 (212) 925-6239
Tuesday-Saturday: 1-6 July & August: closed

One of TriBeCa's newest and most modern exhibiting facilities, the gallery shows an array of contemporary painting and sculpture. Most of the works tend to be abstract and small in scale especially the sculpture.

Painters include Denise Green and Nancy Brett who is one of the few gallery artists who approaches representalism with her landscapes, though most of her works are largely abstract. More unusual in their approaches are Paul Rotterdam, an abstract painter who imparts three-dimensional qualities to his canvases and Ted Stamm who paints monotone geometrics on unusually shaped canvases which create unique spatial relationships. Stewart Hitch is a "star painter" who employs star-shaped objects in figure-graphic relationships. His brilliant colors are an important aspect of the works' dimensional qualities, each painting displaying a different spatial relationship of its subject to its environment.

The sculptors of the gallery are the most untraditional of Bouckaert's stable of artists. Louis Lieberman bridges the gap between sculpture and drawing with his cast paper pieces. Alex McFarlane is a fantasy oriented

Julian Schnabel, *X-ray, the Stages of Man* (1982), 108″ x 156″, oil on velvet. Mary Boone Gallery.

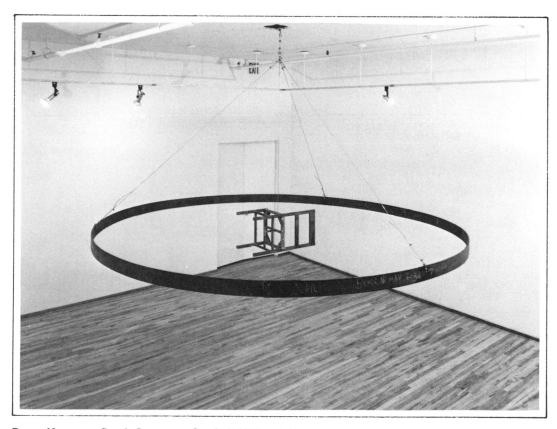

Bruce Nauman, *South American Circle* (1981), 14′ diameter, steel and cast iron. Leo Castelli Gallery.

sculptor working in graphite. His small, table-size pieces are archi-
tectural, yet are begging to be handled. Other gallery sculptors create
wall pieces. Peter Brown, like McFarlane, executes wooden architectural
pieces, though different in their primitive quality. Also working with
wood, and often steel, are Thomas Bang and Garrick Dolberg.

Bowery Gallery

Bowery Gallery 121 Wooster St., 2nd floor, New York, NY 10012
(212) 226-9543 Tuesday-Sunday: 12-6 June-August: closed

This nonprofit, cooperative gallery is devoted to exhibiting figurative
paintings and sculpture by young artists. It is a showcase for those who
might be excluded by commercial galleries. Members numbering about
twenty-five are chosen by artists already in the gallery. All artist-
members pay dues and help run the gallery. About every two years each
artist has a show, planned and executed by the artists themselves.

Bromm Gallery

Hal Bromm Gallery 90 West Broadway, New York, NY 10007
(212) 732-6196 Tuesday-Saturday: 11-6 August: closed

A vanguard gallery for new contemporary art, this was the first com-
mercial gallery to open in the now chic Tribeca area of New York City.
The gallery exhibits painting, sculpture, photography and drawing by
American and European artists, with attention focused on emerging
young talent.

Exhibitions have included "A Matter of Choice: Selections by Critics,
Artists, and Collectors," the first in a series of guest-curated group
shows; and "Agitated Figures: The New Emotionalism," which was
curated by director Hal Bromm for Hallwalls in Buffalo, New York.

Gallery artists include the internationally famous sculptors Rosemarie
Castoro and Jody Pinto, and the neo-expressionist painter Frank Young,
who is known for his exuberant, large-scale paintings. Also exhibited is
the work of internationally known Polish artist Krzysztof Wodiczko, who
will do a series of Public Projections in New York, and Roger Cutforth,
who is currently working on color landscapes of the American South and
Southwest.

New discoveries include Alan Kikuchi-Yngojo, who was included in
the recent exhibition "Counterparts" at the Metropolitan Museum of Art
in New York; Terry Rosenberg, whose cowhide wall-sculpture has
elicited strong response from critics and museum curators across the
country; and Livio Saganic, whose slate sculptures will be the focus of a
one-person show at the Trenton Museum.

John Chamberlin, *White Thumb,* 71" x 118" x 36" painted metal and chrome.
Leo Castelli Gallery.

Susan Caldwell

Susan Caldwell 383 West Broadway, New York, NY 10012
(212) 966-6500 Tuesday-Saturday: 10-6

This second floor Soho gallery, formerly concerned with abstract painting, now has broadened its exhibitions, representing about a dozen artists who work in all veins.

Representational painters include Britisher Graham Nickson and two Chicago painters, Ellen Lanyon and Leon Golub. Nancy Giesmann is also represented with her very large-scale narrative canvases. Golub's latest works tend more toward the abstract depicting his own personal views of mercenaries.

Abstract in nature are the paintings of Doug Ohlson, Frances Barth and Pousette Dart. Jane Couch also shows her large pattern paintings, which are highly unstructured.

A small amount of sculpture is also found. Most prominent are the works of Carl Andre which the gallery shares with Paula Cooper. Craig Langager who the gallery represents shows his large animal imagery. Other media are shown as well, including the architectural drawings of Italian Paolo Soleri and photographer Diana Michener.

Leo Castelli

Leo Castelli 420 West Broadway & 142 Green St., New York, NY 10012 (212) 431-5160 Tuesday-Saturday: 10-6

The gallery premiered in 1957 at an Uptown location with an exhibition of well-known European and American painters including de Kooning, Delauney, Leger and Pollock. Within a year, Castelli had displayed his enthusiasm for ground-breaking new art by introducing the work of Jasper Johns and Robert Rauschenberg. Soon after, several new artists had been added, including Cy Twombly and Frank Stella, and it became clear that the gallery was increasingly involved with art which was newer and more avant-garde than Abstract Expressionism.

Between 1961 and 1964, Roy Lichtenstein, Andy Warhol and James Rosenquist joined the gallery. Despite the criticism that Pop artists were subjected to at that time, this new trend in art had tremendous impact. Richard Artschwager had his first show in 1965. During that year Castelli also began to exhibit work by Donald Judd and Robert Morris, thereby extending his involvement in controversial areas to Minimal art. Both Judd and Morris carried into sculpture the impersonal spareness that characterized Frank Stella's paintings during that decade.

In the early seventies, Bruce Nauman, Richard Serra, and Keith Sonnier had joined the gallery. About the same time, Castelli began exhibiting the fluorescent light sculptures of Dan Flavin.

The gallery also represents several conceptual artists. Among them are Americans Joseph Kosuth, Robert Barry, Douglas Huebler and Lawrence Weiner, and Europeans Laura Grisi and Hanne Darboven.

In 1974, Castelli-Sonnabend Tapes and Films was formed, adding another dimension to the gallery's functions. Video-art and artist's films are available for viewing, rental or sale from this separate corporation.

Today Claes Oldenburg and Ellsworth Kelly are members of the gallery, among others. In order to accommodate the larger works being produced, an additional location was opened a few blocks away, at 142 Greene Street. This 4500 square foot space is used to show extremely large paintings and sculptures by gallery artists.

Castelli continues his involvement with new developments in art. In 1981, Julian Schnabel and David Salle became gallery artists (in conjunction with the Mary Boone Gallery). These artists represent the resurging interest in "image painting."

In addition to its exhibitions, the gallery has always maintained an extensive archive department, in which journalistic archives and biographical information as well as slides, photographs, and transparencies are kept on file for each gallery artist. These materials are available to writers, publishers, art historians, critics, and prospective clients.

At present, the Castelli Gallery represents 35 artists working in diverse styles and media. This figure does not include those who are

represented only by Castelli Graphics or Castelli-Sonnabend Tapes and Films. Jasper Johns, Robert Rauschenberg, Roy Lichtenstein, Andy Warhol, James Rosenquist and Frank Stella, as well as other artists, all remain part of the gallery.

Clock Tower

The Clock Tower 108 Leonard St. (Broadway), New York, NY 10012 (212) 233-1096 Wednesday-Friday: 1-6; Saturday: 10-6 July-September and major holidays: closed Admission: by donation.

The Clock Tower is one of two permanent exhibition and work spaces of the Institute of Art and Urban Resources (See museum review). The building, which is owned by the City of New York, is used for court rooms and municipal offices on its first twelve floors. On the thirteenth and top floor is one of New York's most unique art spaces.

Alana Heiss, the Institute's founder and director, spotted the space nearly a decade ago and thought it worthy of salvaging as an alternative art space. At that time, the thirteenth floor was little more than a warehouse, however she and many volunteers transformed it into a magnificent art space overlooking the city complete with a balcony that affords a 360-degree panorama of the city.

Today the Clock Tower holds numerous art exhibitions, which change approximately once each month. They range from one-person to guest-curated shows. However, at this space special emphasis is given to in-depth exhibitions of emerging artists, and appropriately there is often some unexpected art to be viewed. Many artists including Denise Green, Deborah Turbeville, Doug Sanderson, Win Knowlton and others can attribute to shows held here the first major public attention to their works.

Paula Cooper

Paula Cooper Gallery 155 Wooster St., New York, NY 10012 (212) 674-0766 Tuesday-Saturday: 10-6

One of the first galleries in Soho, Paula Cooper Gallery has continuously focused on new developments in contemporary art. It has shown a long-term commitment to its small group of artists, with many charter members still exhibiting. Visitors are invited to attend informal performances and musical events and to participate in various explorations that seek out new avenues of expression.

Artists represented by the gallery reflect a broad range of artistic expression. A huge, rough wood beam by sculptor Robert Grosvenor stands opposite Joel Shapiro's small-sized pieces, which convey "implied space." Large, simple sculpture by Jackie Winsor exudes an air of permanence. Jonathan Borofsky projects sketches of dreams on the gallery walls and in three-dimensional forms. Painter Jennifer Bartlett orchestrates monumental systems symbolizing the universe and the process of painting. Painter Alan Shields, who bases his imagery on the grid, works on unstretched canvases as well as mixed-media compositions, which incorporate wood and beads. The airy, lyrical wallpieces of Lynda Benglis use fiberglass as the basic material. Abstract painter Elizabeth Murray combines shape, color and line to emphasize surface texture. Carl Andre, who influenced the creation of sculpture in the late 1960s, makes flat floor pieces usually in uniform units and often of found materials. Peter Campus, a video artist, is now working with photographic images as photographs. Michael Hurson creates portraits of specific people and places.

Charles Cowles

Charles Cowles Gallery, Inc. 420 West Broadway, New York NY 10012 (212) 925-3500 Tuesday-Saturday: 10-6

The gallery features contemporary fine arts of diverse media, including sculpture, painting, photography, ceramics and glass.

In general, works shown are abstract with some figurative pieces included, and are often interdisciplinary. Tom Holland's abstract paintings and sculptures are three-dimensional, bright, geometric works on and off the wall. Photographs by Gerald Incandela are each unique

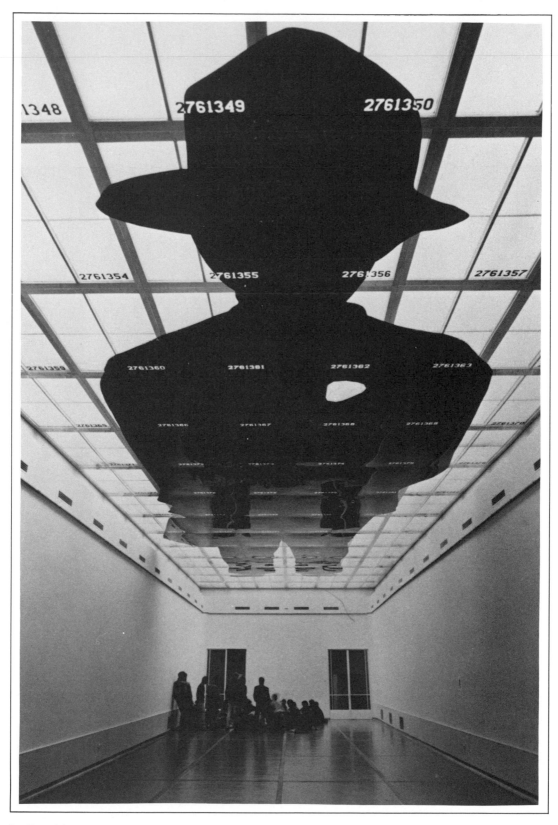

Jon Borofsky, *Man with Briefcase* (1982), 100′ x 27′ enamel on plexiglas panels. (Installation: Museum Boymans van Beuningen, Rotterdam). Paula Cooper Gallery.

collages of negatives developed in a broad painterly technique.

Sculptors in bronze include Manuel Neri, a figurative artist, Michael Todd and Wade Saunders, both abstract and lyrical with their own unique styles. In ceramics, Michael Lucero creates expressionistic figures in porcelain and Ron Nagle makes petite, abstract forms. Dale Chihuly works in glass. Abstract painters are Dennis Ashbaugh, Ronnie Landfield and Laddie John Dill. Installations designed specifically for the gallery have been created by Patrick Ireland, Alan Saret and David Stoltz. Recently Stoltz has been working with welded steel creating unique ova-shaped free-standing forms. Other sculptors include Tom Holland, ceramicist Peter Voulkos, and Italio Scango.

In addition to showing the works of some major contemporary painters such as Nathan Oliveira and Gene Davis, others have been added. Peter Alexander shows his under-water fantasies; Italian Nino Longobardi paints themes in a figurative vein and Dennis Ashbaugh's large abstract geometric canvases can also be found. Some drawings are also shown including those by Scango and Alexander as well as Benno Friedman's unique works which are photographic in detail.

Dia

Dia Art Foundation 77 & 145 Wooster St., New York, NY 10012
(212) 254-1414 Other Exhibitions: 393 West Broadway & 67 Vestry

This is a not-for-profit private foundation that aids in the planning, realization and presentation of major works of art by a group of contemporary artists. They include Joseph Beuys, John Chamberlin, Walter de Maria, Dan Flavin, Donald Judd, Imi Knoebel, Pandit Pran Nath, Blinky Palmero, Rene Ricard, Fred Sandback, James Turrell, Cy Twombly, Franz Erhard Walther, Andy Warhol, Robert Whitman, La Monte Young and Marian Zazeela. The Foundation is committed to the artist's participation, not only in the realization of the work, but also in the determination of the circumstances under which it is to be displayed. It upholds the belief that contemporary art by major artists deserves the highest standards of presentation, which are generally achieved in long-term, carefully maintained installations.

Almost all installations are found in New York. The Foundation also maintains locations in Massachusetts, New Mexico and West Germany.

Ronald Feldman

Ronald Feldman Fine Arts, Inc. 31 Mercer St., New York, NY 10013
(212) 226-3232 Mondays: open to critics, museum and gallery personnel; Tuesday-Saturday: 10-6 July: Tuesday-Friday: 10-5:30; August: Tuesday-Friday: appointments requested

Much of the work at the gallery is experimental and represents a broad range of media. It is not unusual to find performances as well as video pieces or films, in addition to works in traditional media, such as paintings, drawings, graphics, sculpture and photography.

Contemporary artists represented include Vincenzo Agnetti, Eleanor Antin, Ida Applebroog, Arakawa, Conrad Atkinson, Joseph Beuys, Chris Burden, Douglas Davis and Jud Fine. Also represented are Terry Fox, Buckminster Fuller, Helen Mayer Harrison, Newton Harrison, Margaret Harrison, Vitaly Komar, Alexandr Melamid and Piotr Kowalski. Additional contemporary artists are Les Levine, Edwin Schlossberg, Thomas Shannon, Todd Siler, David Smyth and Hannah Wilke.

The gallery publishes and distributes prints and videotapes. Recent editions of prints by Andy Warhol published by the gallery are *Ten Portraits of Jews of the Twentieth Century* and *Myths*. Also recently published by the gallery is a double record album, *Revolutions per Minute (The Art Record)*. The regular edition includes a poster showing twenty-one art works corresponding to the twenty-one sound pieces in the album, while the deluxe edition contains original prints created by each artist as album cover proposals.

The gallery has a wide range of publications, posters and postcards by its artists.

55 Mercer Artists 55 Mercer St., New York, NY 10013 (212) 226-8513
Tuesday-Saturday: 11-6 August: closed

The gallery is an artist-run cooperative operated by a core of permanent members, which include both painters and sculptors. At any given time there will be two one-person exhibitions and/or guest (nonmember) group shows.

The gallery specializes in avant-garde art. Current members include Peter Brown, Domenic Capobianco, Tom Clancy, Joan Gardner, Gloria Greenberg, Jane Handzel, Margo Herr, Diane Karol and Thomas Nozkowski. Other members are Robert Porter, Joyce Robins, Elfi Schuselka, Carol J. Steen, Julius Tobias, Grace Wapner and Jerilea Zempel.

Some artists who were past members of the gallery include Alice Adams, Tom Doyle, Janet Fish and Mary Miss.

The gallery has always tried to maintain an open and receptive attitude to new work. Members look at slides and studios to find artists for guest shows.

First Street Gallery 386 West Broadway, New York, NY 10012 (212) 226-9011 Tuesday-Sunday: 1-6

The gallery was established in 1969 by a group of young artists committed to the then unfashionable practice of realist painting and sculpture. Throughout the flourishing of Soho as an art district and the growth of interest in realist art, First Street Gallery has maintained its dedication to realist art of high quality.

The gallery generally has twelve one-person shows of gallery artists and a group show annually. In a recent group show the gallery invited a group of both emerging and established artists to exhibit along with members. Among the guest artists contributing to the show were Lennart Anderson, Paul Resika, Rackstraw, Downes, Bruno Civitico, Paul Georges, Robert Birmelin, Lois Dodd, Isabel Bishop and Sidney Goodman.

Franklin Furnace Archive Inc. 112 Franklin St., New York, NY 10013
(212) 925-4671 Tuesday-Saturday: 12-6

The gallery was founded as an alternative space specializing in artists' books and publishing. A permanent collection of 10,000 titles includes historical and contemporary examples of artists' use of the printed page. None of the books is for sale; they are available for perusal by appointment only.

Principally an archive, this loft space also contains offices, a gallery and a stage. There is a high level of activity, with performances at least twice a week and frequent shows by emerging artists.

Exhibitions have featured books of the Russian avant-garde from 1910 to 1930; contemporary artists' books from the Eastern-bloc countries; and an ongoing collaboration among minority artists, "Carnival Nocturne," which involves work in photography, performance and music.

Belgian artist Guillaume Bihl recently transformed the gallery space into a travel agency, creating an illusionistic piece "Fly Me," that used the gallery window to project onto the street the notion of a storefront window. Cuban artist Anna Mendiata has performed at the gallery, and so has P. D. Burwell, a percussionist from London. A show of Cubist books is planned.

Greene Space 105 Greene St., New York, NY 10012 (212) 925-3775
Wednesday-Sunday: 12-6

This multi-media art gallery and performance space features local Soho artists who work in painting, sculpture, dye transfers and photogrpahy.

Recent one-person exhibitions include suspended bluestone sculpture

by Pamela McCormick and standing sculptures by Daniel Johnson in a memorial to Ralph Bunch, as well as dye transfers of the sculpture. Also exhibited were abstract representations of the point at which architecture and painting come together by Belgian-born painter and architect Francoise Schein, paintings and posters by Clayton Campbell, and black and white photographic explorations of water surfaces by Adger Cowans.

Several times a year there are thematic exhibits. A show of contemporary Latin American artists coincided with the Soho Latin American cultural festival. The space, which is a community gathering place, is also used by several Soho organizations for meetings and events.

Performance artists Eiko and Koma Dancers, Eric Bojasion and Arlene Schloss have been featured. There is also an avant-garde concert series for which musicians such as Henry Threadgill, Charles Hayden and Don Cherry have played.

Heller Gallery

Heller Gallery 71 Greene St., New York, NY 10021 (212) 966-5948
Tuesday-Sunday: 11-6 August: closed

Recently opened, the gallery features fine art created from the craft media by American and European artists. Monthly exhibitions present works ranging from small-scale sculpture to architectural installations.

In the craft media, Diane Itter, a fiber artist, does miniature works in knotted linen, with rainbow-hued fans and other geometric patterns radiating from a central knotted core. Robert Eisendorf, an artist who began as a jeweler, now works with nonprecious materials to create small sculptures. Pieces include photographs, bones, shells and other found objects and *trompe l'oeil* elements. Erwin Eisch is a German painter and sculptor who recently exhibited a series of portraits.

Large environmental sculpture is presented by C. Andree Davidt. Working with metals, namely brass, steel and aluminum, he creates tables, outdoor sculpture and play environments. Roy Superior, who combines the attitudes of a Rube Goldberg invention with an elegant use of rare woods, creates sculptures entitled "Machinery of the Imagination."

The diverse presentation of work ranges from the contemporary paintings of Erwin Eisch to the traditional crafts of the American Pueblo Indians to the painterly ceramics of Bennett Bean.

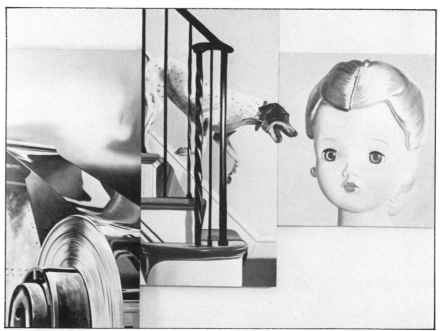

James Rosenquist, *Dog Descending a Staircase* (1979), 84" x 108", oil on canvas. Leo Castelli Gallery.

Henry Street Settlement/Arts for Living Center 466 Grand St., New
York, NY 10002 (212) 598-0400 Monday-Saturday: 12-6 August:
closed

The gallery shows works by emerging, minority and female artists. It
maintains a two-part exhibition area and an outdoor space for installation
pieces. There are six to eight shows yearly, most of them group shows or
thematic in nature. Individual artists are not represented by the gallery,
but an artist-in-residence program is composed of six emerging artists
who work in a communal studio space. Every year some artists leave and
new ones are added, with the entire group changing every two or three
years. A recent group included painters Juan Sancatz, Lewlie Lowinger,
and Susan Sauerbrun; printmaker Marina Gutierrez; and mixed-media
artists William Jung and Willie Birch.

The show "Beyond Aesthetics" featured artists who deal with social
and political issues in their work. Another recent exhibit, "Homework,"
brought together works by thirty female contemporary artists whose
subjects reflect the domestic environment. Unique artists' toys for
children and adults were shown in "At Play." Also exhibited at the
gallery were Joseph Delaney's paintings and drawings of crowd scenes in
New York City, as well as works by well-known Chinese brush painter
Wang Dawer. A New York collective of writers and visual artists known
as Morivivi recently collaborated in an exhibition of their work.

Rafael Ferrer, *Apache Dance* (1982), 72″ x 48″, oil on canvas.
Nancy Hoffman Gallery.

Nancy Hoffman

Nancy Hoffman Gallery 429 West Broadway, New York, NY 10012
(212) 966-6676 Tuesday-Saturday: 10-6 July & August: Monday-
Friday: 10-5

The white-walled spaces of the street-level gallery contain large-
scale paintings, three-dimensional objects and drawings. Works shown
are at the forefront of a number of traditional contemporary trends, al-
though none of them will disappoint viewers who seek out unique modes
of expression.

The gallery, among the foremost in Soho, was established early in the
neighborhood's history on the solid ground of reputable artists doing
representational and realist work among other styles.

Artists range from Natalie Bieser, who first exhibited in the two-person
inaugural show of 1972, to the more established abstract artist, Jack
Tworkov. Artists among the gallery's national spectrum include some
renowned Californians. They are Joseph Raffael, a luminous realist; Bill
Martin, a visionary landscape painter; Peter Plagens, an abstract artist
using geometric shapes; and John Okulick, a sculptor who makes
perspective wall constructions in wood. Other artists reside throughout
the country as well as in New York. David Parrish, from Alabama, is a
futurist-realist; Joe Nicastri, a Floridian, is a realist who paints portraits in
fresco; and Carolyn Brady, from Maryland, is a watercolorist who works
realistically.

Other artists who exhibit at the gallery are realist painter Don Eddy;
abstract painter Howard Buchwald; Rafael Ferrar, painter of expres-
sionist and electric imagery; *trompe l'oeil* artist Paul Sarkisian;
representational painter Ben Schonzeit, figurative painter of rich,
impasto surfaces; Juan Gonzalez, who does detailed, realist drawings
and paintings; Terence LaNoue who makes unstretched abstract
paintings that hang like tapestries; and Don Nice, a realist who works
from life. Others are Frank Owen and Philip Wofford, both energetic
abstract painters who incorporate images into their abstractions; Bill
Richards, who makes finely detailed drawings of fernswamps and
grasses; and sculptor Fumio Yoshimura, who recreates real-life objects
in wood.

Ingber Gallery

Ingber Gallery 460 West Broadway, New York, NY 10012 (212)
674-0101 Tuesday-Saturday: 10:30-5:30

The gallery represents painters and sculptors whose range of styles
includes realism, abstraction and abstract realism.

Among gallery artists are Gretna Campbell and Louis Finkelstein,
painters of representational landscapes. Kermit Adler is a watercolorist
who reproduces textures and gives weight and volume to his still lifes of
food and flowers. In the sculptures of Rosemary Cove, the female body
becomes her source for exploring mass, volume and texture. Ce Roser is
an abstract painter whose colorful work radiates light and energy. Fay
Lansner's work includes abstractions, representational paintings of the
female figure, and colorful multi-media collages.

Edith Schloss works in a variety of media, such as oil, watercolor and
silkscreen. Anne Tabachnick's painted line and color compositions
waver back and forth between the representational and the abstract.
Knox Martin is an artist who has worked in graphics, sculpture, mural
painting and jewelry. Elise Asher's paintings lean towards the visual
embodiment of the poetic experience. Judith Godwin's paintings are
emotional abstractions in the tradition of Clyfford Still and Franz Kline.

Other artists represented at the Ingber Gallery are Rosemary Beck,
Natalie Edgar, Joanne Hartman, Bonnie Woit, Dina Guston Baker and
Betty Klavun.

Key Gallery

The Key Gallery 130 Greene St., New York, NY 10012 (212) 966-3597
Wednesday-Saturday: 11-6 August: closed

The gallery shows collages and drawings on paper, and some oil
paintings on wood and paper.

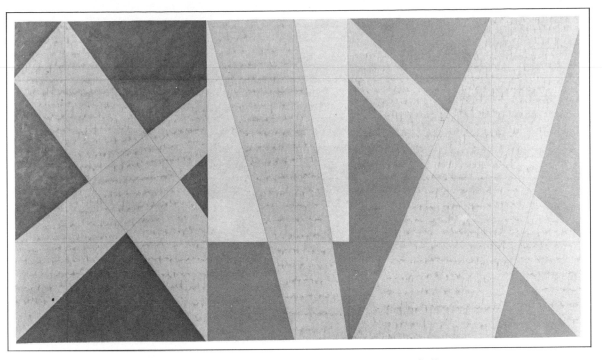

Jack Tworkov, *The Exes II* (1982), 64" x 112", oil on canvas. Nancy Hoffman Gallery.

Sidney Geist, *Thinker* (1959), 7' high, wood. Ingber Gallery..

Calvin Albert, *Shell*, 18" x 15" x 10", terra cotta. Ingber Gallery.

71

The works of Gerard Charriere reflect his dual career as a bookbinder and artist. In creating his collages and drawings, the artist's originality is deeply embedded in his knowledge and experience of decorating fine leather bindings. Other important works shown are the finely detailed collages of John Digby, who builds a present from the imagery of the past with surgical scalpels and fragments of engravings.

The etchinglike pen and ink drawings of Philip Sugden depict landscapes, people, architectural details, and statues from the artist's travels in England, France and Italy. Ellen McLaughlin's collage-drawings utilize carbon paper. Marcia G. Yerman carves and paints mysterious but humorous images on wood, and Dee Jenkins does small, brilliant oil paintings on paper.

Phyllis Kind

Phyllis Kind Gallery 139 Spring St., New York, NY 10012 (212) 925-1200 Tuesday-Saturday: 10-6 June-August: Tuesday-Friday: 10-6

Having gained a controversial reputation by exhibiting unusual art, the gallery is interested in showing untraditional works that center around American artists, many of whom are Chicago and New York painters. There is a heavy emphasis on contemporary naives, artists without formal training.

After establishing a gallery in Chicago, the owner expanded and opened a gallery in New York, to which she brought her selected young Chicago artists, many of whom had come to be known as Chicago Imagists. She later added many other artists from various backgrounds, including naive and contemporary folk artists.

The New York gallery, with its two large rooms, houses works by Chicago Imagists. Roger Brown's paintings are both mysterious and humorous. Gladys Nilsson's organic figures are sensitively painted, mainly in watercolor. Ed Paschke's drawings and paintings often frighten and alarm the viewer. Jim Nutt paints scenes and images that often have a fantasy-like quality. Also included among the Chicago Imagists is Karl Wirsum, a constructionist.

Other prominent gallery artists are William Copley, Russ Warren and Cham Hendon. Artists working in three dimensions include Margaret Wharton and Martin Johnson.

Naive works by gallery artists include Howard Finster's intricate narratives, carvings by Elijah Pierce, fantastic geographical landscapes by Joseph Yoakum, and obsessed linear drawings by Martin Ramirez. Recently the gallery has added the works of Robert Gordon, a figurative painter who works with patterns and Russ Warren who also works in figurative modes. Earl Staley, Mary Stoppert and John Martin also show their works.

The Kitchen

The Kitchen 484 Broome St., New York, NY 10013 (212) 925-3615 Tuesday-Saturday: 1-6

The gallery began as an ad hoc video gallery in the kitchen of the old Mercer Arts Center. A nonprofit organization, it has been a home for experimental work in the performing and visual arts. The Kitchen has grown to include programs in television, music, dance and performance, and maintains a small gallery as well as a video viewing room for closed-circuit screenings.

Each year the gallery showcases 150 video artists, thirty-five composers, twenty-five performance artists, ten choreographers, ten exhibitions and two major television productions. In addition to the presentation programs, an array of support services enables artists to produce their work and present it to the public.

The gallery's Video Archive houses tapes of various modes, including fiction, documentary, performance, image processing and synthesis. It also stores many valuable documents of early performances and works created especially for videotape.

In the viewing facilities, video equipment and screening facilities are provided to artists and the public. Tapes from the archive may be viewed

by appointment. A nominal fee is charged to nonmembers.

Video distribution is a service designed to present videotape programs to museums, galleries and educational and community organizations. Tapes may be selected from the video catalogue or the gallery can curate a show according to a given name or technique. The Touring Program presents the best work of young or emerging composers, choreographers and performance artists in productions in the United States and abroad.

The Kitchen also provides a production program geared to the broadcast of large-scale works by major artists. The initial projects, Robert Ashley's "Perfect Lives (Private Parts)" and a series of video portraits by Joan Logue, were followed by works by other independent producers.

The gallery's Media Bureau gives small grants for exhibitions, workshops and community services to media artists throughout New York State, and is funded by the New York State Council on the Arts.

Ledel Gallery

Ledel Gallery 168 Mercer St., New York, NY 10012 (212) 966-7659
Tuesday-Saturday: 12-6 August: closed

One of the newest galleries in Soho, it features presentation of vintage, contemporary and experimental photography. The gallery comprises two large, well-lighted rooms in an old landmark building, which both have files of reserve prints and store portfolios, posters and books. The gallery also maintains a fine selection of gravures, orotones and important portfolios for discriminating collectors.

The opening exhibit featured Edward S. Curtis' gravures of North American Indians, orotones, portfolios and a full set of books. "Collectors Show" featured famous photographers, such as Imogene Cunningham, Edward and Brett Weston, Berenice Abbott, Ruth Bernhard, Alfred Stieglitz and Barbara Morgan.

Other photographers recently featured include P. H. Polk, the official photographer of Tuskagee, Alabama; Ralph Weiss, a nature photographer, whose images were taken within a radius of forty miles around New York City; and A. Aubrey Bodine, a pictorial photographer. Also exhibiting were Tony Ray-Jones, from Britain, in a presentation of witty but sensitive images; and Irish photographers Paul Caponigro, Alan McWheeney and Ron Rosenstock, among others. The gallery will exhibit works by Lou Bernstein, an original Photo-League member, active teacher, philosopher and artist.

Russ Warren, *Love Moves* (1981), 49" x 69", acrylic on canvas. Phyllis Kind Gallery.

Louis K. Meisel

Louis K. Meisel Gallery 141 Prince St., New York, NY 10012
(212) 677-1340 Tuesday-Saturday: 10-6

The gallery specializes in Photorealism and exhibits the work of several of the major artists of the movement. Audrey Flack paints very large still lifes from memorabilia of experiences in her life. Ron Kleeman treats trucks, fire engines and all other types of racing machines as icons that are painted in large scale. Charles Bell's pictures of the toys and objects of childhood, such as gum ball machines, tin toys, marbles and pin ball machines are painted on a larger-than-life scale. Franz Gertsch and Tom Blackwell are other major gallery Photorealists. Blackwell's fascination with machines has broadened to other subject paintings and many of his newer works are quite different in nature.

The gallery also specializes in abstract illusionistic painting, represented at the gallery by Michael Gallagher, James Havard and George Green. This group of artists paints large-scale, colorful, abstract paintings that give the illusion of objects floating off the canvas.

Some other art styles are shown at the gallery including some abstract expressionism highlighted by the works of Theodoros Stamos. Sculpture, too, is occasionally shown including pieces of Judd Nelson.

Metro Pictures

Metro Pictures 169 Mercer St., New York, NY 10012 (212) 925-8335
Tuesday-Saturday: 11-6 August: closed

The gallery presents new artists in their first one-person shows. The artists work in a wide range of media including painting, photography, records and performance.

The emerging artists are generally identified with postmodernist concerns. Robert Longo does large-scale drawings in black and white of figures in urban attire and animated postures, in addition to sculpted reliefs of figures and buildings. Cindy Sherman works with photographs, playing various roles such as photographer, model and director. Jack Goldstein's current paintings are dramatic black and white scenes taken from World War II photographs.

In presenting new art, the gallery deals with images in all media. They include paintings of newspaper images by Thomas Lawson, painted drawings of faces and crowds by Michael Zwack and near-abstract photographs by James Welling. With an emphasis on cultural information, painter Walter Robinson depicts stereotypical magazine or novel illustrations, and photographer Laurie Simmons reenacts real-life scenes using dolls and miniatures.

Elise Meyer

Elise Meyer, Inc. 477 Broome St., New York, NY 10013 (212) 925-3527 Tuesday-Saturday: 10-6 August: closed

The gallery opened with the owner's intention to exhibit an international group of young artists whose work is concerned with dynamic issues that relate to human systems such as architecture, language, mathematics, politics and nature.

Works exhibited range in media to include traditional paintings, drawings, collage, installation, video projects, photography and sculpture. Emphasis is placed on the expression of the human aspect of investigation and inquiry. The gallery does not show purely abstract or figurative art of any kind.

Works indicative of the programs of the gallery include Agnes Denes's quest to make visible, invisible processes such as probability theory or projected maps. The socio-political video works of Francesc Torres, the manipulated natural elements of David Nash, and the complex mythological language of Charles Luce are also representative of gallery programs.

Other projects with which the gallery is involved include site-specific installations, such as the large-scale porcelain environments of Cathey Billian, the stone and found-wood sculpture of Boaz Vaadia and the primitive-inspired work of Mary Beth Edelson.

Hilo Chen, *City III* (1981), 60" x 60", oil on canvas. Louis K. Meisel Gallery.

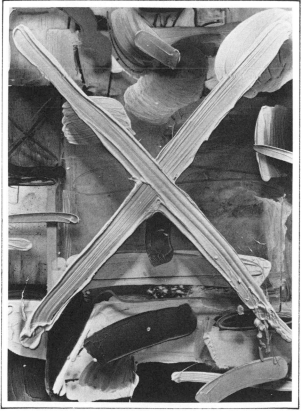

Michael Gallagher, *Blue Shoes*, 81" x 60", acrylic
on canvas. Louis K. Meisel Gallery.

In addition to large-scale works by these artists, the gallery also presents drawings, plans, models and other documentation that relates to the projects.

A further interest of the gallery is color photography. The gallery represents Sandi Fellman in both large-scale polaroids and C-prints, Barnaby Evans, Maureen Paley, and the photographic work of Agnes Denes.

The gallery has organized several traveling exhibitions, including "Schemes: A Decade of Installation Drawings," a show of installation plans by fifty leading contemporary artists. "Corners" was an exploration of three-dimensional sculpture designed for corner spaces. "Young British Color Photographers," and "French Color Now" are photography surveys.

Alexander F. Milliken

Alexander F. Milliken, Inc. 98 Prince St., New York, NY 10012
(212) 966-7800 Tuesday-Saturday: 10-6

The gallery represents twenty living American painters and sculptors whose work is eclectic, extreme and always original.

Wendell Castle, a foremost American wood carver, creates pieces that incorporate inlay and veneer with a high degree of perfection. Master draughtsman Arnold Bittleman shows works on paper that border on the monumental.

Among the sculptors are John Matt, whose wood, chrome and steel works are entertaining, space-age pieces that suggest moonwalkers or futuristic scientific instruments. Geometric wall pieces by Richard Friedberg and bisque, unglazed porcelain sculpture by Frank Fleming are shown here, as are aluminum, chrome, brass and stainless steel works by Ed Hendricks.

Ed Baynard's recent paintings show a shift in subject matter from exquisite flowers to people, and Arlene Slavin's paintings loosely represent fish. Also exhibited are abstract works by Richard Saba, who is concerned with space, and by David Shapiro, whose paintings are intellectual yet personal. All four painters have been with the gallery almost since its inception and provide its backbone. Other gallery artists include David Fick, Stephen Lorber, Jillian Denby, Steve Hawley and Mary Ann Currier.

The gallery takes pride in exploring the unknown by providing artists with their first one-person show. Lois Polansky recently had her first show of works on handmade paper. Other artists represented by the gallery are Paul Rickert, Susumu Sakaguchi, Susan Zises, Henry Cohen and James Hansen.

Elise Asher, *Dead of Winter* (1981), 20" x 60", oil on plexiglas. Ingber Gallery.

David Wojnarowicz, *Diptych,* 48" x 96", spray paint on Masonite. Alexander F. Milliken Gallery.

Wendell Castle, *Demi-Lune Table* (1982), 34" x 38" x 20", Brazilian rosewood and ivory.
Alexander F. Milliken Gallery.

Annina Nosei

Annina Nosei Gallery 100 Prince St., New York, NY 10012 (212) 431-9253 Tuesday-Thursday: 11-6

The owner recently opened her gallery after having been a private dealer. Works shown are by the new German Expressionists and the Italian New Image painters, as well as American artists.

Among Italian New Image artists, Mimmo Paladino paints large triptychs as well as smaller canvases and drawings. Ernesto Tatafiore makes drawings and paintings often based on the French Revolution. Of the German Expressionist artists represented by the gallery, K. H. Hodicke, forty-three, often uses backlighting in his paintings. Salome, his student, often paints subjects related to city life in different metropolitan settings. Also shown are works by Luciano Castelli, a Swiss-born artist who now works in Berlin.

Of American artists, Jean Michel Basquiat uses acrylic and oil stick on masonite or canvas. He is a street artist whose paintings often have a graffiti-like quality. David Deutsch works in ink or pencil on paper to create landscapes, often with strange, unidentifiable objects. Also using landscapes as his subject matter, Jack Barth works with charcoal and ink on paper. Donald Newman works with acrylic and charcoal on photographs and paper. Mike Glier uses oil stick on paper or canvas.

Oil & Steel

Oil & Steel 157 Chambers, New York, NY 10007 (212) 964-1567 Tuesday-Saturday: 12-5:30

Founder Richard Bellamy is a prominent figure in the New York art world going back to the fifties and the Greenwich Village days. A former director of the Hansa, a gallery founded by the pupils of Hans Hofmann, Bellamy's associations with the arts range from writer Jack Kerouac to painter Larry Rivers.

The Tribeca gallery is housed in a former factory building. Entering the space from the outdoors, and encountering the unrehabilitated hallway, is almost a throwback to the beatnik days; however, the art shown in the spacious gallery covers several decades and often takes in the works of artists who are now part of the establishment.

Bellamy favors group shows usually taking in works from the fifties, sixties and seventies. Though the shows are not great in number (about two or three annually), they are carefully organized and tend to feature important works of major artists of the period being featured. More frequently, arrays of sculpture are shown including those of Mark di Suvero who the gallery represents. David Rabinowich who executes massive steel floor-planes is one of the gallery's most frequent exhibitors. Other sculptors include Richard Nonas who recently has been working in wood as well as steel, Michael Heiser, an artist who favors block granite and the erotic sculptures of Crozier. Painting is shown as well. Prominent among the painters are Myron Stout, a purist painter who frequently works in monotones and figurative artists Jan Mueller and Manny Farber.

O.K. Harris

O.K. Harris Works of Art 383 West Broadway, New York, NY 10012 (212) 431-3600 Tuesday-Saturday: 10-6 August: closed

With four simultaneous shows a month, the gallery generates a lot of activity in Soho. The constant variety in modes of painting, sculpture, conceptual work and photography reflect the eclecticism that the director sees as the general disposition of advanced art. Drawn to the freshness of the precise realist styles of the 1970s, the gallery became identified with Super- and Photorealism. While scenes by Californian Robert Bechtle and still lifes by Ralph Goings can still be seen, the Photorealists only represent about one-fifth of the gallery's forty regular artists. In addition, there are many new artists who have had their first one-person exhibition at the gallery.

The spaciousness of the gallery makes room for large-scale art. Installations have included a concrete structure embedded with appliances by Nancy Rubins and a three-dimensional wall relief recreating famous

John De Andrea, *Seated Blonde with Crossed Arms* (1982), lifesize, polyvinyl, polychromed in oil. OK Harris Gallery.

masterpieces by Sharon Quasius. Hyperrealistic sculpted nude figures by John DeAndrea and middle-American people by Duane Hanson are disconcertingly lifelike. Cloth and epoxy-resin sculpture by Muriel Castanis resembles classical statuary.

In addition to large-scale art, the gallery exhibits small-scale works, such as the miniature, hyperrealistic paintings by Daniel Chard. Davis Cone always puts an abandoned theatre somewhere in his atmospheric paintings. Photorealist John Baeder paints the facades of old diners. Painting styles range from perspective geometries to romantic realism in the works of Tony King, superrealist John Kacere, Ian Hsia and H. N. Han.

Photography is taking an increasingly more important place in the gallery. Eric Staller's images of light are taken with multiple and timed exposures during shooting. Denny Moer manipulates his black and white photographs during development to produce pastel-type colors. Al Souza combines photography and collage, using plastic models at the bottom of boxes that are inlaid with photographs. Other photographers on view are Joel Levinson, Jen Sloan and Doug Coder.

Conceptual artist Don Celender annually displays his surveys and correspondence among various people on a wide range of topics. Every June and July the gallery holds a summer invitational show of six to ten artists. Among special thematic shows occasionally held were paintings of the Brooklyn waterfront by a forgotten artist, Winthrop Turney.

Soho Center

Soho Center for Visual Artists 110-112 Prince St., New York, NY 10012 (212) 226-1995 Tuesday-Saturday: 12-6 August: closed

The gallery is a nonprofit organization sponsored by the Aldrich Museum of Contemporary Art, with additional support from the Mobil Foundation. The director of the gallery selects works for monthly group shows of three to four artists. There is an interest shown in work of lyrical abstraction. The purpose of the exhibits is to give exposure to emerging New York artists who have not had a one-person show in a commercial New York gallery. All proceeds from the sale of art go to the artist. A reference library for members is free to artists who register.

Holly Solomon

Holly Solomon Gallery 392 West Broadway, New York, NY 10012 (212) 925-1900 Tuesday-Saturday: 10-6

The gallery features important, avant-garde conceptual and performance artists, both American and international, as well as painters and sculptors who work in a decorative or symbolist tradition.

Laurie Anderson, Alexis Smith and Tina Girouard have had photographic and audio installations of their performances. Crossing into popular art forms, Anderson incorporates music, sound and language along with visual information. Smith paints installations on the wall and uses collage to create architectural compositions in space. Girouard's paintings relate to her performances, which use music and elements of cultural history.

William Wegman's conceptual work also employs popular media, such as pop music and television. Using photographs, drawings and videotapes, he relates his concept and pictures to a narrative in a humorous way. New Image painter Joe Zucker uses idiosyncratic and metaphysical imagery. He is part of a younger group of artists who work in a personal, subjective vein, including Michael Mogavero and Janis Provisor. Other such artists are imagist Charles Garabedian; Rodney Ripps, who does large, provocative relief paintings; and Lynton Wells, who paints metaphysical landscapes.

Robert Kushner's painted costumes and sets are covered with bright, splashing patterns. The large-scale paintings of Valier Jaudon are based on Islamic architectural ornamentation and show Near Eastern interiors. Kim MacConnell and Nicholas Africano also share an interest in decorative patterning.

Thomas Lanigan-Schmidt's small, fanciful chapels, coaches and

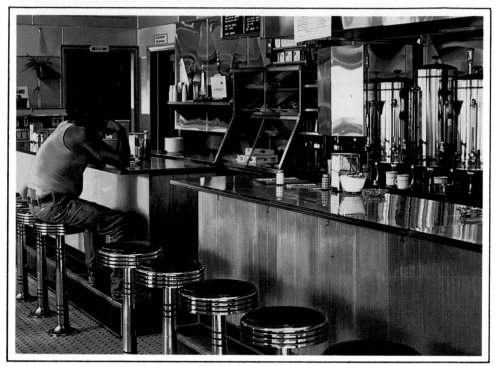

Ralph Goings, *Amsterdam Diner* (1980), 44″ x 60″, oil on canvas. O.K. Harris Gallery.

Nancy Rubins, *Untitled* (1980), 14′ high reinforced concrete with appliances. O.K. Harris Gallery.

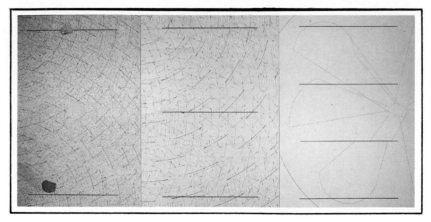

Arakawa, *Blank Stations II* (1980-81)—Panels 1, 2 & 3 (of 6), 120″ x 84″, acrylic on canvas. Ron Feldman Gallery.

Maurice Sievan, *#585 OOMBIX,* 69½″ x 60″, oil on canvas. Vanderwoude Tananbaum Gallery.

Arakawa, *Blank Stations II* (1981-82)—Panels 4, 5, & 6, 120″ x 84″, acrylic on canvas. Ron Feldman Gallery.

Charles Luce, *Chair Metaphor Chart #1* (1981), 48″ x 36″, gouache on paper. Elise Meyer Gallery.

Roy Lichtenstein, *Cosmology* (1978), 107″ x 167″, oil & magna on canvas. Leo Castelli Gallery.

Ed Paschke, *Delamer* (1981), 50″ x 84″, oil on canvas. Phyllis Kind Gallery.

Kermit Adler, *Milk & Cookies,* 29½″ x 22″, lithograph. Ingber Gallery.

Elizabeth Murray, *Just in Time* (1981), 106″ x 97″, oil on canvas. Paula Cooper Gallery. (Collection: Philadelphia Museum).

Anne Tabachnick, *Moving In "II"*, 3′ x 4′. Ingber Gallery.

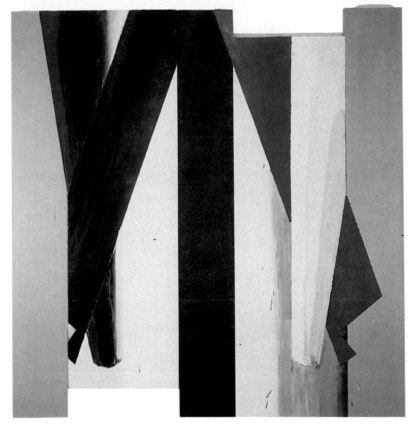

Gary Stephan, *Sator, Arepo, Tenet, Opera, Rotas* (1982), 89″ x 84″,
oil on canvas & linen. Mary Boone Gallery. (Collection: Metropolitan
Museum, N.Y., N.Y.)

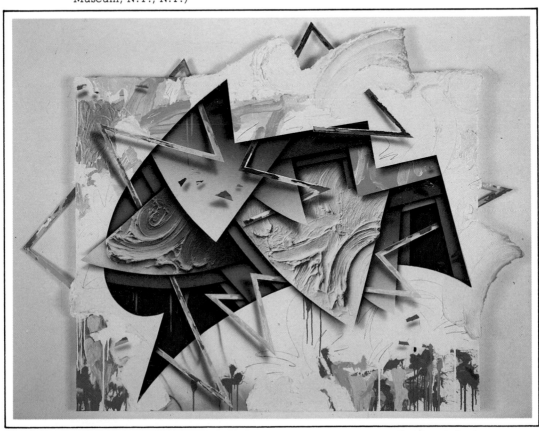

George Green, *Cut Throat* (1982) 58½″ x 75″, acrylic on canvas. Louis K. Meisel Gallery.

Tom Holland, *Pine* (1981), 72½″ x 50″, epoxy on aluminum.
Charles Cowles Gallery.

Peter Alexander, *Bonito* (1982), 48″ x 53″, mixed media on cloth. Charles
Cowles Gallery.

James Havard, *Brahama Night Ride* (1981), 72" x 96", acrylic on canvas. Louis K. Meisel Gallery.

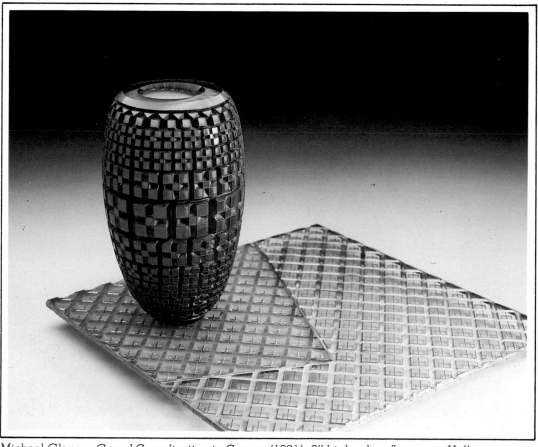

Michael Glancy, *Grand Complication in Copper* (1981), 9" high, glass & copper. Heller Gallery.

Agnes Denes, *Anima/Persona, The Seed* (1979), photograph. Elise Meyer Gallery.

Charles Bell, *Marbles VIII* (1982), 60″ x 78½″, oil on canvas. Louis K. Meisel Gallery.

Tom Blackwell, *Broadway* (1982), 90″ x 60″, oil on canvas. Louis K. Meisel Gallery.

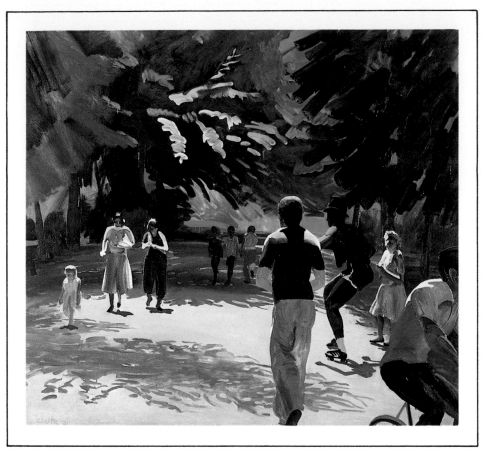

William Clutz, *Park Mall,* 62″ x 72″, oil on canvas. Tatistcheff Gallery.

Yozo Hamaguchi, *Watermelon,* 9½″ x 21¼″, mezzotint. Vorpal Galleries.

Judith Godwin, *Tropic Zone,* 42" x 52", oil on canvas. Ingber Gallery.

Jesse Allen, *Leopards Mating under the Omen of the Blue Seed,* 24¾" x 28½", etching with aquatint. Vorpal Galleries.

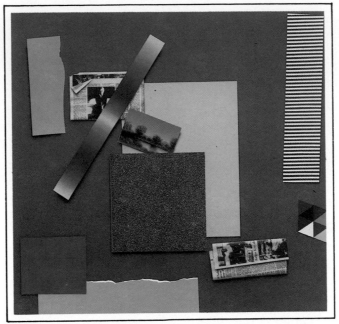

Paul Sarkisian, *Untitled #13* (1981), 48" x 50", acrylic &
glitter on linen. Nancy Hoffman Gallery.

Ed Baynard, *Twist* (1982), 70" x 64", oil on canvas.
Alexander F. Milliken Gallery.

Dale Chihuly, *Macchia Series,* 16″ high, blown glass. Charles Cowles Gallery.

Joseph Raffael, *Luxembourg Gardens: Memory*
(1982), 52″ x 48″, watercolor. Nancy Hoffman
Gallery.

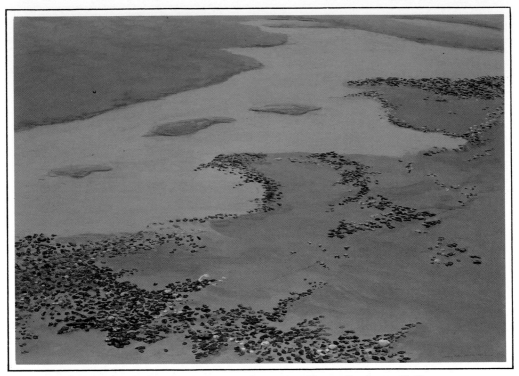

Carlyn Fisher Abram, *Sand Planes,* 30″ x 40″, acrylic. Elaine Starkman Gallery.

Jasper Johns, *Three Flags* (1958), 30¼″ x 45½″ x 5″, encaustic on canvas. Leo Castelli Gallery.

vehicles are allegorical with decorative and symbolic elements. Also working in a decorative tradition, Ned Smyth uses columns and arches, and Brad Davis includes lyrical jungle settings in his drawings. Donna Dennis's sculpture, which always has references to architecture, is done in a narrative-subjective tradition. Judy Pfaf's large environmental installations are colorful and energetic, always marked by perceptual density and gestural energy. All of these artists work pictorially with sculpture. Other artists who show at the gallery include sculptors Gary Burly and Ed Shostak, Jared Bark, Sam Cady, Mary Heileman, Christopher Knowles and George Schneeman.

Sonnabend

Sonnabend Gallery 420 West Broadway, New York, NY 10012 (212) 966-6160 Tuesday-Saturday: 10-6 July-August: closed

The gallery was first established in Paris in 1962 to introduce to Europe American artists such as Jasper Johns, Robert Rauschenberg and Robert Morris. In New York, it has continued to show Abstract Expressionist work and has spotlighted American and European avant-garde art.

John Baldessari does photographic work in a conceptual way. Bernd and Hilla Becher are also conceptual photographers, as are Gilbert and George, who sometimes do live performance pieces. Barry Le Va's environmental sculpture is related to his installations. Italian Gilberto Zorio, who recently showed for the first time in the United States, is a non-representational sculptor who uses unusual materials such as leather and copper. American Terry Winters, who also recently had his first major show, is a young figurative painter of botanical shapes. The gallery also shows two contemporary German painters, George Bafelitz and A.R. Penck, whose works are both expressionistic. Forged sculpture by Alain Kirili, color photographs by David Haxton and abstract paintings by Michael Goldberg may also be seen.

Sperone Westwater Fischer

Sperone Westwater Fischer 142 Greene St., New York, NY 10012 (212) 431-3685 Tuesday-Saturday: 10-6

The gallery is operated by a triumvirate of art dealers from Europe and America. Co-owner Gian Sperone, who is an Italian dealer, has been influential in introducing a number of American minimalists and conceptualists to Europe including Cy Twombly, Jan Dibbits and Richard Long. The other co-owners, German dealer Konrad Fischer and American Angela Westwater, have worked in association to mount a number of shows in the last few years, bringing European artists to the forefront of attention in America.

The gallery is massive in size, lending itself to large scale works. In the tradition of its European roots, the gallery has shown many of the works of American artists who became popular on the Continent including Robert Ryman, Sol LeWitt, Carl Andre and Brice Marden. Today, the gallery puts on a variety of one-man shows featuring its list of gallery artists from around the world. Occasional group shows often take place, at times featuring works by artists represented by a variety of American and European dealers. Frequent offerings are found of the paintings of Italian Sandro Chia, highlighting his current works and those of sculptor Don Glummer who has received considerable acclaim with his wall reliefs.

Elaine Starkman

Elaine Starkman Gallery 465 West Broadway, New York, NY 10012 (212) 228-3047 Wednesday-Sunday: 12 to 5 & by appointment Summer: by appointment

The gallery specializes in works of outstanding contemporary women artists in all categories. The artists represent a broad spectrum of approaches, styles and techniques, from photorealism to abstraction. Painting, sculpture, drawing, papermaking, collage and graphics are presented.

Contrasted among the painters of photorealist style are Carolyn Parker, who depicts Northeastern architectural scenes, and Genevieve

Reckling, whose grand scale nature paintings of cactus, flowers and water emanate from her striking Arizona environment. Contemporary bronze sculptor Lora Pennington's subjects range from the classical realism of her portraits of Georgia O'Keeffe, Virginia Woolf and other prominent figures to photorealistic, satirical forms depicting only the adornments, trappings and paraphernalia of her characters called "nobodys," for which she has won many prestigious sculpture awards.

Contrasts in paper collage are offered by the gallery's papermakers. Ande Lau Chen works in a contemporary oriental style on large panels, and Erika Kahn combines textures and printed embellishments on her abstractions. Works by Genevieve Reckling, Harriet Horwitz and Carolyn Fisher are also shown.

Graphics, such as etchings, lithographs, serigraphs and monotypes feature works of printmakers from all over the country.

Terrain Gallery

Terrain Gallery 141 Greene St., New York, NY 10012 (212) 777-4426
Tuesday-Saturday: 1-6

The gallery opened in 1955 with its motto and *raison d'etre,* Eli Siegel's statement, "In reality opposites are one; art shows this." Exhibitions have included "Meaning in Immediacy," "The Slim Weltanschauung," "Logic and Emotion" and "Art as Gaiety," which highlighted the work of America's leading painters, printmakers, sculptors and photographers.

In 1973 the Terrain Gallery became an aspect of the Aesthetic Realism Foundation, which is located at the same address. The gallery continues to hold exhibitions exemplifying Siegel's theory of opposites. Aesthetic Realism dramatic presentations and larger seminars are held in the gallery.

Printmakers exhibited at the Terrain Gallery include Charlotte Brown, Hank D'Amico, Kathleen E. Gallagher, Michael Knigin, Chaim Koppelman, Chuck Magistro and William Paden. Shows have featured paintings and drawings by Richard Karwoski, Chaim Koppelman, Dorothy Koppelman, Louis Nardo, Selina Trieff, Robert Weiss and Claudia Whitman. Photographs by David Bernstein, Winston Swift Boyer, Ira Lerner and Nancy Starrels can also be seen at the gallery.

Edward Thorp

Edward Thorp Gallery 419 West Broadway, New York, NY 10013
(212) 431-6880 Tuesday-Saturday: 10-6 August: closed Saturday

The gallery's primary focus is on emerging American artists, predominantly those working in the fields of painting and drawing. Among the prominent painters represented, David True sets an image in motion against a placid background to create relationships of shape in space and motion in stagnancy. Eric Fischl explores themes of sexuality in paintings and drawings. Ken Kiff's works of sometimes humorous, juxtaposed dream images are visibly influenced by Symbolism and Surrealism.

The gallery also handles the estate of John Altoon, known for his superb draughtsmanship and sense of color. A recent exhibit highlighted his abstract and figurative styles. Rarely seen organic abstractions were shown along with a group of highly imaginative sexual satires. Additional gallery artists are Carole Alter, Jack Barth, David Deutsch, April Gornik, John Lees, R. L. Kaplan, Jane Rosen, Mira Schor, Martin Silverman and Joseph Santore.

Vorpal

Vorpal Gallery 465 West Broadway, New York, NY 10012 (212) 777-3939 Monday-Saturday: 10-6; Sunday: 1-6

With two branches on the West Coast, the gallery opened in Soho. Twentieth-century contemporary artists working in painting, prints and sculpture predominate, with a number of local New York artists also represented.

The gallery has long handled the impossible structures and personal fantasies of master Dutch printmaker M. C. Escher, and sponsors a major

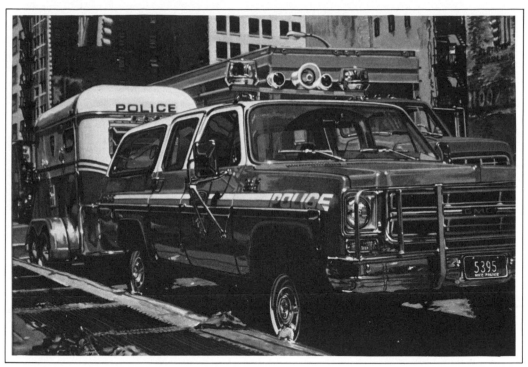

Ron Kleeman, *Police Horse Trailer,* 11½″ x 15½″, acrylic on board. Louis K. Meisel Gallery.

Jud Nelson, *Toilet Paper #1* (1981), 9″ x 8″ x 8″, marble. Louis K. Meisel Gallery.

Lora Pennington, *Mystique,* bronze. Elaine Starkman Gallery.

Escher show every few years. A more recent addition is mezzotint artist Yozo Hamaguchi, whose still lifes may consist of vivid walnuts, watermelon or butterflies against a dark gray or brown background. Jesse Allen's revolutionary use of print techniques can be seen in his totally patterned fantasy landscapes. His paintings are available as are his composite prints, etchings, photographs and photo-offset prints. Gary Smith is a painter and printmaker who employs silverpoint etching to achieve a subtle, abstract, landscapelike quality. The gallery also maintains a substantial collection of Picasso prints, linocuts, lithographs, serigraphs and book illustrations. Prints by Paul Delvaux, Rene Magritte, Odilon Redon and Pierre Bonnard are also available.

The shows change approximately every six weeks in the five exhibit spaces of the gallery. Paintings and prints by New York artists include monoprint fantasy landscapes by Katharine Hagstrum; pastel landscapes by Karen Weenig; abstract paintings by Carl Lubet; monoprints by Ziva Kronzon on handmade papers; scientific fantasies in acrylics on board and gouaches by Massimo De Stefani; subtle, abstract pastels and paintings by Robert Singleton; large monocolor paintings and prints by O Donohue Ros that parody ancient texts; and oil paintings by Jose Morales.

Sculpture by Frederich Zeller is cavelike, with jagged edges, and harkens to an ancient time. Agnese Udinotti's large-scale steel wall pieces are punctuated by her own poetry and small, handcast human figures. Metal and wood sculpture by Robert Singleton suggests a monumental presence.

Ward-Nasse

Ward-Nasse Gallery 178 Prince St., New York, NY 10012 (212) 925-6951 Tuesday-Saturday: 11-5:30; Sunday: 1-4 August: closed

The gallery was founded on the premise that many more artists deserve the right to exhibit in a gallery situation than the current system permits. Through its growing membership, it seeks to understand and fulfill the needs of artists in general.

The gallery is an artist-run, nonprofit corporation, which is totally supported by its artist and public members. The gallery seeks to create an environment in which diverse aesthetic approaches coexist, contrast, complement and interact with each other, and thus accommodate a broad range of public interests.

There is a library of approximately 7,500 slides of works by current and past members, as well as a projection screen in the gallery. The gallery issues a biannual catalogue of its slide shows, distributed free to museums, universities and other institutions throughout the country.

The gallery also sponsors performances. Performances, music, dance, theatre, poetry and mixed-media events take place monthly and are free to members.

The gallery features three artists in a three-week show, once every two years.

Washburn

Washburn Gallery 113 Greene St., New York, NY 10013 (212) 753-0546 Tuesday-Saturday: 10:30-5:30

For complete information see midtown review of sister gallery on 57th St.

John Weber

John Weber Gallery 142 Greene St., New York, NY 10012 (212) 966-6115 Tuesday-Saturday: 10-6

The gallery was established in 1971 by John Weber, who has promoted and exhibited three generations of American and European art covering Abstract Expressionism, Pop Art, Minimalism and Conceptual Art. The latter two movements have been the central focus of the gallery since the mid-1960s.

Works by internationally known artists such as Robert Mangold and Sol LeWitt as well as Daniel Buren, Roman Opalka and Victor Burgin form the core of the gallery's exhibitions. Alice Aycock, who creates

Eric Fischl, *The Catch* (1982), 66″ x 96″, oil on canvas. Edward Thorp Gallery.

Douglass Freed, *Triangle #3* (1980), 19″ x 19″, oil on canvas. Vorpal Gallery.

large, outdoor sculptural pieces, has been with the gallery for eight years. The outdoor work of Nancy Holt and Charles Ross, as well as the estate of Robert Smithson, is also represented by the gallery. The gallery has emphasized what it feels to be the logical successor to minimal art, the work of abstract painters and sculptors, such as Kes Zapkus, James Biederman, Mel Kendrick, Bruce Boice, Jeremy Gilbert Rolfe and Lucio Pozzi. Recently, the gallery has also begun to exhibit the architectural photography of Hedrich-Blessing as well as the photographic work of Gwenn Thomas, Dennis Roth and Barbara Kasten.

Westbroadway Gallery

Westbroadway Gallery/Alternate Space 431 West Broadway, New York, NY 10013 (212) 966-2520 Tuesday-Friday: 11-5; Saturday: 11-6

Westbroadway Gallery and Alternative Space, respectively upstairs and downstairs at the same location, were among the first galleries to open in the Soho area. They have concertedly maintained what they consider to be the original Soho flavor. These artist-owned galleries are both co-operative and commercial.

Work exhibited at both spaces is eclectic; there is no focus or thrust toward collating works of a characterizable school of art. Artists from all over the world exhibit paintings, sculpture, photographs, conceptual art and mixed-media works. The older, regular artists exhibit in the upstairs space, while younger, more transient artists exhibit downstairs.

White Columns

White Columns 325 Spring St., New York, NY 10013 (212) 924-4212 Tuesday-Friday: 4-11; Saturday-Sunday: 1-7

The gallery was recently founded as a reorganization of 112 Greene Street, New York City's first alternative space. Primarily devoted to exhibiting works by younger artists, the gallery mounts dynamic exhibitions that frequently overlap with other events. Painting and sculpture are the general focus of the new work being presented in one-person, group and theme shows. Both American and European artists are shown as well as New Yorkers.

White Columns is also a performance space. Films, video, concerts and readings are held approximately twenty-five times a year. A recent major event was "Noise Fest," an art and music event of thirty-one bands and sixty artists.

Books, records and magazines that the gallery has produced since 1981 are available. The gallery also sponsors special projects and artist collaborative events outside the gallery.

The back space is used as a lounge area rather than as an office. It is both a recreation area and a meeting place for artists.

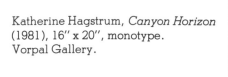

Katherine Hagstrum, *Canyon Horizon* (1981), 16" x 20", monotype. Vorpal Gallery.

Cindy Sherman, *Untitled Film Still,* 40" x 30", photograph. Metro Pictures.

The Midtown Galleries

By Specializations

The following list represents concentrations of a particular artistic mode and not necessarily the individual focus of the gallery.

American:
contemporary:
Adler, Alexander, Anderson, Arras, Blum Helman, Borgenicht, Crispo, de Nagy, del Re, Dintenfass, Emmerich, Esman, Fedele, Fischbach, Findlay, Frumkin, Getler Pall, Grand Central, Hamilton, Janis, Jacobson/Hochman, Kornblee, Kraushaar, Markel, Marlborough, McKee, Midtown, Miller, Odyssia, Pace, Parsons, Pearl, Protetch, Rizzoli, Rosenberg, Sachs, Touchstone, Tatistcheff, Zabriskie, Zarre
periods:
Deutsch, Grand Central, Hammer, Janis, Kennedy, Kraushaar, Marlborough, Washburn

Ceramics/Crafts & Other Media:
Modern Master Tapestries, Protetch, Touchstone

European & Other Continents:
contemporary:
Arras, Brewster, del Re, Emmerich, Findlay, Iolas-Jackson, Jacobson/Hochman, Marlborough, Matisse, Multiples/Goodman, Odyssia, Pace, Parsons, Rosenberg, Touchstone
periods:
Findlay, Hammer, Marlborough, St. Etienne

Graphics:
contemporary:
A.A.A., Fedele, Heidenburg, Multiples/Goodman, Pace Editions, Rizzoli, Rosenberg
periods:
A.A.A., Getler Pall, Pace Editions, Rizzoli

Oriental:
Ronin

Photography:
Light, Janis, Miller, Rizzoli, Witkin, Wolf, Zabriskie

Primitive/Ancient:
Pace Primitive

Sculpture:
Alexander, Blum Helman, Borgenicht, Hamilton, Parsons, Zabriskie, Zarre

By Location

53rd Street Vicinity
A.A.A.	663 Fifth

56th Street Vicinity
Rizzoli	712 Fifth
Light	724 Fifth
Miller	724 Fifth
Borgenicht	724 Fifth
Kraushaar	724 Fifth
Odyssia	730 Fifth

East 57th Street and Vicinity
Midtown	11
Modern Master Tapestries	11
Wally Findlay	17
Pace (including Primitive & Editions)	32
Marilyn Pearl	38
Tatistcheff	38
Andrew Crispo	41
Emmerich	41
Pierre Matisse	41
David McKee	41
Witkin	41
Andre Zarre	41
Washburn	47
Iolas Jackson	52
Ronin	605 Madison

West 57th Street
Dorsky	4
Denise Rene	6
Blum Helman	20
Sid Deutsch	20
Hamilton	20
Alex Rosenburg	20
Brooke Alexander	20
Kornblee	20
Grand Central	24
Jacobson/Hoffman	24
Multiples/Goodman	24
St. Etienne	24
Betty Parsons	24
Arras	29
Tibor de Nagy	29
Rosa Esman	29
Fischbach	29
Touchstone	29
A.M. Sachs	29
Zabriskie	29
Daniel Wolf	29
Hammer	33
Pam Adler	37
Max Protetch	37
Kennedy	40
Marlborough	40
Brewster	41
Marisa del Re	41
Frank Fedele	42
Terry Dintenfass	50
Allan Frumkin	50
Lillian Heidenberg	50
Kathryn Markel	50
Getler-Pall	50
Sidney Janis	110
Martha Jackson	541

Pam Adler

Pam Adler Gallery 37 W. 57th St., New York, NY 10019 (212) 980-9696 Tuesday-Saturday: 10-5:30 and by appointment

The primary purpose of the gallery is to work individually with the thirteen represented artists, all of whom are emerging figures in contemporary American art. Representing artists in search of new forms of artistic expression has kept the gallery's image fresh and unpredictable.

Works by Sarah Canright, Cynthia Carlson, Jack Chevalier, Don Dudley, Edward C. Flood, Ira Joel Haber, Jonathan Santlofer, Jack Solomon and Jeff Way frequently deal with art forms that lie somewhere between painting and sculpture. Works by Brenda Goodman, Charles Clough, David Sharpe and Harry Soviak are exemplary of the wide range of highly individualized imagery among the gallery's artists.

Brooke Alexander

Brooke Alexander 20 W. 57th St., New York, NY 10019 (212) 757-3721 September-June: Tuesday-Saturday: 10-6; July & August: Monday-Friday: 10-5

The gallery features one-person exhibitions of the painters and sculptors it represents. Shows of younger artists, which are scheduled during the summer and in September, are by invitation.

Among a number of realist painters at the gallery, Yvonne Jacquette showed aerial-perspective cityscapes and landscapes and Richard Haas displayed oil and watercolor paintings of architectural buildings. Sondra Freckleton's large watercolor still lifes and Ann McCoy's giant underwater landscapes in colored pencil were also exhibited. Other artists represented are John Ahearn, Richard Bosman, Stephen Buckley, Martha Diamond, Wonsook Kim, George Negroponte, Judy Rifka and Alan Turner.

The gallery also includes in its inventory graphic works by Jack Beal, Richard Bosman, Martha Diamond, Sam Francis, Red Grooms, Yvonne Jacquette, Sondra Freckleton, Philip Pearlstein, Alan Turner and others.

David Anderson

David Anderson Gallery, Inc. 521 W. 57th St., New York, NY 10019 (212) 586-4200 By appointment only

The gallery was formerly the Martha Jackson Gallery, Inc., first opened in 1954. In less than fifteen years, Martha Jackson became a legend as one of the first New York art dealers to exhibit such artists as Willem de Kooning, Jackson Pollock and David Smith of the New York school and Jim Dine, Jasper Johns and Claes Oldenberg of Pop art fame. During this time, Jackson also discovered and brought to America many artists of international acclaim. Antoni Tapies, Karel Appel and William Scott all had their first one-person shows in New York at the gallery.

Since Martha Jackson's death in 1969, her son David Anderson has carried on the gallery's tradition of excellence and quality in abstract art. In 1980, the name of the gallery was changed to the David Anderson Gallery.

Although the gallery no longer represents artists on an exclusive basis, due to a unique buying policy implemented almost from the outset, its inventory contains outstandingly broad selections of works in all media by many of the artists exhibited. They include Louise Nevelson, Karel Appel, Antoni Tapies, Lester Johnson, Julian Stanczak, William Scott, Joan Mitchell, John Hultberg, Norman Bluhm, Michael Goldberg, Sam Francis, Paul Jenkins, James Brooks and others. For some of these artists, the gallery's collection represents the largest in the world.

In harmony with the collection are the gallery document archives, which provide extensive resources for information on the history of art of the third quarter of this century. The gallery also keeps records of all works it has exhibited or sold. It is thus able to provide a rich source of information for academic purposes as well as aid greatly in the maintenance of clients' records. Under most circumstances, the gallery is willing to loan works to qualified institutions for public exhibitions.

A.A.A.

Associated American Artists 663 Fifth Ave., New York, NY 10022 (212) 755-4211 Monday-Saturday: 10-6 June-August: closed Saturday

The gallery, which opened in 1934, deals exclusively in original prints— lithographs, serigraphs, etchings and woodcuts—both old masters and contemporary artists. There is a heavy emphasis on twentieth-century American prints, including works by Thomas Hart Benton, John Stuart Curry, Grant Wood and George Bellows.

In addition, a large number of old master and contemporary prints is available. Old master prints include works by Rembrandt, Albrecht Durer and Callot; European master prints include works by Picasso, Chagall, Pierre Bonnard, Felix Valloton and Jacques Villon, among others. Contemporary printmakers Will Barnet, Isabel Bishop and Raphael Soyer are featured in one-person exhibitions at the gallery.

Other past shows highlighted James Ensor; British masters such as William Blake, Frederic Griggs and Samuel Palmer; and Lyonel Feininger, whose estate is also represented by the gallery. A show of old masters is planned, featuring works by Rembrandt and Durer. Younger, contemporary printmakers occasionally show their works in exhibits of new talent.

Arras

Arras Gallery, Ltd. 29 W. 57th St., New York, NY 10019 (212) 421-1177 Tuesday-Saturday: 9:30-5:30

The gallery features works from an international selection of contemporary paintings, tapestries and sculpture. Collages and prints round out the gallery holdings.

Most of the work is nonrepresentational with a few exceptions. Josep Grau-Garriga does large free-form tapestries, while Enrico Baj is a playful painter and collagist who makes statements about society. Victor Vasarely's multiples are formed from plastic geometric shapes in bright colors.

Jeff Hoare and Rita Letendre are both colorists who work on large canvases. Jill Cannady creates still lifes in oils and pastels. Bill Haendel draws on handmade paper.

Hans Van de Bovenkamp and Kosso Eloul create abstract sculpture in steel, bronze and stainless steel to be used ultimately for monumental works. Sirpa Yarmolinsky's contemporary tapestries and constructions may also be seen.

Original prints of Miro, Max Bill, and Antoni Tapies are available. A new addition to the gallery is a series of cast paper editions by Richard Anuszkiewicz, James Rosenquist, Francoise Gilot and master printer Richard Royce.

Blum Helman

Blum Helman Gallery 20 W. 57th St., New York, NY 10019
(212) 245-2888 Tuesday-Saturday: 10-6 August: by appointment

A variety of artists from Europe and America show their art in this large, airy space which is ideally suited for large scale works. As to be expected, there is an emphasis on Post World War Two painters, many from the New York School. A concentration of works from the fifties and sixties are shown along with current works by some of the main protagonists of this movement.

Works from the West Coast also are shown, highlighted by those of renowned painter Richard Diebenkorn and Craig Kauffman. Sculpture, mostly large in scale, is often the subject of major one-man shows which the gallery mounts several times each year, often in conjunction with another gallery. Dominant among such shows are those concerning current works of Richard Serra, Bryan Hunt and Britisher Andrew Lord. Important works by a number of New York artists often find their way into the gallery, often in group shows, and it is not uncommon to encounter works by Jasper Johns, Frank Stella and Andy Warhol. Ellsworth Kelly's monumental canvases are frequently seen as well as those of Ron Davis, Edda Renouf and Hap Tivey. Showings of the works of Don Sultan and Steven Keister also take place.

Grace Borgenicht

Grace Borgenicht Gallery, Inc. 724 Fifth Ave., New York, NY 10019
(212) 247-2111 Tuesday-Friday: 10-5:30; Saturday: 11-5:30
July-August: closed Saturday

In 1951, painter Grace Borgenicht Brandt founded a gallery with the intention of providing a showcase for works by her artist friends. Today the gallery regularly exhibits the work of contemporary artists whose media and materials are as diverse as their styles.

Among the gallery artists are Milton Avery, Max Beckmann, David Lee Brown, Edward Corbett, Jose Luis Cuevas, Alan D'Arcangelo, Philip Grausman, Hans Hokanson, Angelo Ippolito, Reuben Kadish, David Lund, Gabor Peterdi, Leon Polk Smith, Mark Tansey and Sandy Walker.

Recent shows by gallery artists included painted aluminum and painted-wood works by Charles Biederman, which date from the past fifty years. Late works by action painter Paul Burlin, whose career spanned sixty-five years, are sparked by kinetic activity and explode with emotion. Still lifes by Stuart David from the 1920s, forged iron sculpture by Martin Chirino, recent stainless steel works by Roy Gussow, and the "rabid dog" works of Elbert Weinberg were among the gallery's exhibits. Paintings and pastels by Wolf Kahn are large-scale, quasi abstractions of intricately detailed forms such as barns, windows and sweeps of meadows. Stark, vertical panels recall classical architecture in the mature paintings of John Opper. Tiny colonies of figures populate the canvases of Attilio Salemme, suggesting architectural forms as well as human shapes. Jose de Rivera, who fashions by hand industrial metals into pure abstraction in sculpture, creates stainless steel, aluminum and bronze constructions.

An invitational exhibition, "Episodes," featured works by several younger artists. They included drawings of TV-screen images by Richard Jarden, paperback book-cover images by Walter Robinson, and works of smeared pencil and enamel on paper by Donald Baechler, depicting subjects such as pizza men and kitchen sinks. Also exhibited were absurdist paintings by Mark Tansey; mocking, monochrome works of dramatic incidents by Robin Tewes; pictures of people gesturing by Wonsook Kim; and familiar scenes acted on proscenium arches by Ida Applebroog.

Bryan Hunt, *Caryatid* (1980-81), 52" x 33" x 29", cast bronze on limestone base. Blum Helman Gallery.

Brewster

Brewster Gallery 41 W. 57th St., New York, NY 10019 (212) 980-1975
Tuesday-Saturday: 10-5:30 July: Monday-Friday: 10-5:30

The gallery has a selection of international twentieth-century paintings, drawings and graphics.

The collection of Latin American art, headed by famed Mexican sculp-

tor Francisco Zuniga, is strong. The gallery publishes the artist's lithographs (Brewster Editions) in addition to exhibiting his drawings. Zuniga is known for his expressive portrayal of Mexican Indian women, shown at home and in the market place, who embody larger truths of courage, endurance and serenity. Also available are works by Diego Rivera, Francisco Toledo, Rufino Tamayo and other Mexican masters, as well as works by some South American artists. Leonora Carrington, an English-born surrealist painter considered to be Latin American because of her long association with Mexico, is another artist exclusively represented by the gallery.

American artist Harry McCormick uses dramatic light and a rich, dark palette in his representational style. His series in oil of landmark New York restaurants has become quite well known.

The gallery also shows the colorful and imaginative works of the Yugoslavian naive painters, among them, Branco Bahunek, Ivan Generalic and Ivan Rabuzin.

One of the largest selections of Miro aquatints is found at the gallery. Other modern masters such as Chagall, Alexander Calder, Picasso and Marino Marini are also well represented in both unique and multiple works.

Andrew Crispo

Andrew Crispo Gallery 41 E. 57th St., New York, NY 10022 (212) 758-9190 Monday: closed; Tuesday-Friday: 10:30-4:30; Saturday: 9:30-5:30

The gallery is located on the second and third floors of the Fuller Building, an outstanding Art Deco building completed in 1929. The large exhibition space is appropriately designed for large-scale paintings and installations.

In 1973 when the gallery opened, an auspicious thematic exhibition, "Pioneers of American Abstraction," featured works by Oscar Bluemner, Stuart Davis, Charles Demuth, Arthur Dove, John Marin, Georgia O'Keeffe, Charles Sheeler, Joseph Stella and Max Weber. The following year, the gallery organized another thematic exhibition, "Ten Americans—Masters of Watercolor," with works by Charles Demuth, Arthur Dove, John Marin, Milton Avery, Charles Burchfield, Winslow Homer, Edward Hopper, Maurice Prendergast, John Singer Sargent and Andrew Wyeth. Another thematic exhibition "Twelve Americans, Masters of Collage" featured works by Dove, Frank Stella, Romare Bearden, Joseph Cornell, Robert Courtright, William Dole, Lee Krasner, Robert Motherwell, Robert Rauschenberg, Ad Reinhardt, Anne Ryan, and Tom Wesselman.

The gallery basically deals with nineteenth- and twentieth-century American art, with special emphasis on members of the Alfred Stieglitz group, which included Alfred Maurer, John Marin, Marsden Hartley, Arthur Dove, Max Weber and Georgia O'Keeffe.

Museum-quality works by European artists are also handled. Represented artists include Picasso, Juan Gris, Henri Matisse, Georges Braque and Gino Severini.

One-person exhibitions are often held by regular gallery artists. Sculptor Douglas Abdell works in bronze. Robert Courtright, whose paper collages in square format are reminiscent of architecture, also creates mask collages. Large photorealist scapes by David Ligare and works by visionary realist Lowell Nesbitt are also exhibited. Cynthia Polsky and Charles Seliger work in an abstract expressionist mode.

Tibor de Nagy

Tibor de Nagy 29 W. 57th St., New York, NY 10019 (212) 421-3780 Tuesday-Saturday: 10-5:30

After starting a marionette company with artists Jackson Pollock and Kurt Seligman, the owner was encouraged by some first generation Abstract Expressionists to open a gallery in 1950. Grace Hartigan, Helen Frankenthaler, Larry Rivers, Fairfield Porter and Al Leslie were then given one-person shows at the gallery.

Tibor de Nagy has always generated other art activities, such as

George Tooker, *Study for "Waiting Room"* (1981), 14" x 10", pencil on paper. Marisa del Re Gallery.

Donald Sultan, *Yellow Tulip, Nov. 10, 1981,* 98" x 48", plaster on tile. Blum Helman Gallery.

Jose Luis Cuevas, *Doble Autorretrato con Personajes* (1981), 24" x 36", gouache. Marisa del Re Gallery.

photography, exhibits, publications of poetry magazines and off-Broadway plays.

The gallery currently represents Frank Bowling, Ken Bowman, Rosemarie Castoro, Richard Chiriani, Ray Ciarrochi, Thom Cooney Crawford, Chuck Forsman and Maurice Golubov. Other represented artists include Ken Greenleaf, Harold Gregor, Andrew Hudson, Richard Kalina, Stephanie Kirschen-Cole, Chuck Magistro, Rafael Mahdavi and Dan Marshall. Also represented are Forrest Moses, Yvonne Muller, George Nick, Basilios Poulos, Archie Rand, Tony Robbin, Leatrice Rose, Joe Shannon, the estate of Horacio Torres, and Nancy Wissemann-Widrig. The gallery also carries works by Walter Darby Bannard, Stanley Boxer, David Budd, Robert Goodnough, Tom Holland, Darryl Hughto, Stephen Mueller, Kenneth Noland, Fairfield Porter, Larry Rivers and Sam Scott.

Marisa del Re

Marisa del Re Gallery 41 E. 57th St., New York, NY 10022
(212) 688-1843 Tuesday-Friday: 10-5:30; Saturday: 11-5:30
August: closed

The gallery is one of the leading galleries for art of the New York school. It handles exclusively the American masters of Abstract Expressionism, as well as the leading European masters of Surrealism and abstraction.

Among the gallery's renowned American artists are Alexander Calder, Willem de Kooning, Sam Francis, Helen Frankenthaler, Franz Kline, Morris Louis, Robert Motherwell, Richard Pousette-Dart, Mark Rothko and George Tooker.

Works by George Braque, Max Ernst, Giacomo Manzu, Andre Masson, Picasso and Antoni Tapies represent Marisa del Re's long-standing interest in the European masters of twentieth-century art.

The gallery officially represents the work of Richard Pousette-Dart and George Tooker, and presented important exhibitions of the American years of Andre Masson, the French Surrealist, and a major review of the recent paper works of the Spanish artist Antoni Tapies. Extensive and scholarly catalogues are regularly published in conjunction with major one-man shows.

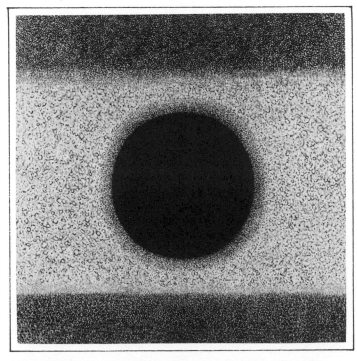

Richard Pousette-Dart, *Beyond Space* (1979-80), 90" x 90", acrylic on linen. Marisa del Re Gallery.

Sid Deutsch Gallery 20 W. 57th St., New York, NY 10019 (212) 765-4722 Tuesday-Saturday: 10-5:30 July-August: Tuesday-Friday: 1-5

The gallery specializes in primarily art of the twentieth century. Emphasis is on artists of "The Eight," the Stieglitz Group and W.P.A. artists, among others. Lithographs, prints and small-scale sculpture are also available. One-person exhibitions of work by contemporary artists are held at intervals throughout the season.

Gallery artists include realists Henry Koerner and Edmund Lewandowski, and impressionist Herman Rose. Among abstract painters are Esphyr Slobodkina, a founding member of American Abstract Artists, and Jacob Kainen, an Abstract Expressionist.

Abstract sculptors Rodger Mack and Oded Halahmy each exhibit work in cast bronze, and California-based Victor Royer shows totemic machine forms. Sculptor Jane Armstrong's stone works are of forms and figures derived from nature.

Color and geometry dominate in abstract compositions by California artist Sidney Gordin who works in both painting and sculpture. The drawings and sculptures of Paul Van Hoeydonck, the Belgian fantasist, can also be seen.

Terry Dintenfass Gallery 50 W. 57th St., New York, NY 10019 (212) 581-2268 Tuesday-Saturday: 10-5:30 June and July: Monday-Friday: 10-5:30

Exhibiting both well-established and lesser-known artists, the gallery emphasizes contemporary American art with a concentration on figurative works. Current shows are held in the larger of two rooms, while the smaller room is reserved for displaying paintings, drawings, prints and sculpture from the gallery's inventory.

The estates of Arthur Dove and Samuel Adler are handled. Paintings by Jacob Lawrence can also be seen. Sepia chalk drawings by Herbert Katzman are romantic in mood, and pen and ink drawings by Edward Koren reveal work on the lighter side. Sidney Goodman's paintings show figures against a detached surrealistic landscape. Paintings by Robert Gwathmey, which rely heavily on color and simplified forms, usually depict Southern scenes involving social commentary. Inside the painted hardware and cloth cages by Donald Sandstrom are miniature buildings depicting actual places that the artist has visited.

The gallery also represents Will Barnett, Hyman Bloom, Peter Blume, Tony Dove, Antonio Frasconi, Elias Friedensohn, Suzi Gablik, John Himmelfarb, Frances Hynes and William King. Other gallery artists are Irving Kriesberg, Ronald Markman, Richard Merkin, Robert Andrew Parker, Paul Suttman, Carl Nicholas Titolo, and Harold Tovish.

Andre Emmerich Gallery 41 E. 57th St., New York, NY 10022 (212) 752-0124 Tuesday-Saturday: 10-5:30 Summer: Monday-Friday: 10-5

The gallery carries a number of foremost Abstract Expressionist and color-field painters. It represents essentially the same artists as its uptown sister facility, but focuses on works of a larger scale. Two one-person shows run concurrently and change every month.

Artists' estates represented are those of Jack Bush, Burgoyne Diller, John Graham, Hans Hofmann, Frederick Kiesler, Morris Louis and John McLaughlin. Works by Milton Avery, Robert Motherwell and Frank Stella can also be found.

Among the artists represented exclusively by the gallery are Piero Dorazio, Italy's leading color abstractionist; color-field abstractionist Helen Frankenthaler; and English figurative painter David Hockney. Hans Hofmann, founding father of the New York Abstract Expressionist movement, and Morris Louis, a leading figure in the color-field movement, are also represented. Other gallery artists include geometrical abstractionist Al Held; California-based painter Sam Francis; English sculptor Anthony Caro, who works in steel and bronze; and painter

Alexander Lieberman, who also sculpts in bronze and steel.

Also exclusively represented by the gallery are Swiss sculptor Raffael Benazzi, who works abstract forms in wood; color abstractionist Stanley Boxer; Canadian color-field painter Jack Bush; geometrical abstractionist Burgoyne Diller; John Graham, who does figurative drawings and paintings; and Frederick Kiesler, whose paintings and sculpture reflect visionary architecture. In addition, there are works by geometric abstractionis John McLaughlin; Ben Nicholson, a leading English painter of figurative and abstract forms; and color-field abstractionists Kenneth Noland and Jules Olitski. Other represented artists include Beverly Pepper, who creates iron and steel, and site sculpture; color abstractionist Larry Poons; sculptor Michael Steiner, who works abstractly in steel and bronze; Sylvia Stone, who does glass, plexiglass and paper sculpture; and abstract sculptor and painter Anne Truitt.

Rosa Esman

Rosa Esman Gallery 29 W. 57th St., New York, NY 10019 (212) 421-9490 Tuesday-Saturday: 10-5:30 July: closed Saturday; August; closed

The gallery specializes in contemporary avant-garde, or post-Modernist, art and architectural drawings that are predominantly, but not exclusively, American. Also featured are Russian avant-garde works from 1912 to 1928 and other works of the 1920s from Europe and the United States.

Among gallery artists, David Diao paints large, geometric abstractions in bold colors. Jean Feinberg's oil paintings on panel explore the nature of the frame with abstract shapes that move in and out of the picture surface. Ed Kerns uses acrylic, canvas and plywood to build torn and scarred surfaces resembling old walls or archaeological sites. Patricia Johanson makes landscape/earth sculptures based on organic forms and Lizbeth Mitty uses poured acrylic paint to evoke banal domestic interiors. Tom Nozkowski's small oil paintings have abstract forms that allude to the natural world.

Thomas Rose's large paintings involve objects in collage and perspective illusions. Hanne Tierney makes marionettes, which she uses in performance, and Ursula von Rydingsvard evokes metaphorical or psychological states in carved cedar sculptures. The gallery also exhibits rug designs of the 1920s from the estates of Eileen Gray; works by Jan Muller, a figurative expressionist painter of the 1950s; and architectural drawings by Louis Kahn and Stanley Tigerman.

Frank Fedele

Frank Fedele Fine Arts, Inc. 42 E. 57th St., New York, NY 10022 (212) 371-0204 Tuesday-Saturday: 11-5

Having been in the publishing business fourteen years, the director recently opened his own commercial space. Works shown at the gallery represent a selection of contemporary sculpture, painting and graphics by international artists.

Among recently featured prints were signed and numbered lithographs from the *Jazz Portfolio* by famous jazz musicians Art Blakey, Ron Carter, Bob Moses and Lenny White. Serigraphs by Benny Andrews present a poetically invented glimpse of nature. Swedish-born Seri Berg works toward simplicity in her embossed etchings, using elemental white shapes on stark black backgrounds. Serigraphs by Venezuelan Rafael Bogarin use geometric shapes and color vibrations to produce geometric "chamber music." He also paints and recently produced a handmade book.

A young painter who works in the American realist tradition, Jon Carsman showed serigraphs that are brightly colored, high-contrast portraits of rural America. Serigraphs by R. J. Christensen are elusive, romantic portraits of nature that approach the abstract, with flowers almost always at the heart of his themes. John Clift's new serigraphs take their inspiration from the American whirligig. Juan Echogoyen's broad knowledge and use of color give his serigraphs an immense solemnity in

Horacio Torres, *Reclining Nude on Pink Background* (1975), 64″ x 92″, oil on linen. Tibor de Nagy Gallery.

Al Held, *M's Passage* (1980), 9½″ x 16″, acrylic on canvas. Andre Emmerich Gallery.

feeling. Social realist Riva Helfond prints her own lithographs, which are stark and dramatic in their subject matter. The gallery also publishes graphics by Jean-Marie Haessle, Budd Hopkins, Risaburo Kimura, Neil Korpi, Hank Laventhol, Mashiko, Bob Pardo, Helen Rundell, Mario Toral, Tom Vincent and Diane Williams, among others.

Fischbach

Fischbach Gallery 29 W. 57th St., New York, NY 10019
(212) 759-2345 Tuesday-Saturday: 10-5:30

The gallery concentrates on paintings, primarily by contemporary American painterly realists whose subjects are generally landscapes and still lifes. The main exhibition space is large with huge, portable viewing panels mounted on the walls that allow the paintings to dominate the space. Shows change every month.

Jan Freilicher and Nell Blaine are perhaps the best known artists represented by the gallery. Freilicher's style is loosely realistic, while Blaine is even more impressionistic. Both mainly work on landscape, with a secondary emphasis on still life. Maurice Grosser has specialized for over fifty years in subdued, impressionistic landscapes of Europe and Morocco, where he lives and works, and also paints still lifes. Jane Wilson's still lifes are well known in the New York art community. Susan Shatter's landscape paintings were recently shown, in addition to her works on paper earlier exhibited. Leigh Behnke also shows works on paper at the gallery. Realist works by Elizabeth Osborne, cityscapes by John Button, acrylic paintings by Ian Hornar and egg tempera paintings by Philip Tarlow are also featured by the gallery. In addition, sculpture by Anne Arnold, which uses wood armatures and stretched and painted canvas, depicts animals.

Montezin, *Le Helage a St. Mammes,* 28" x 24", oil on canvas. Wally Findlay Galleries.

Lilian MacKendrick, *Interior Armchair and Book,* 36″ x 30″, oil on canvas. Wally Findlay Galleries.

Wally Findlay

Wally Findlay Galleries 17 E. 57th St., New York, NY 10022
(212) 421-5390 Monday-Saturday: 10-6

Though the gallery still bears the name of its founder, it is now separate from the Findlay chain, however it continues to show works by American and European contemporaries and works of French Impressionists and Post-Impressionists. Exhibitions vary from one-person shows to surveys of French masters.

The most impressive paintings are rare Impressionist works by Claude Monet, Auguste Renoir, Maurice de Vlaminick, Maurice Utrillo and several others. Contemporary European artists include Yoland Ardisonne, Philippe Auge, Andre Bourrie, Rodolfo Dotti, Louis Fabien, Bernard Gantner, Claude Gaveau, Andre Hambourg, Le Pho, Camille Lesne and Michel-Henry among many others.

Recently the gallery has concentrated on developing a special collection of works by living American painters, such as portraitist Zita Davisson, Loren Dunlap, Ron Ferri, Gregory Hull, Oliver Johnson, Lillian MacKendrick, Eleanor Meadowcroft, Clyde Smith, Richard Stark and Carol Wald, in addition to Fred Jessup, an Australian painter. Popular Canadian painter David Holmes creates quiet scenes of the outdoors. Brad Shoemaker, an American realist, also shows his landscapes and still lifes. Other American works include those of George Elmer Browne, an impressionist who painted during the early part of the century.

Some international relationships have developed under the new ownership which include representation of many artists from the People's Republic of China. A special show is being arranged for painters of the Jenshan County Commune and a separate show will take place for Chen Yifei. Tapestries from Senegal are also shown.

Allan Frumkin

Allan Frumkin Gallery 50 W. 57th St., New York, NY 10019
(212) 757-6655 Tuesday-Friday: 10-6; Saturday: 11-5
Mid-August: closed

The gallery shows a varied group of contemporary American artists ranging from the very realistic to the wildly imaginative. The realist artists include Philip Pearlstein, whose compositions with nude figures have been exhibited here for over twenty years, and Jack Beal, whose paintings tend toward vivid colors and baroque compositions. Alfred Leslie paints monumental figures often several times life size and is known for vigorous drawings. Recently the gallery has taken on two other outstanding young realist artists, William Beckman and James Valerio.

The gallery has a strong group of West Coast artists whose work tends toward the more imaginative. Perhaps best known is William T. Wiley, whose works are in many American museums. Also well known is Robert Arneson, whose ceramic sculpture was recently featured at the Whitney Museum. Among other West Coast artists showing here are Joan Brown, Roy De Forest and Robert Hudson, all of whom work in the Bay Area. Most recently the gallery has started showing the Texas sculptor James Surls, whose large and dramatic wood sculptures echo the Southwest.

The gallery presents about ten shows a year and often does thematic exhibitions. A forthcoming show is a big two-part exhibition of self-portraits, which will include almost all the gallery artists as well as many invited guests. There is an annual summer exhibition which shows a cross-section of the gallery's stable and often features high-quality works on paper and figure drawings, as many gallery artists are outstanding draughtsmen.

Getler Pall

Getler Pall 50 W. 57th St., New York, NY 10019 (212) 581-2724
Tuesday-Saturday: 10-5:30 July & August: closed Saturday

Formerly private dealers, the owners opened their gallery to the public in 1975. Having emphasized major American and some European, graphic artists, the gallery has expanded its focus to include paintings,

David Holmes, *Fisherman's Toil* (1977), 22" x 32", tempera. Wally Findlay Galleries.

James Surls, *Calling Home* (1981), 107" x 40" x 32", wood. Allan Frumkin Gallery.

Robert Arneson, *Pablo Ruiz with Ache* (1980), 87½" high, glazed ceramic. Allan Frumkin Gallery.

drawings and graphics by both major American and younger, emerging artists.

Works by the gallery's emerging artists are essentially abstract. Charlotte Brown uses a 3M color computer machine to transfer images to various media. Richard Carboni works in mixed media, primarily on paper. Caroline Greenwald is a leading American paper maker. David Shapiro and Steven Sorman are both well known for works on canvas and paper.

Getler/Pall continues to exhibit the prints of major American and European artists. Recent shows featured Jim Dine, David Hockney, Jasper Johns, Roy Lichtenstein, Robert Rauschenberg, Frank Stella and others. The gallery also shows prints of its younger, emerging artists.

Although most represented artists are abstract painters, the gallery's graphics are both abstract and figurative, notably works by Jim Dine, David Hockney and Roy Lichtenstein.

The gallery consists of two rooms, a large space for the main exhibition, which regularly changes, and a smaller one for prints. The gallery also sends out regular mailings and a newsletter, and sells publications that document the work of gallery artists.

Grand Central

Grand Central Art Galleries 24 W. 57th St., New York, NY 10019 (212) 867-3344 Monday-Friday: 10-6

Founded in 1922 by American artist John Singer Sargent, the gallery shows international paintings and sculpture that range from turn-of-the-century American works to the contemporary.

Most of the two-dimensional works tend to be representational with a strong emphasis on landscape, figure painting and still life. Among contemporary artists represented are Priscilla Roberts, Charles Pfahl, Thomas A. Daly and David A. Leffel.

Another facet of the gallery is the display of works by American masters, including the Impressionist painters Edmund Greacen and John Singer Sargent as well as other turn-of-the-century Realists.

The gallery also contains sculpture by American artists, which tends to be in the realist vein, and a certain amount of Western art, including the works of Olaf Carl Seltzer, Olaf Wieghorst and others.

Hamilton

Hamilton Gallery 20 W. 57th St., New York, NY 10019 (212) 765-5915 Tuesday-Saturday: 10-5:30 July: varied hours; August: closed

The gallery exhibits painting, sculpture and drawing by mainstream contemporary American artists. Among the twelve artists represented, abstract painting and formal sculpture predominate, with an emphasis on contemporary surrealism. Each year's schedule includes curated theme shows, such as "Bronze" and "The Abstract Image."

Among one-person exhibits, recent work by figurative painter Joan Snyder contains anthropological imagery. The shieldlike, shaped canvases on three-dimensional stretchers by Ron Gorchov are studies in bilateral symmetry. John Torreano's faceted glass jewels show up in paintings, columns and cruciforms. Contemporary surrealist painter Susan Hall employs personal imagery in her work. A show of paintings by surrealist David Hare included his works of the past five years. Michael David, who works off political symbols, makes abstract paintings from forms such as crosses, swastikas and Greek keys. Paintings and drawings by the young artist Auste employ wraiths, spirits and the macabre. John Willenbecher's constructions are created with faux marble and gold leaf.

Sculptor Walter Dusenbery works in stone, using classical architectural elements. Robert Murray's formal sculpture is made of aluminum and steel in curvilinear and organic shapes. Figurative bronze sculptures by Martin Silverman combine concerns of social realism with the New Image content. Isaac Witkin also works in bronze, making expressionistic, generally nonconstructivist sculpture, which reflects a more personal vision.

Joseph Hirsch, *Woman Listening,* 6″ x 2½″, dead matte lithograph. Kennedy Galleries.

Hammer

Hammer Galleries 33 W. 57th St., New York, NY 10019 (212) 644-4400 Monday-Friday: 9:30-5:30; Saturday: 10-5 June-August: closed Saturday

Established in 1928, the gallery specializes in nineteenth- and twentieth-century European and American paintings, as well as contemporary paintings and graphics. There is an extensive collection of Impressionist and Post-Impressionist canvases, in addition to other representational works. Furthermore, there is a separate room housing works of the American West. The gallery, which comprises six floors of exhibition space, presents fifteen to twenty exhibitions every year, including approximately ten one-person shows.

The French collection contains works by Auguste Renoir, Eugene Boudin, Berthe Morisot, Henri Fantin-Latour, Maurice de Vlaminck and Maurice Utrillo. The American collection features the works of Eastman Johnson, Jasper Cropsey, John Singer Sargent, Martin Johnson Heade, Maurice Prendergast, William Glackens and the estate of William Horton. In addition to showing works from the estates of Grandma Moses and Rockwell Kent, the gallery represents contemporary American artists Eric Sloane, LeRoy Nieman, Bob Timberlake, Peter Ellenshaw and David Armstrong. The graphics collection includes rare original prints by LeRoy Nieman, Andrew Wyeth, Miro and Chagall. In addition, there are limited edition graphics published by Hammer Publishing Company, including the unique works of Eyvind Earle and G. H. Rothe.

Lillian Heidenberg

Lillian Heidenberg Gallery 50 W. 57th St., New York, NY 10019 (212) 586-3808 Tuesday-Friday: 10-5:30; Saturday: 11-5:30

The gallery has always shown a variety of international artists working in many media, including sculpture, graphics, painting and works on paper. All work shown is from the nineteenth and twentieth centuries by European and American artists.

The Heidenberg Gallery deals extensively in the work of contemporary masters. These include Henry Moore graphics and sculpture, Fernando Botero paintings and works on paper, Frank Stella paintings, Robert Natkin paintings and graphics, Alice Baber watercolors and oils, Yrjo Edelman oils and graphics, and James Coignard mixed-media originals and graphics.

The gallery is also strong in works by nineteenth- and twentieth-century European masters. They include Henri Matisse, Hans Arp, Pierre Bonnard, Camille Pissarro, Picasso and others.

Young contemporary artists handled by the gallery include Gary Kahn, who does sculpture in geometric forms using wood and steel, and Jim Reed, who paints directly on film or incorporates photos into canvas paintings. Jim Youngerman does watercolors in a naive and surrealistic manner, occasionally reinterpreting master paintings. George Chemeche is a painter originally from the Middle East whose work is based on Byzantine mosaics and Persian manuscripts.

Iolas-Jackson

Iolas-Jackson Gallery 52 E. 57th St., New York, NY 10022 (212) 755-6778 Tuesday-Friday: 10-5:30; Saturday: 11-5 August: closed

Formerly the Brooks Jackson Gallery Iolas, the gallery previously specialized in Surrealist painters, such as Rene Magritte, Echaurren Matta, Man Ray, Max Ernst and Victor Brauner, as well as contemporary European artists, such as Niki de St. Phalle, Jean Tinguely, Yves Klein and Fernand Leger. Now more eclectic, the gallery shows young, emerging New York artists in addition to the established, more well-known artists.

Aside from works by modern masters, the gallery has paintings and drawings by Harrison Burns, whose still frames appear to be taken from video screens in various stages of disruption or interference. Paul Thek's conceptual installations, small poetic paintings and bronze sculptures incorporate universal themes and create a narrative quality. Sculpture

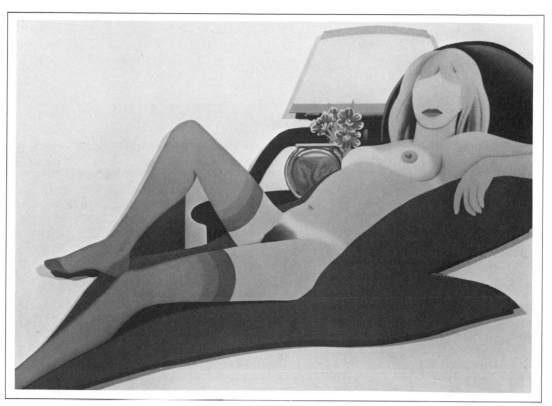

Tom Wesselmann, *Stocking Nude with Fish Bowl* (1982), 48″ x 66″, oil on canvas. Sidney Janis Gallery.

Fernand Leger, *Le Jongleur et La Danseuse* (1954), 37½″ x 50½″, oil. Sidney Janis Gallery.

by Greek artist Takis, who uses large electromagnets and polarities, works with sound. Paintings by Marina Karella involve drapery, usually white on white, and her sculpture of polystyrene resin also uses drapery and human forms. Michael Vivo's graphite and color renderings of fabrics are large still lifes. "Inscapes" by Ed McGowin are public art proposals that use sculpture with interior narrative tableaus, sometimes accompanied by airbrushed drawings and paintings of the proposals. Italian artist Mattiacci creates conceptual installations that center around sound and usually respond with the viewer.

Sidney Janis

Sidney Janis Gallery 110 W. 57th St., New York, NY 10019 (212) 586-0110 Monday-Saturday: 10-5

The gallery has exhibited three generations of leading artists of the twentieth century, who represent a range of artistic movements, namely, Cubism, Futurism, Dadaism, Surrealism, Abstract Expressionism, Pop and Minimal Art. It now focuses on contemporary art of different directions.

Major group shows and retrospectives have included the works of Picasso, Fernand Leger, Piet Mondrian, Kurt Schwitters, Paul Klee, Alberto Giacometti, Constantin Brancusi and Hans Jean Arp. In addition there have been one-person exhibitions of postwar American abstract painters, such as Josef Albers, Willem de Kooning, Arshile Gorky, Adolph Gottlieb, Franz Kline, Robert Motherwell, Jackson Pollock and Mark Rothko.

The gallery has specialized in theme shows over the years. Among them was one of the first important Pop Art shows, entitled "New Realists," which included Jim Dine, Claes Oldenburg, Andy Warhol, Roy Lichtenstein, James Rosenquist, Tom Wesselmann, George Segal, Marisol, Arman and Oyvind Fahlstrom.

Sidney Janis Gallery was one of the first to exhibit works by super-realist painters Duane Hansen, Richard Estes and Malcom Morley. There have also been exhibits of artists including Victor Vasarely and Bridget Riley. Other major abstract artists exhibited here are Robert Ryman, Robert Mangold and Ellsworth Kelly.

Since the mid-1960s, another vein of interest has been film and still elements in art. The gallery's exhibit "Homage to Marilyn Monroe" included a unique multi-media room. The show "Artist and the Photographer" displayed photographs of famous artists by equally well-established photographers. Gallery photographers include Duane Michaels and Gisele Freund.

The gallery also publishes prints and editions of its artists' work.

Vija Celmins, *Desert-Galaxy* (1939), 17¼" x 38", graphite on acrylic ground on canvas. David McKee Gallery.

Jacobson/Hochman Gallery 24 W. 57th St., New York, NY 10019
(212) 581-8346 Tuesday-Saturday: 10-6

Though not large in its physical size, it would be difficult to find many galleries more international in scope. It is affiliated with Bernard Jacobson Ltd. of London, Atlanta and Los Angeles. Polish-born director Irene Hochman shows an array of European and American sculpture, painting and prints.

Chief among the gallery's artists are Robyn Denny, a geometric-format colorist who specializes in subtle color and soft geometric forms. William Tillyer's prints, watercolors and constructions depict still lifes and landscapes. Also shown are the works of abstract artists Howard Hodkin and Edward Rusch who shows his paintings and drawings. Richard Smith's structured paintings are found as well as the works of Ivor Abrahams. There are also a variety of etchings available by two frequent gallery artists, Michael Heindorf and Frank Auerbach.

A good selection of British prints is always available which the gallery acquires through its British affiliate which publishes them. Works by a number of renowned artists are found as well including those of David Hockney, Henry Moore and Edwin Moses. Others to be found are Peter Blake, Stephen Buckley, Patrick Caulfield, John Hoyland, Andrew Johnson, Eduardo Paolozzi, Ludwig Sander, William Tucker, John Walker, Victor Willing and William Willis.

Kennedy Galleries 40 W. 57th St., New York, NY 10019 (212)
541-9600 Monday-Friday: 9:30-5:30 August: closed last two weeks

Kennedy Galleries deals in eighteenth-, nineteenth-, and twentieth-century American paintings, watercolors, sculpture and drawings.

The gallery exclusively represents Leonard Baskin, Allen Blagden, Colleen Browning, Jose de Creeft, Ruth Gikow, Lorrie Goulet, William Harper, Joseph Hirsch, Jack Levine, John Marin, Carolyn Plochmann, Millard Sheets and Frank Wright. It also exclusively represents the estates of Charles E. Burchfield, Marvin Cherney, John Steuart Curry, Walt Kuhn and Abraham Rattner.

The gallery specializes in works by twentieth-century American artists. They include Ivan Albright, George Bellows, Stuart Davis, Charles Demuth, Arthur G. Dove, Lyonel Feininger, Marsden Hartley, Childe Hassam, Edward Hopper, George Luks, Reginald Marsh, Walter Murch, Georgia O'Keeffe, Maurice Prendergast, Charles Sheeler and John Sloan.

The major eighteenth- and nineteenth-century American artists featured in the gallery include Albert Bierstadt, William Merritt Chase, Frederic E. Church, John Singleton Copley, Thomas Eakins, William Harnett, Martin Johnson Heade, Winslow Homer, John Frederick Kensett, the Peale family, John Singer Sargent, Gilbert Stuart and Worthington Whittredge among others.

Kornblee Gallery 20 W. 57th St., New York, NY 10019 (212) 586-1178
Tuesday-Friday: 10-5:30; Saturday: 11-5

Showing a variety of contemporary art, the gallery tends to concentrate on American painters and a small number of Europeans. Some sculpture and works on paper are shown.

Most of the painters work in representational modes, the most notable exception being the work of Robin Bruch. Randi Stevens does large scale whimsical figures. Billy Sullivan also works with large scale canvases, utilizing pastels to achieve a higher degree of realism. His works are figurative in nature, often depicting sports themes. One also finds the watercolors of Hitch Lyman, the works of Donn Moulton and those of contemporary Italian Giancarlo Neri. Paul Linfante who had formerly worked largely with portraits is now showing his more recent fruit series, highly realistic and luscious. Aristodemos Kaldis who paints Aegean

landscapes is represented by the gallery. Occasional works of W. Lewis Jones are also found.

Jill Kornblee, the gallery's director, tends toward sculpture that is architectural. Bruce Montheith's architectural slices are shown as well as Alexander Hollweg's constructions. Gary Kulak's welded steel pieces are also found among the gallery's offerings.

Kraushaar

Kraushaar Galleries 724 Fifth Ave., New York, NY 10019
(212) 307-5730 October-May: Tuesday-Saturday: 9:30-5:30; June-September: Monday-Friday: 9:30-5:30

Founded in 1885, the gallery is the third oldest gallery in New York. It specializes in the works of twentieth-century American artists.

The gallery handles paintings, drawings and sculpture by artists of the early twentieth century, such as the estates of William Glackens, John Sloan, Jerome Myers, Gifford Beal and Robert Laurent, as well as by artists of the 1930s and 1940s, such as the estates of Louis Bouche and Henry Schnakenberg. Also represented are selected works in all media by artists such as Alfred Maurier, Marsden Hartley, John Marin, Arthur Dove, George Luks, Guy Pene duBois, Maurice Prendergast and other artists.

Contemporary artists exhibited by the gallery include Andree Ruellan, Peggy Bacon, William Kienbusch, Karl Schrag, John Koch, John Heliker, John Hartell and Carl Morris. Other contemporaries are Linda Sokolowski, Jerome Witkin, David Cantine and Ben Frank Moss.

Light

Light Gallery 724 Fifth Ave., New York, NY 10019 (212) 582-6552
Tuesday-Friday: 10-6; Saturday: 11-5 Summer: Tuesday-Friday: 11-5

The gallery exclusively represents contemporary photographers. Among the artists included in its inaugural exhibition over ten years ago were Harry Callahan, Aaron Siskind, Emmet Gowin, Thomas Barrow, Frederick Sommer and Michael Bishop, who continue to be represented by the gallery.

The gallery currently represents thirty-six artists. The core group of artists remains virtually the same, however, each year a number of important new photographers are taken on. Most recently, works by Mark Klett and Leo Rubenfein have become part of the gallery's permanent collection. Other new photographers shown included Rosalind Solomon, Vicki Ragan, Sage Sohier and Korinne Bronfman, among others.

The photographers represented display a diversity of styles and subject matter. Arnold Newman, Nicholas Nixon and Frederick Sommer do portraits. Larry Fink's photographs of people, many strangers, are done in a social documentary mode, as are those of Garry Winogrand, who captures the pretenses of urban life, often with a sense of humor. Robert Heinecken, whose controversial work expresses his social stance, reveals the changing conditions of human life through his art.

Landscapes are photographed by Frank Gohlke and Emmet Gowin, who also uses his family as subject matter. Prints by photographer-filmmaker-painter William Klein, who does landscapes and cityscapes of places all over the world, reveal a filmmaker's sense of motion, time and space. Thomas Barrow works in an abstract, experimental mode. Aaron Siskind, whose early work in the 1930s was documentary in style, focuses on abstract images in the environment.

One of the pioneers of color photography, Stephen Shore does cityscapes along formal lines. Sun prints by Linda Conner are gold-tone photographs on printing-out paper.

On a semiannual basis, one of the gallery's directors will curate a major exhibition outside the parameters of the work represented by the gallery. Shows, which travel, have included a history of photographic ideas at Chicago's Institute of Design, photographs made with Polaroid's very large format camera, and NASA photographs made on the Apollo moon missions.

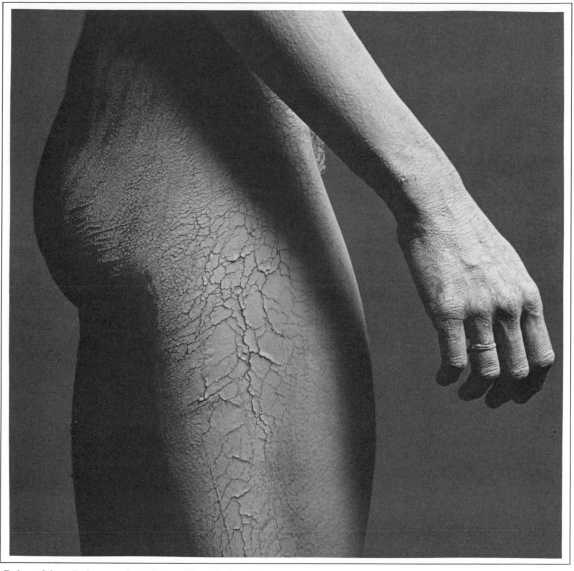

Robert Mapplethorpe, *Lisa Lyon, New York, 1982*, 16" x 20", silverprint. Robert Miller Gallery.

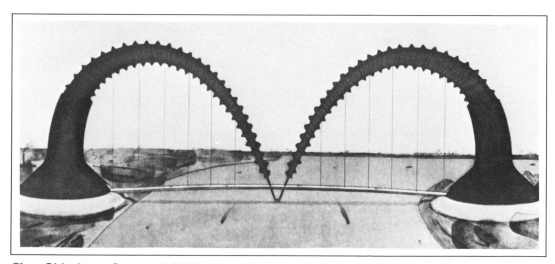

Claes Oldenburg, *Screwarch Bridge,* State II. 31" x 58" color etching/aquatint. Multiples/ Marian Goodman Gallery.

Kathryn Markel

Kathryn Markel Gallery 50 W. 57th St., New York, NY 10019
(212) 581-1909 Tuesday-Saturday: 10-5:30

The gallery specializes in unique works on paper as well as artists' books. Most of the work is done by emerging artists in watercolors, collage, oil or acrylic on paper. The gallery also handles paper constructions.

Artists represented by the gallery include Barton Lidice Benes, who works with rubber stamps and collage; Susanna Briselli, who does hand-colored photographs; and Stephanie Brody Lederman, who uses objects, paint and crayon in mixed-media works. Other gallery artists are Jim Risser, who works with mixed media on paper; Takako Yamaguchi, who does large, decorative oriental images on paper; and Ellen Frances Tuchman, who uses paint and beads on paper. Pat Lasch makes cut-paper assemblages with paint, and Bryan Harrington creates collages.

In addition to works on paper, the gallery carries artists' books, unique as well as editions. The books of Frances Hamilton, Bernard Maisner, Roz Chast, John Eric Broaddus and Bill Giersbach can be seen.

The gallery also carries works on paper for corporations and businesses. Works are mostly abstract and are by relatively unknown artists.

Marlborough

Marlborough Gallery 40 W. 57th St., New York, NY 10019 (212) 541-4900 Monday-Friday: 10-5:30; Saturday: 10-5 Mid-June-Labor Day: closed

With main branches in London and New York, the gallery represents major nineteenth- and twentieth-century, as well as contemporary, artists. Living artists include Francis Bacon, Larry Rivers, Alex Katz, Rufino Tamayo, Fernando Botero, Red Grooms, Ron Kitaj, James Rosati, Neil Welliver and Henry Moore. Also represented are the estates of Jacques Lipchitz, Barbara Hepworth, Kurt Schwitters, Oskar Kokoschka and Graham Sutherland. Important works by Impressionists Edgar Degas and Claude Monet, among many others; Post-Impressionists Paul Cezanne and Vincent Van Gogh; and other modern masters, including Picasso, Georges Braque, Alexander Calder, Fernand Leger and Constantin Brancusi, are also available. Postwar American artists represented by the gallery include Jackson Pollock, Clyfford Still, David Smith, Ad Reinhardt, Adolph Gottlieb and Mark Tobey.

The gallery regularly holds photographic shows that have featured well-known artists such as Irving Penn, Eugene Atget, Brassai, Berenice Abbott and Bill Brandt. The graphics division, constituting a mini-gallery, offers numerous works by Red Grooms, Alex Katz and Rufino Tamayo, among many other prominent artists.

One or more exhibitions, accompanied by a catalogue, are scheduled approximately every month. The beautiful sculpture terrace is used to exhibit monumental works.

Pierre Matisse

Pierre Matisse Gallery 41 E. 57th St., New York, NY 10022 (212) 355-6269 Tuesday-Saturday: 10-5 July-August: closed

The younger son of artist Henri Matisse, Pierre Matisse established the gallery in 1931 at the Fuller Building, its present location. The gallery opened with a roster of avant-garde painters of the period who have become classics, and has continued to represent artists with striking individual styles.

The gallery is the principle representative of painters Miro and Chagall and sculptor Albert Giacometti. Works by Balthus, including his paintings of brooding adolescents, are also available. British artists Raymond Mason and Reg Butler are also represented. Mason's epoxy and acrylic dioramas in small boxes depict colorful, crowded urban scenes such as "Les Halles," the Parisian food market. Butler's bronze sculptures of young females done in the 1950s and 1960s stem from the classical tradition. His more recent pieces display greater detail, such as strands of hair and painted features, which creates an amazing lifelike

Edgar Buonagurio, *Decoy* (1982), 120″ x 84″, acrylic on canvas. Andre Zarre Gallery.

effect. The gallery also shows work by Wilfredo Lam, Echaurren Matta and Yves Tanguy as well as Jean Dubuffet and Marino Marini.

Members of "El Paso," a group founded in Madrid in 1957, are also represented. Included are Manolo Millares, who works with heavy textures in torn, spotted and sewn canvases; Antonio Saura, an Abstract Expressionist who executes figurative images with brutal, powerful strokes; and Manual Rivera, who works with wire and metallic screenings to produce intricate, weblike sculptures.

Color abstraction characterizes the works of French painters Jean Paul Riopelle, Simon Hantai and Francois Rouan. Riopelle's paintings are dark-colored mosaics that suggest early twentieth-century Synchronism, while Rouan's works show many tiny squares of pastel colors in a tighter, rectilinear framework. Hantai achieves brilliant effects by covering the entire canvas with bright blue and orange leaflike interiors and landscapes. Loren MacIver, an American painter of great delicacy and sensitivity, has been with the gallery since 1940.

David McKee

David McKee, Inc. 41 E. 57th St., New York, NY 10022
(212) 688-5951 Tuesday-Saturday: 10-5:30 August: closed

The gallery represents established contemporary artists and has strong affinities with the postwar American school. High-quality works are shown by artists such as Robert Motherwell, Clyfford Still, David Smith and Francis Bacon. A group exhibition of postwar American artists is held annually. The estates of Franz Kline and Philip Guston are also handled by the gallery.

Recent one-person exhibitions included the works of Vija Celmins, whose graphite drawings of seas, galaxies and deserts are shown with her actual objects, which might include giant erasers or combs. Works by Katherine Porter employ circular forms, such as tornadoes, moons and spirals, in daring, strongly colored compositions. Sculpture of steel and stone by Jim Huntington strives to retain the natural poetry of the materials themselves.

Loren Madsen's gallery installations incorporate heavy materials suspended on wires; the light plays on the wires, and the whole gives the appearance of threat and imbalance. Madsen has done several commissions for public spaces using bricks, granite, wood and other materials. Paintings by Harvey Quaytman integrate color and light within a tightly controlled, sometimes eccentrically shaped canvas. Jake Berthot's paintings incorporate earth tones and muted colors that show little contrast and give off a mystical quality.

Midtown

Midtown Galleries 11 E. 57th St., New York, NY (212) 758-1900
Tuesday-Saturday: 10-5:30 June-September: Monday-Friday: 10-5:30

Established in 1932, the gallery has always promoted the works of contemporary American artists. Emphasis is on drawings, paintings, prints and sculpture in the mainstream of American art. Artists who had their first exhibition at the gallery's inception have continued with the gallery, so that fifty years later the gallery still retains some of its original members. Some of the most notable of these artists are Isabel Bishop, Paul Cadmus, William Thon, Philip Guston and Philip Evergood.

Among contemporary figurative artists represented is Isabel Bishop, who recently had a retrospective show of her delicate and subtle graphics and oils. Waldo Pierce and Maurice Friedman recently had retrospective shows during the gallery's fiftieth anniversary exhibition. The estate of Waldo Pierce is also handled by the gallery.

Monthly exhibitions occupy two rooms, while another room is devoted to a sampling of works by gallery artists. They include Cadmus, known for his grotesque caricature paintings, impressionist landscape painter William Palmer, Emlyn Etting, Margaret Varga and sculptor Fred Myers.

Philip Guston, *City Limits* (1969), 77″ x 103″, oil on canvas. David McKee Gallery.

Katherine Porter, *I am an American . . . Uneasy Dream* (1981), 91″ x 91″, oil on canvas. David McKee Gallery.

Brad Shoemaker, *Bentwood,* 28″ x 22″, watercolor. Wally
Findlay Galleries.

Andre Masson, *Combat Legendaire* (1943), 30″ x
22″, pastel on paper. Marisa del Re Gallery.

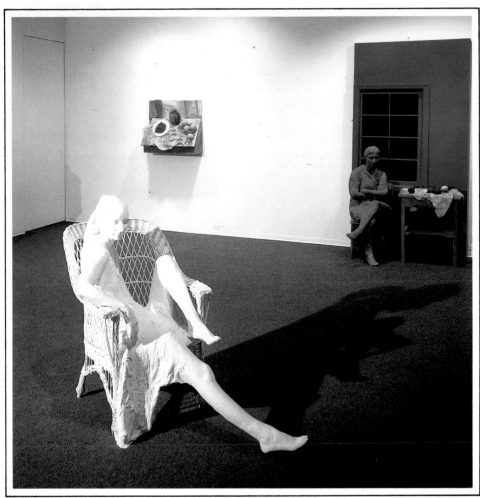

George Segal, *Installation View* (1982) at Sidney Janis Gallery.

Howard Kanovitz, *If it Be* (1981), 78″ x 118″, acrylic on canvas. Alex Rosenberg Gallery.

Michael Loew, *May* (1981), 32″ x 24″, acrylic and watercolor on linen. Marilyn Pearl Gallery.

Dee Shapiro, *Rotunda III* (1980), 40″ diameter, acrylic on canvas. Andre Zarre Gallery.

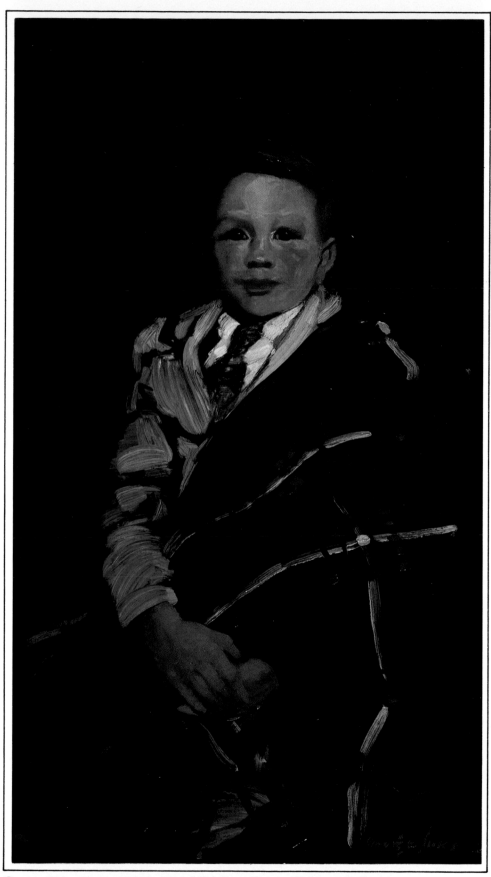

George Luks, *Danty* (1915), 40″ x 24″, oil on canvas. Hammer Galleries.

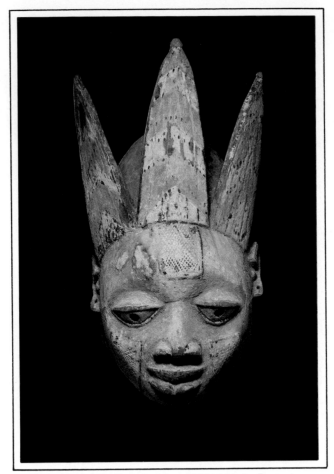

Yoruba (Nigeria), *Gelede Mask*, 16½″ high. Pace
Primitive Gallery.

Lincoln Perry, *Conversation Piece* (1982), 48″ x 50″, oil on
canvas. Tatistcheff Gallery.

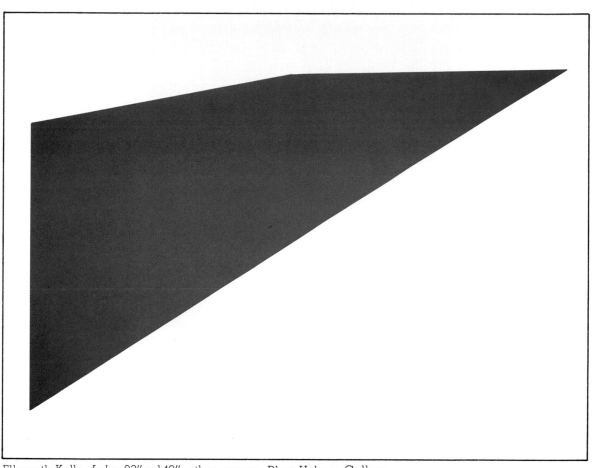

Ellsworth Kelly, *Lake*, 93″ x 148″, oil on canvas. Blum Helman Gallery.

Chen Morong, *Harvest,* 22″ x 29″, gouache. Wally Findlay Galleries.

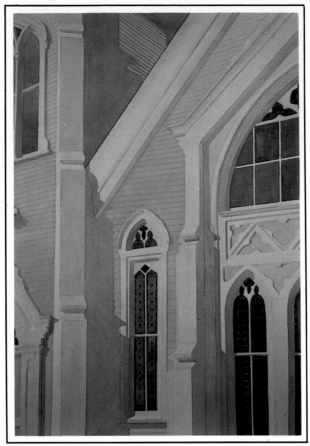

David Dewey, *Facade, Franklin Church, Cape May*
(1982), 60" x 40", watercolor. Tatistcheff Gallery.

Irene Rice Pereira, *Core of Substance* (1956), 45" x 50", oil on
canvas. Andre Zarre Gallery.

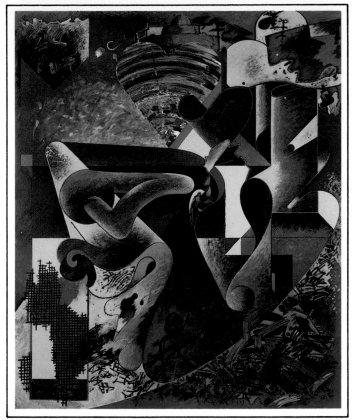

Robert Hudson, *Art Felt Swoop* (1982), 74¾" x 61¾",
acrylic/pastel on canvas. Frumkin Gallery.

Michael Boyd, *Laporte* (1980), 60" x 60", acrylic on canvas.
Andre Zarre Gallery.

John Marin, *Deer Isle, Maine Movement No. 3* (1927), 22½" x 17", watercolor on paper. Kennedy Galleries.

Paul Klee, *Drei Baume* (1940), 7½" x 14½", tempera on paper. Marisa del Re Gallery.

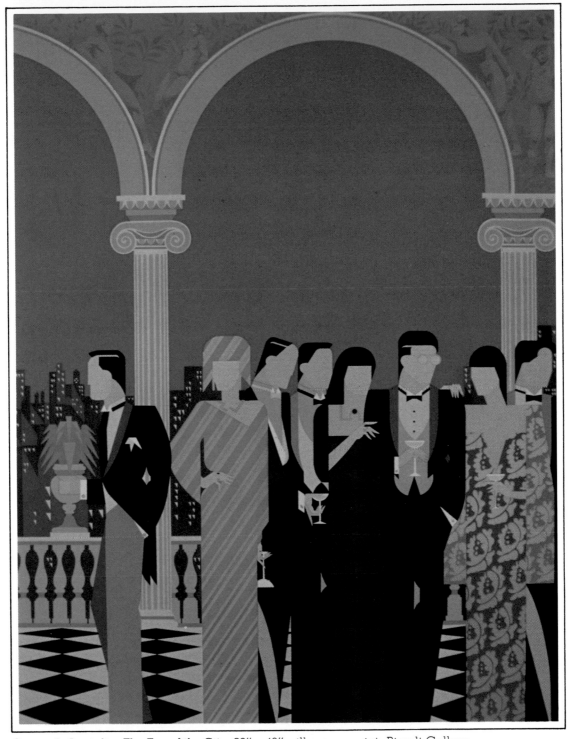

Giancarlo Impiglia, *The Top of the City,* 29″ x 40″, silk screen print. Rizzoli Gallery.

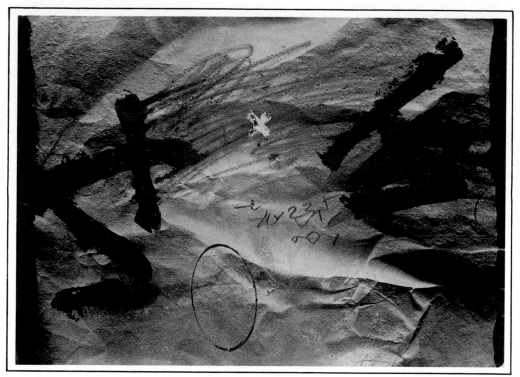

Antoni Tapies, *Effecte d'arrugue* (1980), 14½" x 20", gouache on paper. Marisa del Re Gallery.

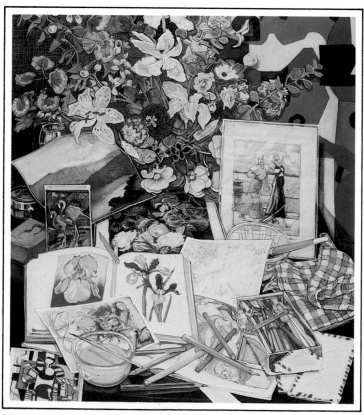

Loren Dunlap, *Singular/Plural* (1980), 44" x 50", acrylic on canvas. Wally Findlay Galleries.

William Kienbush, *The Island, Penobscot Bay,* 29" x 29", casein. Kraushaar Galleries.

Peter Solow, *Model in the Studio (Elise),* 84" x 54",
oil on canvas. Touchstone Gallery.

John Ferren, *Composition* (1934-7), 42″ x 62″, oil. A.M. Sachs Gallery.

Egon Schiele, *Reclining Woman with Green Stockings,* 11″ x 18″, tempera & chalk. Galerie St. Etienne.

Charmion Von Wiegand, *Chambers of Potala* (1959), 18″ x 18″,
gouache on paper board. Andre Zarre Gallery.

Jim Dine, *Fourteen Color Woodcut
Bathrobe* (1982), 77½″ x 42″, woodcut.
Pace Editions.

Jean Xceron, *Composition #324A* (1947), 9½" x 7", watercolor on paper. Andre Zarre Gallery.

John Stuart Ingle, *Still Life with Watermelon* (1981), 60" x 40" watercolor. Tatistcheff Gallery.

Robert Miller Gallery 724 Fifth Ave., New York, NY 10019
(212) 246-1625 Tuesday-Saturday: 10-5:30

The gallery is eclectic, representing both abstract and realist works of twentieth-century modern and contemporary art and photography. There are monthly one-person exhibitions.

Recent shows featured the painting of Dana Garrett in the artist's first one-person exhibition, unpublished vintage photographs by Diane Arbus, watercolors by Don Bachardy, portraits of artists by August Sander, prints and unique works in colored paper pulp by Robert S. Zakanitch, bronze and clay sculpture by Juan Hamilton and large-scale photographs by Robert Mapplethorpe.

Other artists represented by the gallery include Gregory Amenoff, Louise Bourgeois, William Brice, Louisa Chase, Janet Fish, Jedd Garet, Robert Graham, Al Held and Maxwell Hendler. Also represented are Roberto Juarez, Alex Katz, Lee Krasner, Michael Mazur, Rodrigo Moynihan, Nabil Nahas, George Sugarman and photographers Clarence John Laughlin and Paul Outerbridge. Works by Hans Hofmann, Georgia O'Keeffe and Jackson Pollock are also available.

Modern Master Tapestries 11 E. 57th St., New York, NY 10022
(212) 838-0412 Tuesday-Saturday: 9:30-5:30

Modern Master Tapestries is one of the few galleries which exclusively exhibits tapestries in the United States. Opened in 1972 by noted art dealer Charles E. Slatkin, the gallery initially housed the European tapestry collection of Mme. Marie Cuttoli which included such artists as Picasso, Miro and Calder. This collection, brought to this country for the first time by Slatkin, was instrumental in recreating interest in this ancient art.

By working with contemporary American and European artists, the collection grew in size and importance. The gallery features handwoven pile and Aubusson tapestries in limited editions by such masters as Karel Appel, Roy Lichtenstein, Robert Motherwell and Isamu Noguchi and others.

In responding to the mounting excitement and interest in this collection, the gallery is now showing exemplary works by artists in the growing fiber art movement. The fiber artists—including Lenore Tawney, Lia Cook, Nancy Guay, Sherri Smith among many—employ a wide range of techniques; works are shown that have been woven, lashed, wrapped, knotted, pleated, painted and stitched.

The gallery has representatives in more than twenty cities throughout the United States, and tapestries from the gallery are in major private collections.

Multiples, Inc./Marian Goodman Gallery 24 W. 57th St., New York, NY 10022 (212) 755-3520 Monday-Saturday: 10-6

Although the gallery began dealing exclusively in prints, painting and sculpture of international artists are now exhibited. Recently, photography has been included in the gallery.

Painting and sculpture shown at the gallery is characterized by abstract imagery as in the works of German artists Anselm Keifer and Marcus Luppertz and Italian artist Mimmo Paladino. Ger Van Elk, a Swiss artist, manipulates photographic images on canvas with paint.

An important facet of the gallery is its print publications. The gallery handles the prints of many prominent artists, such as Claes Oldenburg, Robert Rauschenburg, Andy Warhol, Helen Frankenthaler, James Rosenquist, Sol LeWitt, Dennis Oppenheim and Susan Rothenberg. Also handled are prints by Shusaku Arakawa, Alan Ruppersburg, William Wegman, Robert Wilson, Judy Pfaff, Francesco Clemente, Mimmo Palladino and Jan Dibbets.

Furniture sculpture by American artists Robert Wilson and Larry Bell is also represented by the gallery.

Odyssia

Odyssia Gallery 730 Fifth Ave., New York, NY 10019 (212) 541-7520
Tuesday-Saturday: 10-5:30 August: closed

Odyssia A. Skouras opened her New York gallery in 1964, seven years after she established her first gallery in Rome, Italy. Both galleries specialize in European masters and contemporary American artists, and work with museums and private and corporate collections from all over the world.

The American paintings and drawings are primarily figurative even though there is a wide range of individual styles. William Allan is known for watercolors of freshwater fish and irises, as well as large acrylic Western sky paintings. New Jersey-born Robert Birmelin paints crowded cityscapes from his own urban world. Jess (who uses only his first name) calls his rare thickly painted oils "translations" or "salvages," and his personal imagery most recently include pastels and oils inspired by the Old Testament. Marjorie Portnow's small landscapes carry the viewer to some of the more beautiful parts of the United States.

Balthus, Giorgio Morandi, Giorgio de Chirico and Egon Schiele are typical examples of works by European masters that form the second area for which the gallery is known.

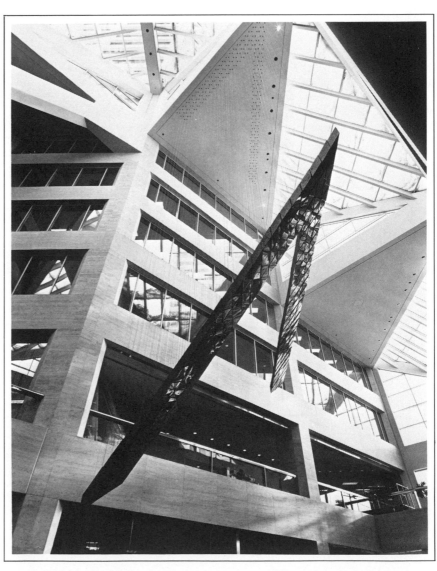

Loren Madsen, *Untitled* (1981), granite blocks and steel cable, 36' x 21' x 83'. David McKee Gallery.

The Pace Gallery of New York, Inc. 32 E. 57th St., New York, NY 10022 (212) 421-3292 Tuesday-Friday: 9:30-5:30; Saturday: 10-6 June 21-mid-September: Monday-Friday: 9:30-5:30

The gallery represents a wide range of styles and exhibits paintings and sculpture by leading American and European contemporary artists.

Artists represented by the gallery include Chuck Close, Jim Dine, Jean Dubuffet, Julio Gonzalez, Robert Irwin, Brice Marden, Agnes Martin and Louise Nevelson. Other gallery artists are Isamu Noguchi, Picasso, Ad Reinhardt, Mark Rothko, Lucas Samaras, Tony Smith, Saul Steinberg, Ernest Trova and David von Schlegell. Works by Henri Matisse, Alexander Calder and Milton Avery are also shown.

In addition to regular exhibitions of work by these artists, the gallery handles large-scale sculpture commissions by Dubuffet, Nevelson, Noguchi, Smith, Trova and von Schlegell.

Illustrated catalogues with essays by major art critics and historians accompany most of the exhibitions.

Pace Editions 32 E. 57th St., New York, NY 10022 (212) 421-3237 Tuesday-Saturday: 9:30-5:30 Summer: Monday-Friday: 9:30-5:30

Initially established to publish and exhibit prints and multiples by artists represented by the Pace Gallery, Pace Editions has expanded tremendously in activities and facilities as both a publisher and a dealer in contemporary prints. An extensive selection of museum-quality prints from all of the contemporary print publishers is available and on open display in the gallery.

Artists whose prints and multiples are published by Pace Editions on an exclusive basis are Chuck Close, Jim Dine, Jean Dubuffet, Michael Mazur, Don Nice, Louise Nevelson, Lucas Samaras, Saul Steinberg, Ernst Trova and Joe Zucker. A wide selection of prints from other publishers, also on display, include works by Josef Albers, Richard Diebenkorn, Richard Estes, Helen Frankenthaler, David Hockney, Jasper Johns, Roy Lichtenstein, Robert Motherwell, Claes Oldenburg, Robert Rauschenberg, Frank Stella and Andy Warhol.

The prints of these artists represent a wide spectrum of imagery from realistic to abstract in a complete breadth of printing techniques, which include aquatints, etchings, lithographs and serigraphs. All of the prints are limited editions and published to meet exacting professional standards. Carefully selected young and unaffiliated artists with promise are also represented.

Pace Master Prints was established several years ago to offer modern master prints by artists such as Henri Matisse, Picasso and Henri de Toulouse-Lautrec. It specializes in artists of the first half of the twentieth century and Picasso prints from the artist's estate.

Hemba Figure (Zaire). Pace Primitive Gallery.

Exhibitions are constantly changing every four weeks and catalogs are regularly published. Prices cover a wide range from a few hundred dollars to several thousand. Pace Editions is a member of the Art Dealers Association of America.

Pace Primitive 32 E. 57th St., New York, NY 10022 (212) 421-3688 Tuesday-Saturday: 9:30-5:30 Summer: Monday-Friday 9:30-5:30

The gallery specializes in traditional sculpture from the art-producing areas of West and Central Africa. These masks and figures were created for native ceremonial and religious use. The objects are old, but not ancient. Their age depends greatly on their area of origin. The pieces are of museum quality and are of increasing rarity.

A permanent exhibition space is open to the public on the tenth floor, in which an assortment of African sculpture is displayed. Exhibitions are changed approximately every four weeks. It is also used periodically for special exhibitions. Major exhibitions with elaborate catalogs are held on the second floor, such as shows of Yoruba beadwork and Yoruba

sculpture of West Africa. Books and catalogs of African art are also available for sale.

Among art-producing cultures whose sculpture can be found at Pace Primitive are the Ashanti, Bambara, Baule, Chokwe, Dan, Dogon, Fang, Kota, Duba, Kongo, Ibon, Hemba, Lega, Mende, Reade, Senufo, Songye and Yoruba.

Prices for authentic African art vary widely based on the relative importance and rarity of the piece, from a few thousand to over one hundred thousand dollars. Authenticity is the most important criteria for establishing value. There are still opportunities in the field of African art to build an important collection for a reasonable amount of money.

Pace Primitive is a member of the Primitive Art Dealers Association of America and the Art Dealers Association of America.

Betty Parsons

Betty Parsons Gallery 24 W. 57th St., New York, NY 10019
(212) 247-7480 Tuesday-Friday: 10-5:30; Saturday: 11-5

Over the past fifty years, the owner has established a stable of international contemporary artists whose paintings, drawings and sculpture are primarily abstract in style.

The roster of artists includes Eliza Moore, whose paintings employ light colors and collage; Riduan Tomkins, who paints with small figures in bright primary colors; and Jonathan Thomas, who cuts into painted masonite. Sculptor George Grant creates house or plant forms from wood and plaster with glass or mosaic embedded in the surface. Irish artist Maria Simonds-Gooding makes incisions in plaster that appear to be abstract but are representations of primitive life, huts or dwellings.

Sybil Weil's installations are environmental pieces about sculpture. Canvas and wood wall constructions by Barbara Valenta suggest windmills. Israeli sculptor Yehiel Shemi bolts wood to steel to create minimal works powerful in scale and size. Robert Yasuda, who is known for his installations, has recently painted minimal, softly colored canvases shaped to the edge. The current work of colorist Calvert Coggeshall is in variations of blue, with horizontal bands or zigzag forms on the surface.

There are numerous artists who participate in gallery shows and whose works are in the gallery's extensive stock. They include Mino Argento, Helene Aylon, Fanny Brennan, John Cunningham, Richard Francisco, Michael Gillen, Cleve Gray, Sylvia Guirey, Lee Hall and Emil Hess. Also included are Minoru Kawabata, Mark Lancaster, Sandra Lerner, Jeanne Miles, Jacqueline Monnier, Maud Morgan, the estate of Walter Murch, Vita Petersen, Arthur Pierson, Aline Porter and Stephen Porter. Others are V.V. Rankine, Risa, Jim Rosen, Toko Shinoda, Tom Stokes, Oliver Steindecker, Bill Taggart, Marie Taylor, Bruce Tippett, estate of Bradley Walker Tomlin, Ruth Vollmer, Zuka and Ed Zutrau.

Marilyn Pearl

Marilyn Pearl Gallery 38 E. 57th St., New York, NY 10022
(212) 838-6310 Tuesday-Saturday: 10-5:30 August: closed

The gallery features both established and young, emerging artists. They include Stephen Greene, now working in a more abstract and free-form manner, and Michael Loew, who continues to create abstractions. Matt Phillips' monotypes have become larger with subtle coloration and a sense of place. Bernard Chaet's figurative works and Richard Lytle's abstract landscapes have been shown. Also included in the roster of the gallery are sculptors Winnifred Lutz and Lawrence Fane, photographer Marvin Lazarus, and Anna Bialobroda, Clinton Hill, Henry Pearson, Piedro F. Perez, Leo Rabkin, Barbara Siegel and Charmion Von Wiegand.

Max Protetch

Max Protetch 37 W. 57th St., New York, NY 10019 (212) 838-7436
September-May: Tuesday-Saturday: 10-6; June-August: Monday-Friday: 10-5

The gallery deals primarily with art of an architectural bent and repre-

Louise Nelson, *Sun-set* (1981), cast polyester resin. Pace
Editions.

Ronnie Elliott, *Collage #17* (1975), 18″ x 15″,
mixed media on paper. Andre Zarre Gallery.

sents some of the foremost conceptual architects in the world today. The gallery has pressed to see architecture be accepted as an art form, that of sculpture on a human scale. Works by gallery artists demonstrate that the line between the fine arts and architecture is blurred. Gallery sculptors and painters often incorporate into their work architectural perspectives and scale.

Some gallery painters use the medium for its texture and flow rather than just for pictorial representation. Works by Pat Steir, one of the best-known painters in the gallery, are historical and emotive in content.

The artists represented are Vito Acconci, Siah Armajani, Gary Bower, Scott Burton, Farrell Brickhouse, Pinchas Cohen Gan, Jackie Ferrara, Richard Fleischner, Denise Green, Doug Hollis, Will Insley, Mary Miss, David Reed and Pat Steir.

The architects represented are Peter Eisenman, Frank Gehry, Michael Graves, John Hejduk, Rem Koolhaas, Leon Krier, Aldo Rossi, Venturi, Rauch and Scott Brown. Architectural photographer Ezra Stoller is also represented.

Rizzoli

Rizzoli Gallery 712 Fifth Ave., New York, NY 10022 (212) 397-3712
Monday-Saturday: 10-10 Christmas Season: Sunday: 12-5

The gallery is located on the mezzanine level of the Rizzoli bookstore, which has volumes on literature, art, photography, design and architecture, as well as foreign periodicals and classical records. Paintings, lithographs, silk screen, watercolors and photographs are displayed throughout the shop.

In recent years, the gallery has been interested in exhibiting original works that have a strong graphic sense with an emphasis on design and architectural qualities. The gallery has thus featured works by architects, illustrators, designers and photographers.

Among important shows was an exhibit of architectural illustrations and models that revealed the processes used by architects in abstract thought and creative thinking. Works by Robert A. M. Stern, Charles Moore and Rob Krier were included, from drawings and sketches to three-dimensional, torn cardboard. In another show, fifteen well-known book illustrators presented originals of their work. They were John Collier, Paul David, Daniel Maffia, Bib Peak and Bernie Fuchs. Decorative screens were created for a group show of trompe l'oeil pieces by architects Stanley Tigerman, Michael Graves, Richard Haas and Robert A. M. Stern. Another exhibit featured works by inventor Christian Thee, which always have mechanical devices or a sound track to include a playful element. The effect of the three-dimensional environment was also explored by the husband-and-wife team of architects Jean-Pierre Heim and Christine Feuillette, who juxtaposed actual three-dimensional pieces against painted backgrounds.

Photography exhibits have showcased contemporary photographers Ruth Orkin and Arthur Rothstein. Orkin captures the character of a city, place or mood. Rothstein is known for his insight into light.

Portfolios by major modern and contemporary artists and photographers include works by Picasso, Chagall, Giorgio de Chirico, Moses Soyer, Giancarlo Impiglia and Alfred Stieglitz.

Ronin

Ronin Gallery 605 Madison Ave., New York, NY 10022 (212) 688-0188 Monday-Saturday: 10-6

A major New York source for Japanese arts and crafts, the gallery carries items ranging from small gifts to major works of art.

The gallery is fashioned in Japanese style with authentic furniture by George Nakashimi, shoji screens, and a Japanese rock garden. The open gallery space is large enough to contain four or five exhibits at one time.

A collection of over 10,000 Japanese woodblock prints ranging in time from early Ukiyo-e masters to the present is maintained by the gallery. It owns works by the Ukiyo-e masters, such as Moronobu, whose prints date from 1680. Major eighteenth-century artists include Utamaro,

Anna Bialobroda, *Lot* (1980), 96" x 48", acrylic on canvas. Marilyn Pearl
Gallery.

Haranoba and Kiyonaja. Among the nineteenth-century artists that figure prominently in the collection are Hokusi, Hiroshige, Kuniyoshi, Toyokuni and Yoshitoshi.

The gallery also has a fine collection of *inro*, miniature lacquer boxes once used by Japanese men, and *netsuke,* small delicate carvings of wood or ivory used to counterbalance the *inro* on a gentleman's sash. Most of these objects, as well as the gallery's collection of Japanese jewelry, are not on display, but may be viewed on request.

Major exhibitions have included the works of master Utamaro, in addition to a series of nineteenth-century landscapes by Hiroshige, *Fifty-three Stations of Tokaido.* The gallery does one major show a year of contemporary woodblock prints.

A large selection of books on Japanese art is available, as well as posters that are produced by the gallery. A mail order catalogue, *The Japan Collection*, enumerates Japanese items for sale, ranging from gifts such as handmade paper to fine art.

Alex Rosenberg Transworld

Alex Rosenberg Gallery/Transworld Art 20 W. 57th St., New York NY 10019 (212) 757-2700 Monday-Saturday: 10-5 July & August: Monday-Friday: 10-5

The gallery specializes in paintings, sculpture, drawings and prints by American and European contemporary artists working in diverse styles.

Among works by gallery artists are the realist paintings and pastels of Howard Kanovitz. James Coignard and Manoucher Yektai use highly painted surfaces in their abstract canvases. Mark Tobey, an Abstract Expressionist, blends the figurative into his calligraphic abstractions. The bronzes and drawings of Henry Moore encompass the human figure and the abstract. Lila Katzen's abstract sculpture incorporates curves in a combination of metals for indoor and outdoor spaces. Ilse Getz uses found and reconstituted fragments to create three-dimensional constructions, collages and paintings. Sven Lukin's fan- and wing-like structures embrace both painting and sculpture. Gordon Parks' photography in both black and white and color spans representational and abstract images.

The romantic landscape paintings by Stephen Woodburn are invented images. Ann Chernow handles the human figure in hushed tones in her paintings and drawings. Diana Kurz plays the human figure against an architectural structure in large-scale paintings. Stephen Brown's painted portraits depict a classical formalism. Paintings on paper by Dina Gabos are vignettes from life.

Transworld Art has published original graphics, multiples and art posters since 1969. Its collection includes the work of contemporary masters Yaacov Agam, Romare Bearden, Alexander Calder, James Coignard, Dali, Paul Jenkins, Conrad Marca-Relli, Miro, Henry Moore, Rufino Tamayo, Mark Tobey, Esteban Vicente, Tom Wesselmann, Jack Youngerman and others. The gallery carries editions by emerging print-makers including Susan Elias, Claus Hoie, Harry Koursaros, Phyllis Sloane and Stan Taft.

Another facet of the gallery is theme exhibitions of internationally known artists and young, emerging talent.

A.M. Sachs

A.M. Sachs Gallery 29 W. 57th St., New York, NY 10019 (212) 421-8686 Tuesday-Saturday: 10-5:30 July: Tuesday-Friday: 10-5:30 August: closed

The gallery occupies two large rooms with additional space where works by gallery artists are always on hand. The contemporary American painters and sculptors represented by the gallery are eclectic.

Each year, the gallery introduces two or three new artists, whose shows are generally well received. Alice Dalton Brown recently displayed paintings of realistic interiors in Victorian houses, and Sally Vagliano exhibited landscape paintings. Power Boothe, an abstract painter, is another new talent who had his first show at the gallery.

Lila Katzen, *Entendre with Double Front Curve* (1981), 38″ x 24″ x 17″, brushed aluminum. Alex Rosenberg Gallery.

Eugene Mihaesco, *Puzzle* (1973), 19½″ x 15″, pen and ink on Sihl Superbus. Galerie St. Etienne.

John Gundelfinger, *Sunset after Thunder Showers—Delaware River Valley* (1979), 50″ x 70″, oil on canvas. A.M. Sachs Gallery.

Among the gallery's regular artists are John Gundelfinger, Stephen Pace, Joseph DeGiorgio, Geri Taper, Bert Carpenter, Thomas Cornell and Ben Norris. Abstract sculptor Dorothy Dehner makes unique structures of carbonized steel that stand about eight feet high, and also shows small bronzes at the gallery. The gallery handles the estate of John Ferren, a twentieth-century abstract painter, and has planned a retrospective of his work of the 1930s, particularly 1933-1934.

Touchstone

Touchstone Gallery 29 W. 57th St., New York, NY 10019
(212) 826-6111 Tuesday-Saturday: 10-5:30 July: by appointment
August: closed

The gallery was established to introduce the work of unknown contemporary American artists, as well as renowned foreign artists who had never exhibited in New York.

The gallery deals with painting, sculpture and mixed media in a variety of modes. Peter Solow does figures in landscapes in oil paintings and pencil drawings. Sydney Butckhes works abstractly. Allan Sly sculpts figures, singly and in environments, in cement and bronze. Ryo Tokita concentrates on mystical geometric abstractions.

Periodically, the gallery organizes an exhibition around a theme suggested by the current concerns of artists. Past shows have included "The Photograph Transformed," "Ritual and Landscape," and "System, Inquiry, Translation." The gallery has also presented annual "New Talent" shows.

A special feature of the gallery is the occasional presentation of "Art for the Stage," an exhibition comprised of scenery and costume designs for ballet, opera and theatre.

Tatistcheff

Tatistcheff & Company, Inc. 38 E. 57th St., New York, NY 10022
(212) 888-1599 Tuesday-Saturday: 10-6

The gallery's specialization is contemporary American paintings, drawings, watercolors and pastels. Predominantly realistic works—landscapes, still lifes, figures, interiors and urban scenes—have a painterly nature in common and tend to show the hand of the artist.

The work of approximately twenty artists is available, although each exhibit is devoted to a single artist's work. Paintings by John Gordon depict suburban gardens and backyards, verdant in late afternoon light. Lincoln Perry's multiple-figure narratives show invented interiors and landscapes in rich colors with strong chiaroscuro. Landscape paintings by Richard Crozier highlight the Albemare County of Virginia; the small oil studies are direct from nature, while the large-scale studio works based on the studies reveal an overriding interest in precise weather and light. William Clutz interprets the figure in urban settings.

Watercolors by John Stuart Ingle are formal still lifes that use household objects in a highly realistic setting. David Dewey's larger-scale watercolors show light on Victorian architecture. Drawings by James Childs feature extremely detailed, classically-inspired figures. Also shown are the oils of Irene Buszko who depicts suburban landscapes as well as those of Seaver Leslie and David Dewey.

St. Etienne

Galerie St. Etienne 24 W. 57th St., New York, NY 10019 (212)
245-6734 Tuesday-Saturday: 11-5; summer hours: Tuesday-Friday:
11-5

The gallery was founded by the late Dr. Otto Kallir (1894-1978) in 1939. Its field of specialization has always been twofold: early twentieth century Austrian and German Expressionism and naive art—both European and American—of the nineteenth and twentieth century. About twice a year comprehensive, museum-scope exhibitions are organized, accompanied by book-length, lavishly illustrated catalogues which explore the particular subject in depth. Though a commercial gallery, one of its main functions is educational; it maintains extensive

Irene Buszko, *Gina on 120th St.* (1981), 30″ x 48″, oil on canvas. Tastistcheff & Co.

Peter Plamondon, *Styrofoam Cups #2* (1979), 39″ x 46″, oil on canvas. Touchstone Gallery.

archives which serve the scholar, serious collector, as well as a wide public.

The now famous Europeans, Egon Schiele, Oskar Kokoschka, Gustav Klimt, Alfred Kubin, Lovis Corinth, and Kaethe Kollwitz are among the artists this gallery has introduced to the United States, as well as one of the internationally best known painters, Anna Mary Robertson (Grandma) Moses; the gallery held her first one-woman show in 1940 and has represented her ever since. There is generally on view or available a large number of works by these artists.

A recent addition to the gallery roster is the illustrator Eugene Mihaesco, best known through his *New Yorker* covers and contributions to major articles in *Time* and other magazines. His first U.S. one-man exhibition in 1981 displayed his many-faceted, poignant drawings, pastels and collages. A selection can always be seen.

The gallery has a collection of oils, watercolors, drawings and prints by several lesser known Austrian Expressionists, such as Oskar Laske and L. H. Jungnickel; by the American Expressionists Martin Pajeck and Marvin Meisels; and oils by the contemporary American folk artist Nan Phelps, as well as by other nineteenth and twentieth century naive painters.

Books and catalogues on the gallery artists and related fields are available for sale, as well as posters and reproductions of works by Moses, Schiele, Klimt, and Mihaesco. Lists of these items are sent upon request.

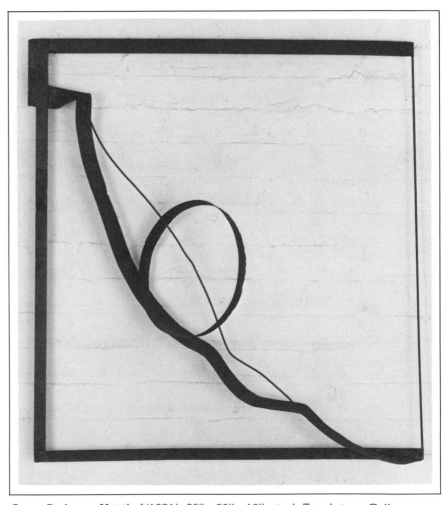

Susan Rodgers, *Untitled* (1981), 36″ x 36″ x 12″, steel. Touchstone Gallery.

Washburn

Washburn Gallery 47 E. 57th St., New York, NY 10019
(212) 966-3151 & 113 Greene St., New York, NY 10013 (212)
753-0546 Tuesday-Saturday: 10-5:30

Two different locations of the gallery serve to house separate shows or, within one show, different facets of the same artist's work. The downtown space has high ceilings and large, open rooms, which can accommodate oversized works. The uptown space consists of two exhibition rooms and a private showroom.

Featured artists are Bill Jensen, creator of abstract icons; Leon Polk Smith, a hard-edge constructivist; Jack Youngerman, whose broad range of painting styles now extends to "relief paintings" (carved and painted wall reliefs); and Richard Benson, a traditional photographer who works with paladium prints and platinum prints.

Also represented are Ilya Bolotowsky, whose biomorphic and geometric abstractions of the 1930s evolved into Neoplastic formations, and Alice Trumbell Mason, whose works also reflect the changing artistic theories and styles during her lifetime, especially Surrealism and the lessons of Mondrian.

The gallery is also a resource for works by artists affiliated with photographer Alfred Stieglitz, such as Arthur Dove, Marsden Hartley and Georgia O'Keeffe, who developed strong styles that were relatively independent of European modernist movements of their time. In addition, the estates of Charles Shaw and Byron Browne are represented. Selections from the photographs of James Abbe are also available.

Major exhibits have included a show of works by Patrick Henry Bruce. In an exhibit on decorative arts of the 1930s, furniture and objects of industrial designer Gilbert Rohde were complemented by paintings of the time. Other past exhibitions range from those of nineteenth-century landscape painters Martin J. Heade and William T. Richards, to a variety of folk artists and portraitists such as Ammi Phillips and Joshua Johnston.

Doug Prince, *Magnolia Chamber* (1973). Witkin Gallery.

Witkin

Witkin Gallery 41 E. 57th St., New York, NY 10022 (212) 355-1461
Tuesday-Saturday: 11-6 July & August: closed Saturday

Specializing in photography, the gallery now represents the work of over 100 photographers. Exhibitions change approximately every five weeks. The gallery is expanding into other areas of the graphic arts, but will continue to focus on photography.

A selection of prints by gallery photographers is always on hand, and most images are available upon request. A few of the well-known names are Elsa Dorfman, Morris Engel, Abraham Menashe, Joanne Mulberg and Jack Welpott. The estates of Dean Brown, Wendell Macrae, Elli Marcus, Marion Palfi, Kay Bell Reynal, Peter Sekaker, Doris Ulmann and Edward Weston are represented. Prints of a number of photographers are always available, some in very sizable selections. These photographers include Eugene Atget (both original prints and prints by Berenice Abbott), Margaret Bourke-White, Imogen Cunningham, Edward Curtis and Paul Diamond. Others are Laura Gilpin, Clarance John Laughlin, Elliott McDowell, Eadweard Muybridge, Bill Weegee and Walker Evans, among many others. In addition, camera work gravures, Civil War photographs and prints of the Farm Security Administration are also always available. The gallery keeps in stock an interesting selection of work by young photographers.

The gallery recently had two nonphotographic shows. Gustave Baumann, a woodcut artist from Santa Fe, and Kyra Markham, who showed paintings, etchings and lithographs were the exhibiting artists. Other graphic work handled by the gallery includes lithographs and etchings by Kerr Eby, drawings and lithographs by George William Eggers, woodcuts by Helen Hyde and watercolors by Christopher James.

Besides the large selection of photographic images, the Witkin Gallery along with Witkin-Berley, Ltd. has produced twelve limited

157

edition portfolios of individual photographers' work. The gallery also has a book department specializing in rare and out-of-print photographic books as well as a wide selection of current books on photography. The posters, stereoviews and daguerrotypes on display are for sale.

Daniel Wolf

Daniel Wolf, Inc. 30 W. 57th St., New York, NY 10019 (212) 586-8432
Monday-Saturday: 10-6 June-August: Monday-Friday: 10-6

The gallery features a wide range of photography from early French photographers of the nineteenth century to the most important contemporary photographers of our time. Recently, the gallery has allocated space for exhibiting primitive art, notably fine American Indian arts and crafts.

The gallery maintains an expansive collection of nineteenth-century American West photographs by Carleton Watkins, William Henry Jackson, Timothy O'Sullivan and Adam Clarke Vroman among others. Also represented are nineteenth-century European photographers including Gustave Le Gray, Julia Margaret Cameron and Peter Henry Emerson, as well as early twentieth-century European photographers including Martin Munkasci, Man Ray and Moholy-Nagy. Contemporary photographers in the gallery's collection are Eliot Porter, Art Sinsabaugh, Tod Papageorge, Sheila Metzner, William Garnett, Helen Levitt, Harold Edgerton, Andreas Feininger and Joel Sternfeld.

In addition to photography, the gallery exhibits American Indian arts including nineteenth- and twentieth-century navajo rugs and tapestries, Indian jewelry, sculpture, baskets, peace pipes and clothing, and Peruvian pottery. American and European paintings and sculpture from the nineteenth and twentieth centuries are also shown.

A subdivision of the gallery, Daniel Wolf Press, Inc. deals exclusively with editioned portfolios and works catering to corporate markets. Among the photographers whose portfolios were published are Eliot Porter and Ernst Hass. The press also publishes large format images of many well-known photographers, such as Eliot Porter and Michael Geiger.

Daniel Wolf Press, Inc., publishes fine art photography posters including those that cover Carleton Watkins, Sheila Metzner, William Garnett, the New York World's Fair of 1939, Francis Frith and French primitive photography.

Zabriskie

Zabriskie Gallery 29 W. 57th St., New York, NY 10019 (212) 832-9034
Monday-Saturday: 10-5 June-August: closed Saturday

Though established twenty-nine years ago to exhibit paintings of contemporary artists, the gallery has recently emphasized sculpture and photography for the past several seasons. In 1976 the gallery opened a Paris branch, which initially showed only photography, and did a great deal to educate Europeans about recent developments in American photography. Recently the Paris gallery moved to larger headquarters to accommodate paintings and sculpture as well.

Contemporary sculptors include Mary Frank, Ibram Lassaw, Kenneth Snelson, Edward Mayer, Richard Stankiewicz and Timothy Woodman. The gallery also handles a large variety of important historic works, including sculpture by Elie Nadelman and paintings and photographs by Alfred Stieglitz, Marsden Hartley, Georgia O'Keeffe and Paul Strand.

Within the last year, director Virginia Zabriskie has added photographers Harry Callahan and Lee Friedlander to her list of represented artists. Emphasis in photography has been given over to the French, including nineteenth-century artists Baldus and the Bisson brothers, and twentieth-century artists Eugene Atget, John Batho, Constantin Brancusi, Brassai, Pierre Boucher, Francois Kollar and Man Ray. The gallery specializes in theme exhibitions, showing the relationships between photography and the other plastic arts.

Exhibitions of paintings are held regularly; they have included the works of Abraham Walkowitz, an artist member of Stieglitz's 291 Gallery;

Seaver Leslie, *East Village After St. Mark's Fire,* 10″ x 13″, prismacolor. Tastistcheff & Co.

George Harkins, *Manhattan, West Side—Sixth Avenue* (1981), 40″ x 60″, watercolor. Tastistcheff & Co.

Arnold Friedman, an early modernist; and Pat Adams, a contemporary artist.

Andre Zarre

Andre Zarre Gallery 41 E. 57th St., New York, NY 10022 (212) 752-0498 Tuesday-Saturday: 10:30-5:30

Founded almost a decade ago by the poet, Andre Zarre, the gallery exhibits contemporary American paintings, works on paper and sculpture. Approximately ten solo shows are held each season in an architecturally compact space located in the Fuller Building. Group shows are usually thematic in nature and may comprise guest artists whose work highlights the focus of each exhibit. Both individual and group exhibits exemplify in a non-repetitive manner the diverse facets of the gallery's profile.

Among the young artists presented are Michael Boyd, who employs intuitive color to explore geometric compositions, and Jerry Lubensky whose superimposed and interlocking nonrepresentational forms float on seas of mottled pigment. Constance Kheel concerns herself with the emergence of painterly structure and the relationship of disparate elements in her acrylics composed of thick layers of dripped and poured paint and large geometric shapes that interact with each other to create a tension and spatial complexity. Winifred Godfrey executes lush, realistic florals rendered with sensitivity and almost photographic veracity. Basing herself on the Fibonacci number system, Dee Shapiro builds up densely-textured canvases with myriads of vibrant colors evoking Islamic-like mosaics and conveying musically-inspired rhythms undulating with seemingly electrical energy. Edgar Buonagurio's architectural abstractions are time machines, eccentric vehicles to pipe-dreamed realities having an illusionary quality.

The unique, welded spheres of Michael Malpass spatially define cosmic worlds in bronze and steel. They incorporate found objects such as nuts, bolts and locks moulded into orbs of stirring vitality.

The gallery represents Jean Xceron (1890-1967), the subject of a retrospective at the Guggenheim Museum in 1965, and Irene Rice Pereira (1907-1971), the first American woman presented in a solo show at the Museum of Modern Art in New York in 1946 and later honored in a retrospective at the Whitney. In addition, selected works are available by Ronnie Elliott, Charmion Von Wiegand, Nassos Daphnis, Carl Holty, Rolph Scarlett, Gene Davis, Sonia Delaunay, Josef Albers, Richard Anuszkiewicz and Joy Walker.

Winifred Godfrey, *Salmon Daylillies* (1982), 40" x 60", oil on canvas. Andre Zarre Gallery.

Constance Kheel, *High on Five* (1982), 7'6" x 7', acrylic on canvas. Andre Zarre Gallery.

The Uptown Galleries

By Specializations

The following list represents concentrations of a particular artistic mode and not necessarily the individual focus of the gallery.

American:

contemporary:
A.C.A., Acquavella, Arman, Castelli, Coe Kerr, Cordier & Ekstrom, Maxwell Davidson, Elkon, Ericson, Findlay, Forum, Fourcade, Gimpel & Weitzenhoffer, Goodman, Hirschl & Adler Modern, Knoedler, Knowlton, Mathes, Randall, Schoel-kopf, Staempfli, Stone, Vanderwoude Tananbaum, Willard

periods:
A.C.A., Babcock, Berry-Hill, Castelli Feigen Corcoran, Coe Kerr, Davis & Langdale, Forum, Hirschl & Adler, Mathes, Sabarsky, Smith, Spanierman, Vanderwoude Tananbaum, York

**Ceramics/Crafts
& Other Media:**
Heller

**European &
Other Continents:**

contemporary:
Elkon, Findlay, Gimpel & Weitzenhoffer, Goodman, Hirschl & Adler, Lefebre, Mathes, Perls, Sindin, Staempfli, Waddington

periods:
Acquavella, David & Langdale, Findlay, Gerst, Hutton, La Boetie, Matignon, Noordman & Brod, Saidenburg, Wildenstein

Graphics:

contemporary:
Castelli, Christies, Rheinhold-Brown

periods:
Goldschmidt, Rheinhold-Brown, Weyhe

Photography:
Castelli, Neikrug, Pfeifer, Prakapas

Sculpture:
Forum, Fourcade, Perls, Randall, Sindin, Weintraub

**Western &
Native American:**
A.C.A. Indian, Coe Kerr, Smith, Spanierman

By Location

58th Street Vicinity
| Berry-Hill | 743 Fifth |

60th Street Vicinity
| Hilde Gerst | 685 Madison |

East 61st Street Vicinity
| Wehye | 794 Lexington |

East 64th Street
| Wildenstein | 19 |

East 65th Street Vicinity
| Richard York | 21 |
| Davis & Langdale | 746 Madison |

East 67th Street
Helios	18
Babcock	20
A.C.A.	21
Christie's Contemporary	799 Madison

West 68th Street
| Neikrug | 224 |

East 69th Street Vicinity
Yves Arman	817 Madison
Pfeifer; Schoelkopf	825 Madison
Randall	832 Madison

East 70th Street
| Knoedler | 19 |
| Hirschl & Adler | 21 |

East 71st Street
| Mathes; Knowlton; Prakapas | 19 |
| Hirschl & Adler Modern | 851 Madison |

East 72nd Street
| Matignon | 897 Madison |
| Willard | 29 |

East 73rd Street
| A.C.A. Indian | 25 |

East 74th Street
| Ericson | 23 |
| Hutton | 33 |

East 75th Street and Vicinity
Xavier Fourcade	36
Cordier & Ekstrom	417
Heller	965 Madison

East 76th Street Vicinity
| David Findlay | 984 Madison |

East 77th Street and Vicinity
Castelli Graphics	4
Staempfli; Lefebre	47
Serge Sabarsky	987 Madison

East 78th Street and Vicinity
Rheinhold-Brown	26
Maxwell Davidson	43
Ira Spanierman	50
Weintraub	992 Madison

East 79th Street and Vicinity
Acquavella	18
Rosenberg	20
Perls	1016 Madison
Forum; Saidenberg	1018 Madison
Castelli Feigen Corcoran; Goodman; Noordman & Brod	1020 Madison
Sindin	1035 Madison
Gimpel & Weitzenhoffer	1040 Madison
Waddington	1044 Madison
Smith	1045 Madison

East 81st Street and Vicinity
| Vanderwoude Tananbaum | 24 |
| Elkon | 1063 Madison |

East 82nd Street
| La Boetie | 9 |
| Coe Kerr | 49 |

85th Street Vicinity
| Lucien Goldschmidt | 1117 Madison |

East 86th Street
| Allan Stone | 48 |

A.C.A. Galleries 21 E. 67th St., New York, NY 10021 (212) 628-2440
Tuesday-Saturday: 10-5:30 July-August: Tuesday-Friday: 10-5

The gallery concentrates on late nineteenth- and twentieth-century American painting, including work by contemporary American artists. American masters include members of the Ashcan School of realist painters, notably Robert Henri, George Luks, Everett Shinn and William Glackens. Other American masters belong to the Stieglitz group, namely Max Weber and Georgia O'Keeffe. American Impressionists Childe Hassam and Ernest Lawson, and American abstractionist Gertrude Greene are also featured. The gallery always has a floor showing twentieth-century American art, including works by Milton Avery, Childe Hassam, Joseph Solman, Georgia O'Keeffe and others.

The contemporary artists who exhibit at the gallery are representational for the most part. Fritz Scholder, well known for his images of the American Indian, recently showed canvases done in broad brushwork that are expressionistic with abstract qualities. Paul Pletka's paintings capture the spirit of the American Indian through their depiction of rituals and symbols. Egg-tempera painter Robert Vickrey works in a realist style reminiscent of Andrew Wyeth. Roy Carruthers paints unreal figures that are distorted and caricaturelike. He also shows lithographs, drawings and sculpture with expressionistic qualities. Paintings by Barkley Hendricks are highly representational images of present-day Black urban dwellers. Balcomb Greene's semiabstract paintings show nudes in seascapes. Among artist's estates the gallery handles Moses Soyer.

ACA American Indian Arts 25 E. 73rd St., New York, NY 10021
(212) 861-5533 Tuesday-Saturday: 10-5:30

This is New York's first gallery to exhibit outstanding Indian art dating from pre-history through the historic era, as well as the finest traditional and innovative contemporary work made by twentieth-century American Indian artists. Although the gallery specializes in the pottery, basketry and textiles of the Southwest, its collection also includes rare and beautiful works of art from the Indian cultures of California, the Pacific Northwest Coast, Alaska, the Plains, the Great Lakes and the Eastern Woodlands.

Antique old pawn Navajo and Pueblo silver and turquoise jewelry is also displayed at the gallery, along with the work of Charles Loloma and other contemporary American Indian jewelers. The Plains quill and beadwork dates from the nineteenth and early twentieth centuries. The original vintage photographs are by Edward S. Curtis and other early photographers. The gallery's collection of painting and sculpture

features the work of important contemporary American Indian artists.

Along with displaying a constantly changing selection of Indian art, the gallery also mounts special exhibitions and presents public demonstrations, workshops and lectures given by noted artists and scholars. ACA American Indian Arts is a joint venture of ACA Galleries of New York and Gallery 10 of Scottsdale, Arizona.

Acquavella

Acquavella Galleries 18 E. 79th St., New York, NY 10021 (212) 734-6300 Monday: by appointment; Tuesday-Saturday: 10-5

Established over fifty years ago, the gallery features nineteenth- and twentieth-century painters and sculptors. Works shown are by the following renowned artists: Pierre Bonnard, Eugene Boudin, Georges Braque, Mary Cassatt, Paul Cezanne, Chagall, Gustave Courbet, Dali, Edgar Degas, Jean Dubuffet, Max Ernst, Henri Fantin-Latour, Juan Gris, Paul Klee, Fernand Leger, Henri Matisse, Miro, Amedeo Modigliani, Claude Monet, Picasso, Camille Pissarro, Odilon Redon, Jean Renoir, and Alfred Sisley.

In addition to regular exhibits of works from the gallery, an annual show of works on loan from museums and private collections is presented. Though not for sale these works are publicly displayed and reproduced in a full-color catalogue published by the gallery.

In the same building, Acquavella Contemporary Art is a subsidiary gallery whose major focus is contemporary American paintings and sculpture. A large number of major artists are represented. They include Jack Bush, Anthony Caro, Christo, Jim Dine, Richard Estes, Sam Francis, Helen Frankenthaler and Franz Kline. Others are Roy Lichtenstein, Morris Louis, Robert Motherwell, Louise Nevelson, Isamu Noguchi, Kenneth Noland, Jules Olitski, Jackson Pollock and Larry Poons. Robert Rauschenberg, James Rosenquist, Mark Rothko, David Smith, Frank Stella, Mark Tobey, Cy Twombly and Andy Warhol are additional key artists represented by the gallery. Works by lesser-known artists, such as watercolors by Todd McKie, found-paper collages by Robert Nickle and sculpture by Willard Boepple are also exhibited.

Reginald Marsh, *Adults 10c, Children 5c,* 36" x 48", egg tempera. A.C.A. Gallery.

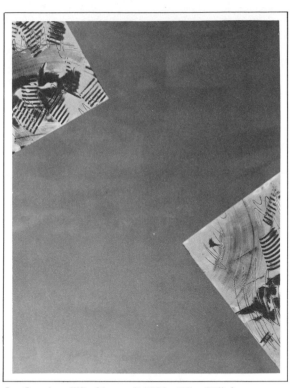

Eric Appel, *Silver Speckled Moons* (1981) with artist, 8' high; plastic, steel and acrylic paint. Gallery Yves Arman.

Jim Jacobs, *Elf's Chasm* (1982), 49" x 37", lacquer on board. Gallery Yves Arman.

Asher B. Durand, *View in the Catskills* (1844), 37½" x 54", oil on canvas. Berry-Hill Galleries.

Yves Arman

Gallery Yves Arman 817 Madison Ave., New York, NY 10021
(212) 570-2700 Tuesday-Saturday: 11-6 August: closed

The gallery represents a diverse group of artists who share an ability to stimulate the viewer. Approximately twelve artists are featured in the one-person shows that run for three weeks and alternate with a one-week group show.

The current stable of artists includes several painters. Biff Elrod dramatizes everyday occurrences in a pointillistic style. Jim Jacobs paints lacquer panels in Art Deco patterns, and Tony Bechara's quarter-inch, quietly vibrant, colored squares cover his compositions. Photo-realist Doug Webb paints landscapes based on humorous concepts. Two figurative painters, Linda Prince and Susan Pines, are also represented by the gallery.

Canadian Wendy Knox-Leet's wall sculptures are spontaneous and elegant. Algernon Miller also creates wall sculpture made of intertwined metal scraps. The wall constructions of Joan Wenzel are eccentric, composed of thickly painted, abstract shapes. Toby Buonagurio's ceramic sculpture is wild, glittery and very colorful.

The gallery maintains a permanent exhibition of paintings and sculpture of Yves Klein, an influential postwar French artist.

Some two dozen editions have been published by the gallery. There is also an extensive inventory of graphics available.

Babcock

Babcock Galleries 20 E. 67th St., New York, NY 10021
(212) 535-9399 By appointment only

Established in 1852, the gallery is one of the oldest in New York and is devoted exclusively to American art. Director Michael St. Clair operates the gallery on the first floor with two private viewing rooms in the rear. Landscapes, still lifes, and figurative and abstract works are included in the collection of nineteenth- and twentieth-century paintings, drawings and sculpture. The director is interested, not in advancing art of one particular style or persuasion, but in exhibiting many different schools of art ranging from Hudson River painters to modernists.

Nineteenth- and twentieth-century painting is emphasized with works by renowned artists of their respective eras. They include Thomas Eakins, Winslow Homer, Albert Ryder, William Glackens, Childe Hassam, Marsden Hartley, Alfred Maurer, E. Ambrose Webster and the estate of Sol Wilson. Contemporary artists shown are Byron Burford, Helen Hole and Werner Groshans.

Berry-Hill

Berry-Hill Galleries, Inc. 743 Fifth Ave., New York, NY 10022
(212) 371-6777 Monday-Friday: 9-5:30; Saturday: 10-4 Summer:
closed Saturday

The gallery deals in nineteenth- and early twentieth-century American art, with emphasis on the American Impressionist and Luminist movements.

Among main works by American Impressionist painters are land-scapes and seascapes by Ernest Lawson, Childe Hassam, Theodore Robinson, Edmund Tarbell, John Twachtman and Maurice Prendergast; portraits by Robert Henri, William M. Chase and Frederick Frieseke; and Western scenes by H. F. Farny and William R. Leigh. Works by American Luminists include landscapes and seascapes by Martin Johnson Heade and Fitz Hugh Lane, still lifes by William Harnett, and genre paintings by J. G. Brown.

The gallery is one of the leading dealers in paintings done for the export market in a "Western" style by nineteenth-century Chinese artists. It also represents the estate of Malvina Hoffman, an American sculptress of the early twentieth century, and Wayman Adams, an important twentieth-century painter of portraits and still lifes.

The gallery maintains a collection of delicate flower still lifes by nine-teenth-century, Pre-Raphaelite artist Fidelia Bridges, from Connecticut.

Werner Groshans, *Young Woman with Auburn Hair,* 17″ x 13″, pastel. Babcock Galleries.

Recent paintings by Cornelia Foss, which include Long Island land-scapes in oil and watercolor, can also be seen.

Castelli Feigen Corcoran

Castelli Feigen Corcoran 1020 Madison Ave., New York, NY 10021
(212) 734-5505 Tuesday-Saturday: 10-6 August: closed

Three well known art dealers—Leo Castelli and Richard Feigen, both of New York, and James Corcoran of Los Angeles—teamed up to open this space a few years ago. The gallery was founded to represent the estate of surreal assemblagist Joseph Cornell. Almost all the exhibitions are confined to Cornell's work. Occasionally some other artists are exhibited which usually are culled from the stables of the three gallery owners. Some of these exhibitions have included the works of Dubuffet, James Rosenquist, and others.

Castelli Graphics

Castelli Graphics 4 E. 77th St., New York, NY 10021 (212) 288-3202 Tuesday-Saturday: 10-6 and by appointment
43 W. 61st St., New York, NY 10023 (212) 245-0673 Tuesday-Saturday: 1-6 and by appointment August: closed

Although the original Leo Castelli Gallery was founded in 1957, Castelli Graphics was opened twelve years later to represent the graphics of Castelli artists and the work of contemporary photographers.

The graphics department includes works of American artists Ellsworth Kelly, Robert Rauschenberg, James Rosenquist, Frank Stella, Cy Twombly, Richard Serra and Jasper Johns. Works of many well-known Pop artists of the 1960s, such as Roy Lichtenstein, Claes Oldenburg and Andy Warhol, are also shown.

Photographers shown at the uptown gallery deal with a wide range of subject matter. They include Eve Arnold, Lewis Baltz, Robert Cumming, Bernard Faucon, Ralph Gibson, John Gossage, John Gutmann, Mary Ellen Mark, Hans Namuth, Don Rodan, Sandy Skogland and Eve Sonneman.

Christie's

Christie's Contemporary Art 799 Madison Ave., New York, NY 10021
(212) 535-4422 Monday-Saturday: 10-6

The gallery recently opened in order to meet an expanding American print market. Starting with mail order catalogues in 1977, the company currently has more than 25,000 active members who regularly purchase prints from its collection. Each year approximately 160 new editions are published in eight separate launchings. All editions are accompanied by a certificate of authenticity and a biography of the artist. Christie's plans to supplement its European print collection by publishing a number of editions by American artists.

Christie's also deals in works by Henry Moore, Miro, David Hockney, Ben Nicholson, Graham Sutherland and other internationally famous artists. The gallery's collection of Moore graphics is the largest of any commercial gallery and is supplemented by a selection of Moore bronzes.

Christie's has scheduled one-person shows of works by Hockney and Moore, as well as other special shows.

Coe Kerr

Coe Kerr Gallery 49 E. 82nd St., New York, NY 10021 (212) 628-1340
Monday-Friday: 9-5; Saturday during advertised exhibitions: 10-5

Established in 1969, Coe Kerr Gallery specializes in nineteenth and twentieth century American paintings and sculpture. The gallery occupies a townhouse between Park and Madison Avenues. The lower two floors comprise a public exhibition space for organized shows while the upper two floors contain semi-private viewing rooms where paintings from the gallery inventory can be individually displayed.

The gallery attempts to have available at any given time high quality examples of the Hudson River Valley school artists, among them Thomas

Frank Benson, *Portrait of Mrs. Benjamin Thaw and Her Son,* 60″ x 39½″, oil on canvas. Berry-Hill Gallery.

George Cochran Lambdin, *Calla Lilies* (1874), 20″ x 11½″, oil on canvas. Berry-Hill Galleries.

Pablo Picasso, *Fireplace* (1945), 20″ x 25¼″, ink wash. James Goodman Gallery.

Cole, Frederic E. Church, Martin J. Heade; the American Impressionists, among them Ernest Lawson, Childe Hassam, Alden Weir; the Ash Can School, among them John Sloan, George Luks, Everett Shinn; the Modernists; the Regionalists and the best-known Western artists.

In the contemporary field Coe Kerr is the primary dealer for Andrew Wyeth and his son Jamie. Among other contemporary artists represented by the gallery are James Bama, Jonathan Kenworthy and Robert Cottingham.

Cordier & Ekstrom

Cordier & Ekstrom 417 E. 75th St., New York, NY 10021 (212) 988-8857 Tuesday-Saturday: 10-5:30 June-August: closed Saturday

Located in what director Arne Ekstrom believes is an emerging area near Sotheby-Parke Bernet's New York outlet, the gallery puts on provocative theme shows, a tradition it started more than two decades ago.

The gallery consists of two spacious floors. Monthly one-person shows are held on the lower floor, while works by gallery artists constitute a permanent exhibit on the upper floor.

Among the artists represented are Romare Bearden, Varujan Boghosian, Margaret Israel and Howard Newman, who are generally unconventional and innovative. Margaret Israel works in mixed-media combinations, such as paintings on canvas, painted wood panels, blackboard drawings, fabric constructions, stained glass pieces, feather creations, and plaster, ceramic and papier mache sculpture. Howard Newman is a sculptor who works in bronze. His numerous drawings are also shown.

Painter Michael Flanagan also shows his works. They are very finely detailed, narrative studies, somewhat surrealistic, reflecting observations of his youth. Herk Van Tongeren shows his paintings and constructions, executed somewhat like Italian de Chirico. Other works are found, some unusual. Alan Siegel shows his constructions and Sandra McIntosh's currency collages also make up part of the gallery's diverse offerings.

Niki de Saint Phalle, *Two Headed Serpent* (1981), 26" x 44" x 14½", cast polyester and metal. Gimpel & Weitzenhoffer Gallery.

Tony Buonagurio, *Bionic Toby with Pet Boa* (1982), 25″ high, Ceramic. Gallery Yves Arman.

Barbara Hepworth, *Head (Chios)*—1958, 8¼″ high, alabaster. Gimpel & Weitzenhoffer Gallery.

Edgar Degas, *Draught Horse,* 4″ high, bronze. Hammer Galleries.

Maxwell Davidson

Maxwell Davidson Gallery 43 E. 78th St., New York, NY 10021
(212) 734-6702 Tuesday-Saturday: 10-6 August: closed

The gallery specializes in master works of the nineteenth and twentieth centuries with emphasis on American and French art. Only paintings, drawings and sculpture are shown. In addition to master works, the gallery is also committed to exhibiting works by young painters of exceptional promise with little or no previous exhibition record.

The concentration is on American twentieth-century masters, such as Sam Francis and George Richey, who have had one-person shows. Works by William Baziotes, Bradley Walker Tomlin, Kenneth Noland and Alfred Jensen are also available at the gallery.

The gallery has a special interest in drawings and watercolors by the French Impressionists and other nineteenth-century masters. Included in the current holdings are works by Auguste Renoir, Camille Pissarro, Berthe Morisot, and Edgar Degas.

Exhibiting contemporary artists are diverse in style. The gallery represents Carol Anthony, who does landscapes and still lifes of extraordinary sensitivity, and Tony Scherman whose bold, colorful encaustic canvases put him at the forefront of an international reputation. Also represented is Gary Komarin, whose abstract expressionist works are powerful and unique.

Davis & Langdale

Davis & Langdale Company, Inc. 746 Madison Ave., New York, NY 10021 (212) 861-2811 October-May: Tuesday-Saturday: 10-5; June-September: Monday-Friday: 10-5

Formerly Davis & Long, the gallery owns a large collection of British and American oil paintings, watercolors, drawings and pastels spanning three centuries.

Specializing in British art of the nineteenth and twentieth centuries, the gallery has works by such renowned painters as Thomas Gainsborough, John Martin, Edward Lear and Gwen John. There is a sizable collection of works by American painters Maurice Prendergast and William Merritt Chase. Landscapes in oil by Albert Bierstadt, a nineteenth-century Hudson River painter, are also represented.

A growing stable of contemporary American artists is regularly exhibited at the gallery. Painters Lennart Anderson and Aaron Shikler are primarily realists, with Shikler specializing in portraits. Robert Kulicke is a jewelry maker as well as a painter, and Addie Herder creates collage constructions. Albert York recently had a one-person show of landscape paintings and still lifes. Harry Roseman's medium-sized bronze sculptures are miniature cityscapes. Conceptual artist Michael Langenstein also works in three dimensions, and recently displayed his "Proposals" at the gallery. The first American one-person exhibit of works by contemporary English figurative artist Lucian Freud was held at the gallery.

Robert Elkon

Robert Elkon Gallery 1063 Madison Ave., New York, NY 10028
(212) 535-3940 Tuesday-Saturday: 10-5:45 August: closed

The gallery specializes in works by modern masters and contemporary artists. It exhibits paintings, sculptures and works on paper by a range of American and European artists.

Major twentieth-century artists exhibited include such masters as Jean Dubuffet, Matisse, Alberto Giacometti, Wassily Kandinsky, and Rene Magritte. Artists of the New York school, such as Jackson Pollock, Robert Motherwell, Mark Rothko and Clyfford Still are represented. Also represented are the color-field painters Morris Louis, Friedl Dzubas and Jack Bush. Other eminent artists include Sam Francis, Hans Hofmann, Agnes Martin, Echaurren Matta and Ad Reinhardt.

Works by contemporary artists seen at the gallery include paintings by William Ridenhour, Jean-Pierre Pericaud, David Roth, Kimber Smith

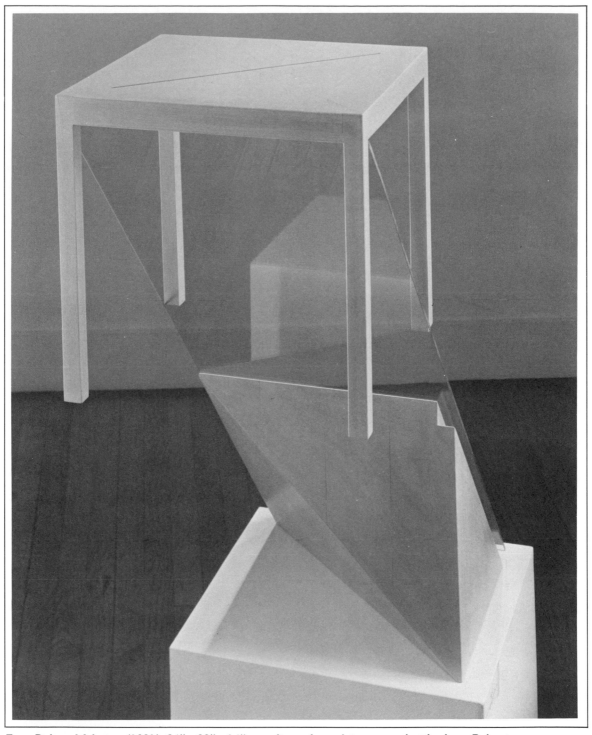

Tony Delap, *Mahatma* (1981), 34" x 33" x 14", acrylic and graphite on wood with glass. Robert Elkon Gallery.

and John Wesley; drawings by William Koenigstein; and sculptures and two-dimensional pieces by Charles Arnoldi, Tony Delap, Nigel Hall and william Tucker.

Most of the work carried by the gallery is abstract, although the director does not strictly adhere to any particular style.

Ericson

Ericson Gallery 23 E. 74th St., New York, NY 10021 (212) 737-6155
Tuesday-Saturday: 11-6

The gallery exhibits works by both young, emerging New York artists and well-established artists. All works shown are contemporary and non-objective. Paintings and collages in various media are generally represented.

One-person shows change once a month, and occasionally there is a group show of the gallery artists.

Edith Newhall is a new artist, whose simple abstract forms refer to landscape. Abstract expressionist Theodoros Stamos paints floating colors, so that his work has an ethereal feeling similar to stain paintings. Dove Bradshaw's small-scale collages use mixed media, encaustic and carbon removals to create abstract forms. Robert Quijada makes architectonic constructions of canvas, wood, string and acrylics that deal with color. Minimalist William Anastasi does collages, encaustics and performance art. Dana Gordon's paintings are expressionistic and abstract, sometimes referring to landscape and always using strong colors and aggressive imagery. Abstracted masks by Clayton Mitropoulos, which are meant to be hung on walls rather than worn, are constructivist in style with themes that relate to their personalities. Hans Hinterreiter, from the Swiss Concrete Art movement, works in color theory and design.

David Findlay

David Findlay Galleries 984 Madison Ave. at 77th St., New York, NY 10021 (212) 249-2909 Monday-Saturday: 10-5 July & August: Monday-Friday: 10-5

The gallery was founded in Kansas City in 1870 and moved to New York in 1937. It exhibits nineteenth- and early twentieth-century French and American paintings, contemporary French paintings, and contemporary American paintings and graphics.

Artists included in the gallery's collection of nineteenth- and twentieth-century paintings are Childe Hassam, Fantin-Latour, Irving Couse, Henry Farny, Armand Guillaumin, Eugene Boudin, Martin Johnson Heade, George Inness, Johan Berthold, Gustave Loiseau, Willard Metcalf, Thomas Moran, Severin Roesen and Andre Segonzac.

Among contemporary French artists represented are Bernard Cathelin, Pierre Lesieur, Maurice Brianchon, Roger Muhl, Rene Genis and Bardone, who are all Post-Impressionist painters from the Paris School.

Contemporary American artists exhibited range from Abstract Expressionist painters to photorealists. They include Ida Kohlmeyer, Philip Mullen and Lucinda Parker, who work abstractly, and Peter Poskas, John Register, Donald Roller Wilson and Bob Paige, who are realists.

The David Findlay Galleries also carries graphics of contemporary French and American painters represented by the gallery.

Forum

Forum Gallery 1018 Madison Ave., New York, NY 10021 (212) 772-7666 Tuesday-Saturday: 10-5:30

Specializing in American art with emphasis on figurative works of the late nineteenth and twentieth centuries, the gallery carries an extensive inventory of works by prominent artists and sculptors.

Artists represented include sculptors Chaim Gross and Bruno Lucchesi and landscape painter Herman Maril. David Levin is noted for his exquisite watercolors and whimsical facial studies. Laura Zieger shows her portraits in terra cotta. Also exhibited are paintings by realists

Alexander Calder, *Little Critter* (1974), 31"
high, painted metal. James Goodman
Gallery.

Howard Newman, *Torso #4*, 10 high,
bronze. Cordier & Ekstrom Gallery.

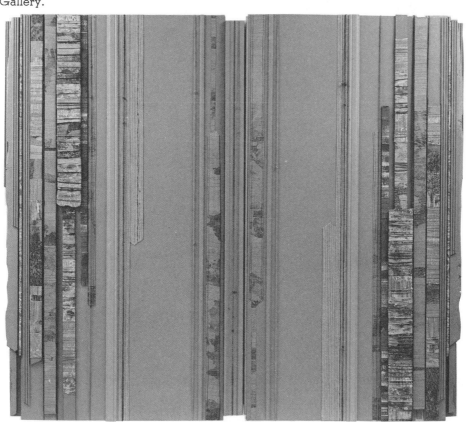

Robert Quijada, *Gray Construction No. 2* (1982), 48" x 54", acrylic, canvas and
wood. Ericson Gallery.

Edward Hopper and Raphael Soyer, both of whom often depicted New York City street scenes. Works from the estates of Max Weber and Hugo Robus are also available. Other distinguished artists whose works may be seen include George Bellows, Arthur B. Davies, Stuart Davis, Philip Evergood, George Grosz, Charles Hawthorne, John Marin, Reginald Marsh, Elie Nadelman, Jules Pascin, Ben Shahn and James McNeil Whistler.

Xavier Fourcade

Xavier Fourcade, Inc. 36 E. 75th St., New York, NY 10021
(212) 535-3980 Monday: by appointment; Tuesday-Friday: 10-5:30; Saturday: 10-5

The gallery represents major contemporary painters and sculptors as well as important works of the first half of the twentieth century. Shows which run approximately six weeks, focus on individual artists, periods or formal styles.

Pioneer abstractionists represented by the gallery include Willem de Kooning, Marcel Duchamp and Raymond Duchamp-Villon, in addition to the estate of Arshile Gorky. Other gallery artists are Tony Berlant, Georg Baselitz, William Crozier, Raoul Hague, Michael Heizer, Joan Mitchell, Henry Moore, Malcolm Morley, Catherine Murphy, Dorothea Rockburne, Bram van Velde and the estates of Barnett Newman and H. H. C. Westermann.

In addition, the gallery carries a large inventory of works by Joseph Cornell, Jean Dubuffet, Roy Lichtenstein, Tony Smith and Louise Bourgeois. The gallery also deals in works by major old masters and nineteenth- and twentieth-century masters.

Hilde Gerst

Hilde Gerst Gallery 685 Madison Ave., New York, NY 10021
(212) 751-5655 Monday-Saturday: 11-5

The gallery has specialized in high-quality French paintings by Impressionists and Post-Impressionists. Works by Marc Chagall, Maurice Utrillo, Maurice R. Vlaminck, Raoul Dufy, Marie Laurencin, Henri Manguin and others in this category are displayed together with modern paintings by artists such as Andre Lanskoy, Matta, Serge Poliakoff and other.

The owner has sought and introduced new talents to her American and international clientele. Most of these artists are of French and Spanish origin.

A large space of the gallery has been devoted to graphics by the world's leading artists, including Chagall, Picasso, Braque, Miro and others. Modern sculpture, tapestries, and antique Oriental paintings and weavings are also shown to complement the gallery's focus on paintings.

Gimpel & Weitzen-hoffer

Gimpel & Weitzenhoffer Ltd. 1040 Madison Ave., New York, NY 10021
(212) 628-1897 Tuesday-Friday: 10-6; Saturday: 10-5:30

The gallery specializes in abstract contemporary painting and sculpture. Both European and American artists are represented. There is also a small graphics department. The gallery is associated with Gimpel Fils in London and Gimpel-Hanover in Zurich.

Most of the art is nonrepresentational. Among the nonfigurative artists represented are Paul Jenkins, Robert Natkin, Alan Davie and Pierre Soulages, who have all achieved international reputations for their bold styles.

Works of figurative artists such as Lester Johnson, Clarence Carter and Joachim Berthold are also exhibited at the gallery. The unusual cast polyester figures by Niki de St. Phalle may also be seen at the gallery.

Sculpture exhibited at the gallery is diverse in nature. The geometrical cast bronzes of English sculptor Robert Adams contrast with the light-weight small-scale, tinplate pieces by Robert Cronin. Minoru Niizuma is the only sculptor represented who uses marble in his work.

The gallery has two floors for exhibition. The top floor is usually the

Paul Jenkins, *Phenomena Track the Wind* (1980), 36″ x 24″ acrylic on canvas. Gimpel and Weitzenhoffer Gallery.

Clayton Mitropoulos, *Mask: The Assasin* (1981), 18½″ diameter, Gesso on cut out mahogany. Ericson Gallery.

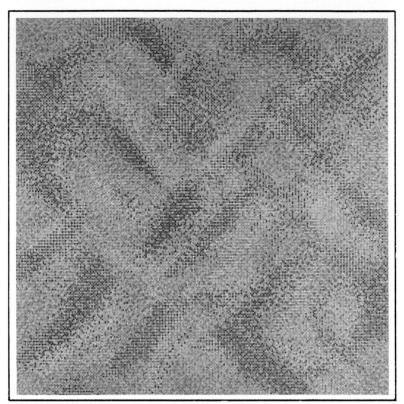

Tony Bechara, *Ghislane's Dust* (1982), 66″ x 66″. Gallery Yves Arman.

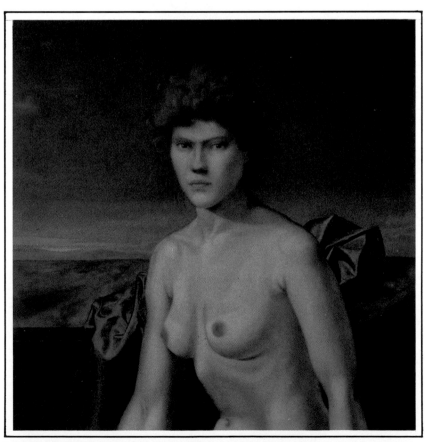

Martha M. Erlebacher, *Memory of Diane* (1981), 22″ x 22″, oil on canvas.
Robert Schoelkopf Gallery.

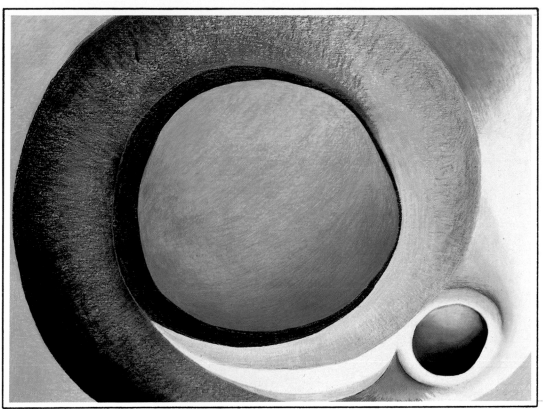

Georgia O'Keeffe, *Goat Horn with Blue* (1945), 27¾" x 35½", pastel on paper mounted on board. Barbara Mathes Gallery.

Fernand Leger, *Composition a la Feuille* (1931), 19¾" x 25½", oil on canvas. James Goodman Gallery.

Jean Dubuffet, *Sourire, Tete Hilare II,* (1948),
36¼" x 38¾", oil on canvas. Robert Elkon Gallery.

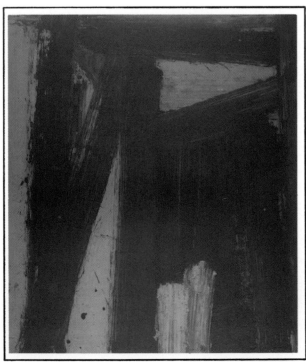

Edvins Strautmanis, *For Cherry,* 91" x 78", acrylic
on canvas. Allan Stone Gallery.

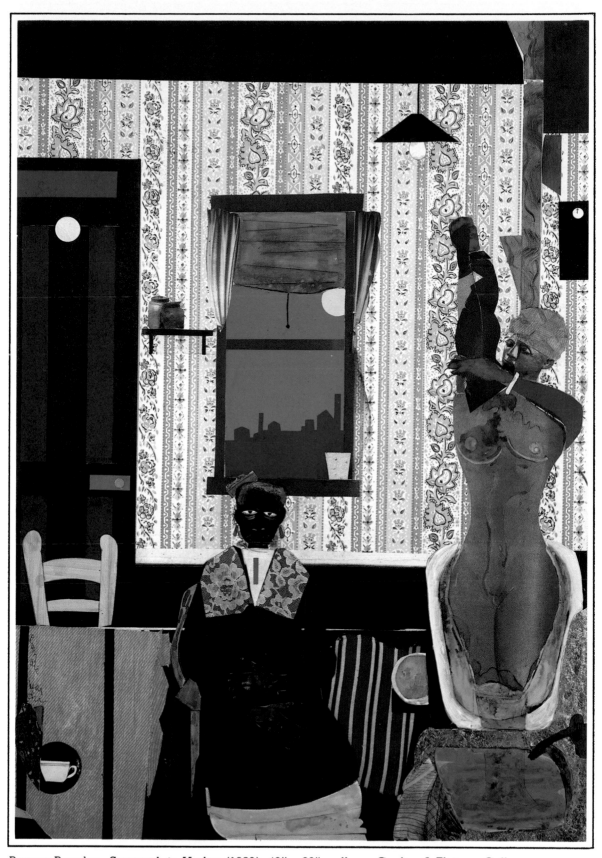

Romare Bearden, *Suzannah in Harlem* (1980), 40″ x 30″, collage. Cordier & Ekstrom Gallery.

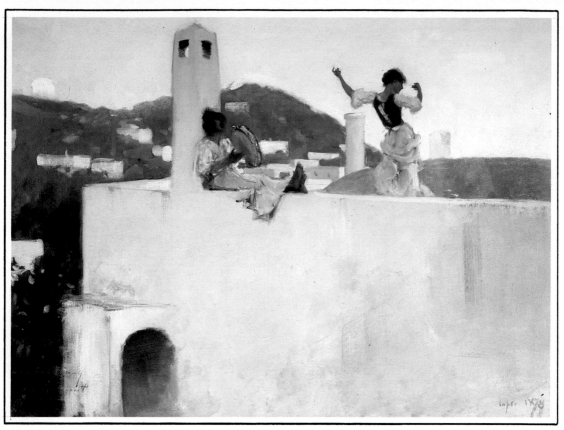

John Singer Sargent, *Capri* (1878), 20″ x 25″, oil on canvas. Berry-Hill Galleries.

Pablo Picasso, *The Musketeer* (1967), 29″ x 24″, oil on canvas. Sindin Galleries.

Marsden Hartley, *Shell and Sea Anemones, Gloucester* (c. 1934), 18" x 24", oil on panel.
Babcock Galleries.

Fitz Hugh Lane, *Castine Harbor and Town* (1851), oil on canvas. Berry-Hill Galleries.

Kieff, *Folklore 30,* 26" high, polished bronze.
Randall Galleries.

Michael Malpass, *Morning Sphere* (1982), 19"
diameter, bronze. Andre Zarre Gallery.

Charles Burchfield, *From Autumn to Winter* (1966), 49″ x 74½″, watercolor. A.C.A. Gallery.

Jasper Cropsey, *Stoke Poges* (1867), 20″ x 32″, oil on canvas. Ira Spanierman Gallery.

Asger Jorn, *Animals in the Garden* (1955) 37½″ x 31½″.
Lefebre Gallery.

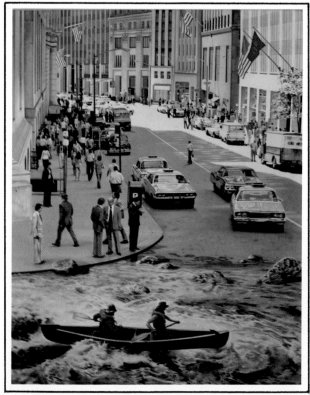

Doug Webb, *Rapid Transit,* 40″ x 30″, acrylic on linen.
Gallery Yves Arman.

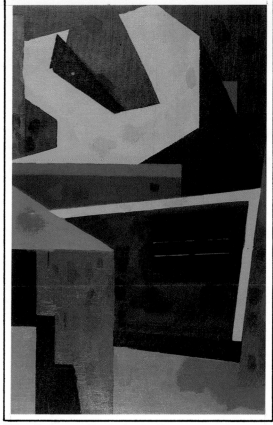

Niles Spencer, *Study for In Fairmont,* 24″ x 15″,
oil on canvas. Vanderwoude Tananbaum Gallery.

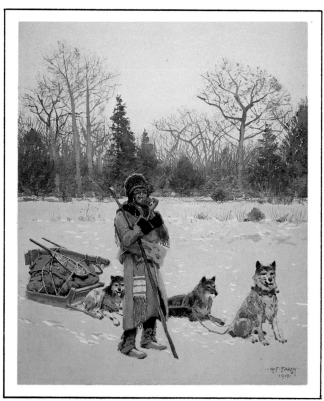

Henry F. Farny, *Indian Lighting Pipe by Dog Sled* (1903),
10½″ x 7¼″, gouache. Ira Spanierman Gallery.

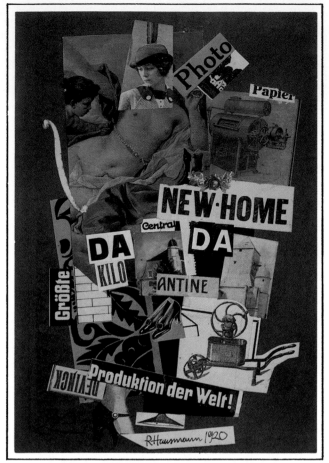

Raoul Hausmann, *New Home* (1920), 11½″ x 8½″,
collage. La Boetie Gallery.

Hugo Scheiber, *Cocktail Hour,* 19″ x 27″,
gouache. Matignon Gallery.

Edward Potthast, *On the Beach,* 12½ x 15", oil on panel. Ira Spanierman Gallery.

Claude Gelee (a.k.a. Claude Lorrain), *Pastoral Landscape* (c. 1657), 38" x 52", canvas. Noort-man & Brod Gallery.

Charles Demuth, *Tree Trunks.* Richard York Gallery.

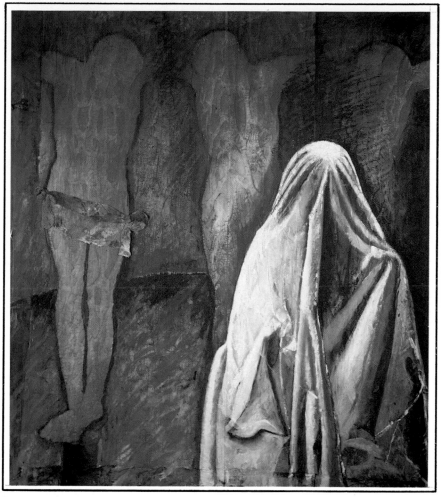

Juan Martinez, *Gruenwald* (1982), 73½" x 63", mixed media on gauze.
Lefebre Gallery.

Thomas Shotter Boys, *Les Invalides, Paris, Late Afternoon,* 5¼" x 9", watercolor. Noortman &
Brod Gallery.

191

Robert Natkin, *Bern Series* (1982), 42″ x 29″, acrylic
on paper. Gimpel & Weitzenhoffer Gallery.

Paul Klee, *Allegorical Figurine* (1927), 18½″ x 16¾″, oil on
board. James Goodman Gallery.

setting of one-person shows and the lower floor is used to show works by all the gallery artists. Display windows are used also to exhibit works by gallery artists.

Lucien Goldschmidt Inc. 1117 Madison Ave., New York, NY 10028 (212) 879-0070 Monday-Friday: 10-6; Saturday: 10-5

The gallery represents graphic art from Albrecht Durer to Picasso, Henri Matisse and Jacques Villon. It emphasizes, not only famous artists like Rembrandt, Goya or Henri de Toulouse-Lautrec, but also many print-makers of French, Italian, German and Dutch schools. Illustrated catalogues are issued at regular intervals.

Exhibitions of both drawings and prints are held. Most recently on view were designs by the Navone brothers executed for a Roman theatre in 1791, and *Pasiphae*, ninety linoleum cuts by Matisse, which were not printed until 1981 and were first displayed at the gallery.

The owner has a special interest in works by Piranesi, French and Italian Mannerists and Jacques Villon, as well as in ornament prints and architectural drawings. The gallery also specializes in modern illustrated books.

James Goodman Gallery, Inc. 1020 Madison Ave., New York, NY 10021 (212) 427-8383 Monday-Saturday: 10-5 Summer: closed Saturday

The gallery handles paintings, drawings, watercolors and sculpture by twentieth-century European and American masters as well as by many contemporary artists.

The collection of works on paper is of special interest. This includes small works by Roy Lichtenstein and original drawings by Saul Steinberg. Pencil drawings by Amedeo Modigliani and gouaches by Alexander Calder are exhibited, in addition to works by Adolph Gottlieb, Sam Francis, Picasso, Hans Hofmann, Jean Dubuffet, Matisse, Henry Moore, Fernando Botero, and Modigliani.

Paintings are available by Roy Lichtenstein, Mark Rothko, Matisse, Willem de Kooning, Fernand Leger, Andy Warhol, Tom Wesselmann, Jim Dine and Claes Oldenburg. The gallery also shows watercolors and washes by Miro.

The collection of sculpture includes small object pieces by Joseph Cornell, bronzes by Alberto Giacometti and mobiles by Calder, as well as more traditional pieces by Barbara Hepworth, Marino Marini and Auguste Rodin.

Exhibitions are usually group shows of the gallery artists. Several times a year there is a special exhibition of works by one artist, most recently Botero and Picasso.

Germantown "Moki" Blanket, (Navajo, c. 1890), 80" x 54". A.C.A. Indian Gallery.

193

Heller

Heller Gallery 965 Madison Ave., New York, NY 10021
(212) 988-7116 Monday-Saturday: 11-6

The gallery is devoted to the presentation of contemporary glass sculpture by American and European artists.

American and European glass artists are expanding on traditional techniques to create innovative sculpture. The gallery represents artists such as Harvey Littleton, with his massive, vibrantly colored sculptures, and Tom Patti, with his subtle miniature, blown forms.

The majority of artists represented have university training in the glass arts. Some of the young, skilled artists shown are William Carlson, whose geometric glass scent bottle can be seen in the Metropolitan Museum of Art, Steven Weinberg, who creates sculptures of geometric units, and John Kuhn, whose glass sculptures appear to be geological jewels.

The gallery presents two one-person shows each month in its rear and lower spaces. The front space is designed for the gallery's permanent collection.

Hirschl & Adler

Hirschl & Adler Galleries 21 E. 70th St., New York, NY 10021
(212) 535-8810 Tuesday-Friday: 9:30-5:30; Saturday: 9:30-5 June, July & September: Monday-Friday: 9:30-5 August: by appointment only

The gallery maintains an encyclopedic collection of eighteenth- and nineteenth-century European paintings as well as American works ranging from the mid-eighteenth century through the 1950s. The gallery's contemporary works are now exhibited at a separate location (See Hirschl & Adler Modern).

The collection of American art includes portraits by John Singleton Copley, still-life paintings by William Harnett and figurative scenes by Eastman Johnson. Also featured are detailed landscapes by painters of the Hudson River school, such as Albert Bierstadt and Jasper Cropsey. Luminist landscapes by Martin Johnson Heade and Fitz Hugh Lane may also be seen as well as cityscapes by realist painters of "The Eight," including Robert Henri, John Sloan, George Luks, Everett Shin, and William Glackens. Watercolors by Winslow Homer are also available.

Works by French Impressionists and Post-Impressionists, namely Camille Pissarro, Pierre Bonnard and Paul Gauguin, contribute to the magnitude of the gallery's holdings.

The gallery moved to this landmark building which houses their expanding collection. The building, designed by William Rogers, was a residence when erected in 1918. In 1970 it was renovated to house a modern art gallery and now includes sophisticated lighting and atmospheric controls. The elegant interior creates a quiet, subtle mood which focuses the viewer's attention on the paintings.

Hirschl & Adler Modern

Hirschl & Adler Modern 851 Madison Ave., New York, NY 10021
(212) 744-6700 Tuesday-Saturday: 10-5:30

Norman Hirschl and Don McKinney have recently opened this large modern art space which features the works of most of the contemporary artists previously affiliated with its parent gallery, Hirschl & Adler on 70th Street. A number of other artists will be featured in exhibitions ranging from one-person to group shows. Twentieth century modernists will dominate the exhibitions with a heavy emphasis on Americans.

Extensive offerings of paintings by artists of the New York School will be shown highlighting the First Generation including Franz Kline, Jackson Pollock, and William Baziotes. Some works will be available by Jasper Johns, Louise Nevelson and Henry Moore. Artists represented exclusively by the gallery include Britisher John Walker, Fairfield Porter, and the Estates of Ann Ryan and George L. K. Morris.

Approximately a dozen contemporary painters are represented whose works are largely abstract or concerned with figuration. Among them are a group of San Francisco Bay painters, many influenced by David Parks.

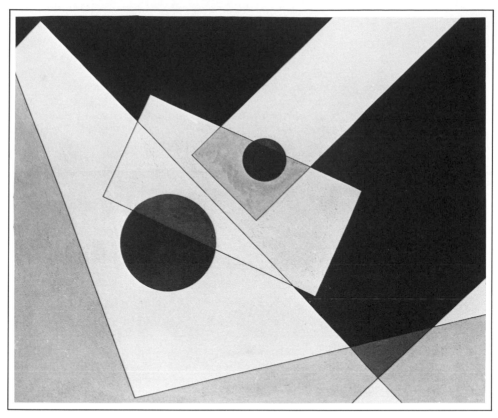

Laszlo Moholy-Nagy, *Study for AM4* (1926), 12½″ x 14″, gouache and ink. La Boetie Gallery.

Carl-Henning Pedersen, *The Chinese Luck God* (1980), 49″ x 41″, oil on canvas. Lefebre Gallery.

Roy Superior, *Celestial Rake* (1981), 16″ high, wood. Heller Gallery.

Chief among them are James Weeks, Elmer Bishoff and Paul Wonner. Some realism will be shown in the works of Rackstraw Downes, John Moore, Sarah Supplee and Nancy Mitchnik whose paintings lean more toward the surrealistic. Also shown will be Lloyd Goldsmith and Mark Stock.

Some works will be available by artists of the Stieglitz Group including those of Arthur Dove, Georgia O'Keeffe, Charles Demuth and Marsden Hartley.

Leonard Hutton

Leonard Hutton Galleries 33 E. 74th St., New York, NY 10021
(212) 249-9700 Monday-Friday: 11-5:30

The gallery specializes in German Expressionist and Russian avant-garde works of art. Paintings, watercolors, drawings and, occasionally, lithographs of the finest artists of these periods are always on view. German Expressionist artists whose works are shown include Alexej Jawlensky, Wassily Kandinsky, August Macke, Franz Marc, Gabriele Munter, Emil Nolde, Max Pechstein and Georg Tappert. Russian avant-garde artists include Vladimir Baranoff-Rossine, Ilya G. Chashnik, Alexandra Exter, Natalia Gontcharova, Mikhail Larionov, Lazar (El) Lissitzky, Kazimir Malevich, Ivan Puni, Alexandre Rodchenko, Olga Rozanova and Nadezhda Udaltsova. Costume and theatre designs by artists such as Sonia Delaunay are also featured.

Knoedler

M. Knoedler & Co., Inc. 19 E. 70th St., New York, NY 10021
(212) 794-0550 Tuesday-Friday: 9:30-5:30; Saturday: 10-5:30

Founded in 1846, the gallery is one of the oldest exhibiting institutions in New York and also has a well-established London branch. Artists represented by the gallery are international and well known. Each has a show, generally of recent works, within a two-year span.

Recent works by color-field painters Walter Darby Bannard and Friedel Dzubas have been featured, as well as recent paintings by Abstract Expressionist Herbert Ferber, Minimalist Jules Olitski, Jack Roth and Nancy Graves.

The estates of several important artists are represented by the gallery. They include the Esther and Adolph Gottlieb Foundation and the estates of Alexander Calder, Ludwig Sander and David Smith.

Calder's past show at the gallery featured his small-scale works and gouaches. Other shows highlighted David Smith's early works, spray paintings and drawings, and Frank Stella's metal reliefs. A small retrospective of the work of Adolph Gottlieb included the artist's early paintings up to works prior to his death.

Monique Knowlton

Monique Knowlton Gallery 19 E. 71st St., New York, NY 10021
(212) 794-9700 Tuesday-Friday: 9:30-5:30; Saturday: 12-6

Before opening a public space, the owner was a private dealer in works on paper by Austrian Expressionist Egon Schiele, *Jugendstil* artist Gustave Klimt and Swiss fantasist Paul Klee, as well as in paintings by Oscar Bluemner, whose work became her specialty. In a turn towards contemporary art, Monique Knowlton now shows a new kind of surrealism that deals with personal narrative and lush decorative motifs. Among the best known artists working in this mode who made their first one-person shows at the gallery are Frank Faulkner, Robert Beauchamp, Gaylen Hansen, Joseph Piccillo, Helen Miranda Wilson, Helen Oji, Ron Isaacs, Tommasi Ferroni, Phyllis Bramson and Richard Thompson.

The work, for the most part, is expressionistic and surrealistic, with an obsessive quality in either image or technique and often both. The owner looks for a sense of mystery and a childlike, naive quality, as well as extraordinary attention to detail and a central appeal in both color and luminosity of surface.

Among past major exhibitions, "Art in Boxes" featured Andy Warhol, Robert Rauschenberg, Lucas Sumaras, Joseph Cornell, Louise Nevelson

Robert Beauchamp, *Untitled* (detail)—1980, charcoal on paper. Monique Knowlton Gallery.

and gallery artist Betty Saar. Works by Gerome Kamrowski, who worked with Jackson Pollock and William Baziotes on the first drip paintings, were also shown in a major exhibition at the gallery.

La Boetie

La Boetie, Inc. 9 E. 82nd St., New York, NY 10028 (212) 535-4865
Tuesday-Saturday: 10-5:30 August: closed

The gallery concentrates on works in all media by artists belonging to major movements of the twentieth century, namely German and Austrian Expressionism, Dadaism, Surrealism, Futurism, the Bauhaus, and the Russian avant-garde. In addition, the gallery handles work of high quality by such modern masters as Balthus, Henry Moore, Henri Matisse, Giorgio Morandi and Fernando Botero.

The gallery's director, Helene Serger mounts several important exhibitions every year. Herwarth Walden's Der Sturm Gallery was highlighted with works from the first ten years of exhibitions, mostly works on paper, by Oskar Kokoschka, Wassily Kandinsky, Chagall, Alexander Archipenko, Kurt Schwitters, August Macke, and Laszlo Moholy-Nagy. A selection of objects by artists from 1915 to 1965 featured ready-mades, collages and found objects by Marcel Duchamp, Man Ray and Andre Breton, among others. Choice Dada works on paper included rare pieces by Hannah Hoech, Johannes Baader and Jean Arp.

The exhibit "Three German Artists' Colonies: Worpswede, Moritzburg, Murnau" featured works by young German artists of the early twentieth century. Other recent shows included "Pioneering Women Artists: 1900-1940" and "Abstract and Constructivist Art 1910-1930."

Lefebre

Lefebre Gallery 47 E. 77th St., New York, NY 10021 (212) 744-3384
Tuesday-Saturday: 10-5:30 June: Tuesday-Friday: 11-5 July and August: closed

The gallery features works by European painters and sculptors. Since opening, the owner has shown the work of several artists associated with COBRA, a group of painters from Copenhagen, Brussels and Amsterdam. They include Pierre Alechinsky, Corneille, Christian Dotremont, Carl-Henning Pedersen and Asger Jorn.

Others represented by the gallery are German artists Horst Antes, Julius Bissier and Klaus Fussmann; Belgian sculptors Pol Bury and Reinhoud and Belgian watercolorist and printmaker Jean-Michel Folon. Also represented are British artist Tom Phillips, Argentinian painter Antonio Segui, Chinese painter Walasse Ting and Spaniard Juan Martinez.

These gallery artists were first represented in America by the Lefebre Gallery. Only Hans Hartung and Serge Poliakoff, personal friends of the owner since the time he lived in Paris in the 1950s, had already been internationally established when they joined the gallery.

Barbara Mathes

Barbara Mathes Gallery 19 E. 71st St., New York, NY 10021
(212) 249-3600 Tuesday-Friday: 9:30-5:30; Saturday: 10-5:30
June & July: Monday-Friday: 10-5 August: closed

The gallery, which is small and elegant, specializes in nineteenth- and twentieth-century European and American paintings, sculpture and works on paper. It handles important American pictures of the twentieth century by such artists as Oscar Bluemner, Charles Burchfield, Andrew Dasburg, Stuart Davis, Charles Demuth, Arthur Dove, O. Louis Guglielmi, Marsden Hartley, John Marin, Georgia O'Keeffe, Charles Sheeler, Joseph Stella and John Storrs. Postwar American artists include Milton Avery, Alexander Calder, Joseph Cornell, Willem de Kooning, Sam Francis, Helen Frankenthaler, David Hockney, Hans Hofmann, Roy Lichtenstein, Robert Motherwell and Frank Stella. Works by European masters such as Degas, Matisse, and Picasso are also available. The gallery will locate paintings by specific artists for collectors and institutions.

Charles Sheeler, *Still Life* (1921), 12½" x 15", pencil on paper. Barbara Mathes Gallery.

Horst Antes, *The Painter* (*figure in the head*)—1980, 27½" x 38", mixed media.
Lefebre Gallery.

Matignon

Matignon Gallery 897 Madison Ave., New York, NY 10021
(212) 628-6886 or 737-4563 Tuesday-Saturday: 11-6; July & August:
by appointment

The aim of the gallery is to acquaint the public with the work of the
forgotten, forbidden and neglected artists of the European avant-
garde working between the two world wars, particularly those of the
Bauhaus and Der Sturm-related periods. Gallery director Paul Kovesdy's
dream is to provide a place for these artists to find rightful recognition
among the well-known artists of this period.

The exhibition "The Avant-Garde in Eastern Europe" gave the public
its first opportunity to see works by Lajos Kassak, Hugo Scheiber, Bela
Kadar and others. From the early 1920s to the late 1930s, Eastern
European art together with publications such as the *Der Sturm* and *MA*
magazines became internationally known as these artists celebrated new
abstractions and previously unexplored nonfigurative work in the plastic
arts.

The following exhibition in the year of the Bartok Centennial, "Allegro
Barbaro: Bela Bartok and the Eastern European Avant-Garde," showed
the composer's influence transmuted in the visual arts in works by Bela
Kadar, Laszlo Moholy-Nagy, Zsigmond Kolos-Vary, Etienne Beothy,
Sandor Bortnyik and Lajos Kassak.

As more works are recovered, Matignon's exhibitions continue to
expand. Recent exhibitions include "Construtivist Aspects: A Selection
of Eastern European Artists from the 1920's to the Present" which demon-
strated the extensive development of Constructivist ideas in Eastern
Europe, and "Expressionists, Futurists, Cubists and Constructivists,"
which included the work of Janos Mattis-Teutsch, Lajos Tihanyi,
Wladyslaw Strzeminsky, Lajos Kassak and Bela Kadar. The show brings
to light the wealth of ideas and experimentation that actively engrossed
the artists of the European avant-garde.

Neikrug

Neikrug Photographica Ltd. 224 E. 68th St., New York, NY 10021
(212) 288-7741 Wednesday-Saturday: 1-6

One of the city's oldest photography galleries, this three-story space
features a wide selection of nineteenth- and twentieth-century photog-
raphy, an inventory of daguerrotypes and tintypes, an exhibit of antique
cameras and a library of out-of-print photographic books.

The photographers exhibited are eclectic and include both acclaimed
photographers and younger, lesser-known talents. The gallery's stable of
photographers includes such notables as Eva Rubinstein, Bill Brandt,
Cartier Bresson, Andre Kertesz, Irving Penn, Richard Avedon and Jay
Jaffee.

Recent shows featured Erika Stone, a documentary photographer who
has developed a unique way of seeing. Marvin Schwartz mounted his
portfolio of portraits of twenty-five American artists, showing a photog-
rapher's understanding of the relationship between artists and their
work. Patrizia della Porta creates abstract architectural studies in black
and white. John Staszyn's black and white photographs show techniques
of manipulation in front of the camera. Cibachrome color prints by
Sandra Baker are multiple exposures of construction sites. Inge Morath,
Suzanne Szasz, Harvey Lloyd, Ellen Sandor and Barbara Norfleet also
show their work at the gallery.

Noordman

Noordman & Brod, Ltd. 1020 Madison Ave., New York, NY 10021
(212) 772-3370 Monday-Saturday: 9-6 August: closed

The gallery specializes in old master paintings, particularly Dutch and
Flemish works from the sixteenth through the nineteenth centuries, as
well as English and French paintings, drawings and watercolors from the
seventeenth through the nineteenth centuries.

Seventeenth-century Dutch and Flemish works include portraits by
Nicolaes Maes; marine paintings by Willem van de Velde the Younger;

Bela Kadar, *The Diners*, 24″ x 29″, gouache. Matignon Gallery.

Johannes Barthold Jongkind, *Scene d'hiver* (1870), 13½″ x 45″, oil on panel. Noortman & Brod Galleries.

still lifes by Jan van de Velde, Jan and Cornelius de Heem, Balthasar van der Ast and Jacob van Hulsdonck; military and equine subjects by Philips Wouwermans; and genre scenes by Adriaen and Isaak van Ostade and David Teniers. Salomon van Ruysdael, Jacob van Ruisdael and Frans Post are primarily landscape painters. Henrick Terbrugghen is a figurative painter whose subjects are allegorically portrayed.

Other sixteenth- and seventeenth-century Dutch and Flemish masters the gallery has an interest in include Quirinch van Brekenlenkam, Hendrick van Steenwyck, Johannes Leemans, Joos de Momper, Master of the Half Lengths, and Bonaventura Peeters. There are also nineteenth-century works by Dutch artists such as Johan Barthold Jongkind, Barend Cornelis Koekkoek, Hermanus Koekkoek, Charles Leickert and Jan Jacob Spohler.

French seventeenth-century artists Jacob Jordaens and Charles Francois paint religious scenes. Peter Paul Rubens uses religious, historical or mythological subjects, and Claude Lorrain paints landscapes. Paintings of landscapes and still lifes by artists of the Barbizon School include works by Charles Daubigny, Theodore Rousseau, Georges Miche, and Diaz de la Pena. There is also a collection of nineteenth-century French works by Eugene Isabey, Jules Noel, Jean Beraud, Antoine Vollon, Germain Ribot, Leon Richet, Henri-Joseph Harpignies, Jean-Louis Forain and Paul Cesar Helleu.

The gallery has watercolors by eighteenth-century English artists, namely Thomas Gainsborough, the Shotter Boys and Thomas Rowlandson. Drawings by Rowlandson are also shown.

Perls

Perls Galleries 1016 Madison Ave., New York, NY 10021
(212) 472-3200 Tuesday-Saturday: 10-5 Summer: closed

This elegant, forty-year-old gallery has the appearance of a small museum. It has always specialized in School of Paris paintings, watercolors, drawings and sculpture. This group includes such artists as Georges Braque, Chagall, Dali, Raoul Dufy, Juan Gris, Fernand Leger, Henri Matisse, Miro, Amedeo Modigliani, Jules Pascin, Picasso, Georges Roualt, Chaim Soutine, Maurice Utrillo, Kees van Dongen and Maurice de Vlaminck.

Also strongly represented are Camille Bombois, Andre Bauchant and Louis Vivin, who work in a primitive style. The sculpture of Alexander Archipenko, Aristide Maillol and Alexander Calder is shown, in addition to occasional pieces by Miro, Braque and Picasso.

American artist Darrel Austin, who paints fantasies of landscapes, animals and people, recently had his first major show at the gallery.

Marcuse Pfeifer

Marcuse Pfeifer Gallery 825 Madison Ave., New York, NY 10021
(212) 737-2055 Tuesday-Saturday: 10-5:30

Works shown at the gallery are generally by lesser-known contemporary photographers, however an inventory of vintage prints and nineteenth-century photographs is maintained. A series of exhibitions of work by older photographers, especially women who have been well-known but are now almost forgotten, is an ongoing project of the gallery.

Many of the gallery artists were given their first shows at the gallery. Lilo Raymond does interiors filled with light and simple objects. Olivia Parker is primarily interested in still lifes with objects from her attic. Rosamund Purcell, who exclusively uses Polaroid materials, builds her pictures from multiple images and collages. Timothy Greenfield-Sanders, who specializes in portraits, first showed portraits of New York artists of the 1950s taken in the 1980s with his seventy-five-year-old camera, which makes eleven-by-fourteen-inch negatives. David Hanson makes one-of-a-kind books with tipped-in photographs that are usually homages to ancestors in the field. Lois Conner makes eight-by-ten-inch platinum prints of landscapes. Fredrich Cantor is a painter as well as a photographer. Hiromitsu Morimoto makes large prints of white subjects, such as bathrooms, shirts and ceilings. Keiichi Tahara has taken seventy-

Herbert Bayer, *Playing Knight* (1930), 9″ x 11″, photograph. Prakapas Gallery.

Meindert Hobbema, *Watermill* (1662), 33½″ x 45″, oil on panel. Noortman & Brod Galleries.

two photographs from the windows of his apartment house in Paris. Robert D'Alessandro focuses on landscape in New Mexico and architecture in New York. Paul Cava makes mixed-media work, usually erotic, using old photos and bits of found picture.

"Forgotten" artists exhibited at the gallery include Carlotta Corpron, now in her seventies, whose abstract work had not been shown since the 1950s. Clara Sipprell, a photorealist, had not been seen in New York since the 1920s. Nell Dorr, who is now in her eighties, had been known only from her books, mostly about mothers and children. Fred Korth, who worked for Fortune magazine in the late 1930s and early 1940s will also be shown.

The gallery also maintains an inventory of works by Eugene Atget, George Platt Lynes and Bill Weegee. Anonymous nineteenth-century works and rare, early works by pioneers in the field can be seen. Prints by the masters of photography are also on hand and displayed when available.

Prakapas

Prakapas Gallery 19 E. 71st St., New York, NY 10021 (212) 737-6066
Tuesday: 11-8; Wednesday-Saturday: 11-6 June: closed Saturday
July & August: closed

Twentieth century Modernism, with special emphasis on photography, is the gallery's area of concentration. The gallery exhibits more European than American work of the 1920s and 1930s. Of particular note is the gallery's interest in bringing to attention neglected work, especially photography, often for the first time ever or in the United States. In addition to photography, the gallery has exhibited works in various media, notably paintings, drawings, graphics and sculpture.

Man Ray and Laszlo Moholy-Nagy are two of the most prominent of major artists exhibited by the gallery. The gallery prides itself in having one of the largest and most important selections of works by Man Ray in this country; the same can be said of its holdings of Moholy's works, in particular, the early photograms of the 1920s. The photographs of Hans Bellmer, Florence Henri, Eugene Atget and Josef Sudek are all represented extensively.

Gallery "firsts" include exhibitions of the photographic work of T. Lux Feininger, Albert Renger Patzsch, Werner Mantz, Jacob A. Riis, Ben Shahn, Dan Weiner, Herbert J. Seligmann, Agustin Victor Casasola, Humphrey Spender, John Havinden and Wright Morris. Other first-time shows include the constructivist work in various media by Marcel Louis Baugniet, the graphics of Howard Cook, and the constructivist drawings of Leon Tutundjian.

The gallery's collection of photographic work of the 1920s and 1930s is unique. Perhaps the most comprehensive American gallery collection, it includes in-depth selections of works by Ralph Steiner, Constantin Brancusi, August Sander, Jaromir Funke, Piet Zwart, Hans Finsler, Paul Grotz, Walker Evans, Paul Citroen, Felix Man and many others.

Quality is the dominant factor at the Prakapas Gallery, whose specialized inventory caters to museums and serious art collectors. The gallery's constantly changing exhibitions perform an educational function for the public.

Randall

Randall Galleries, Ltd. 832 Madison Ave., New York, NY 10021
(212) 628-2097 Monday-Saturday: 9:30-5:30 June & July: closed
Saturday August: closed

Established in 1973, the gallery exhibits and sells a very diversified, eclectic collection of paintings and sculpture. The collection includes nineteenth- and twentieth-century French and American paintings, a good selection of contemporary art and a group of contemporary Yugoslav naive paintings. Heavy emphasis is placed on contemporary sculpture of all media.

Contemporary sculpture covers a wide range from figurative works in bronze by Milton Hebald and Doris Caesar to rhythmic abstractions in

Thea Tewi, *Double Breasted,* 20″ high,
Greek white marble. Randall Galleries.

Francisco Zuniga, *Meditation,* 7′2″
high, cast bronze. Sindin Gallery.

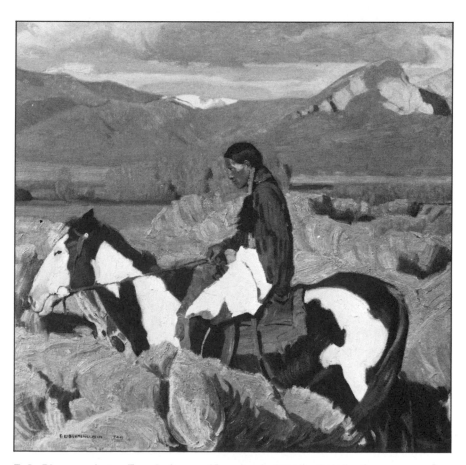

E. L. Blumenschein, *Taos Indian on Horseback,* 24½″ x 24½″, oil on canvas. Ira
Spanierman Gallery.

polished bronze by Kieff, the geometric fabricated stainless-steel works by Michi Raphael, and highly original forms in marble sculpture by Thea Tewi. A recent addition to the collection is the exciting laminated acrylic sculpture of Stephan Weiss. Other outstanding contemporary sculpture includes works by William P. Katz, Larry Young, Claire Rosner and the unusual work in exotic woods by Bob Longhurst.

Outstanding among the group of contemporary painters is Edward Clark. His abstractions are of elemental forms of nature with sweeping vistas of land, the motion of wind and water and the brightness of sun and sky. Iris Kaplan fills the role of the figurative painter. Karl Schmidt, an American Post-Impressionist, is represented with paintings of the late 1920s and early 1930s.

The gallery also represents the painting estates of several artists. The work of Charles Alston, an artist who emerged from the WPA era and who taught at the Arts Students League in New York, ranges from early figurative work to non-objective paintings in the 1960s to 1970s. Anthony Thieme was an American traditionalist of the 1930s to 1950s.

Philip Perkins, a hard-edge painter of the 1960s, belonged to the New York school and spent several years in Paris. Karl Schmidt was an American Post-Impressionist who painted from 1911 to the 1960s. Doris Caesar was a figurative sculptor of the 1930s to 1960s. All of these artists have works in important museums throughout the country.

Also featured in the gallery collection is a large selection of Yugoslav naive paintings. Outstanding examples by the internationally well-known artists, Ivan Lackovic, Ivan Rabuzin and Branko Bahunek are included in the group along with several good young artists of the movement.

Reinhold-Brown

Reinhold-Brown Gallery 26 E. 78th St., New York, NY 10021
(212) 734-7999 Tuesday-Saturday: 10:30-5

The gallery specializes in rare and important posters from the 1900 to 1940. Emphasis is placed on works by the most significant graphic designers and posters associated with the avant-garde art movements of the 1910s and 1920s. The gallery also collects, displays and sells posters from 1950 to the present.

At any given time, the gallery makes available a large selection of rare typographic and photo-montage posters. Among the artists most likely to be found are major figures of such movements as the Vienna Secession, Bauhaus, Dada, and Russian Constructivism, as well as important twentieth-century architect-designers who created posters.

The gallery offers a large number of commercial posters (promoting products, travel, fashion and culture) by outstanding designers from 1900 to the present. They include Ludwig Holhwein, A.M. Cassandre, Lucien Bernhard, Charles Loupot, Marcello Dudovich and many others.

The upstairs gallery is devoted to three or four yearly exhibitions, which focus on poster history or one specific poster maker or graphic designer. In the later case, nonposter works of graphic design are sometimes included. Print storage cabinets hold a selection of several hundred posters available for sale.

Paul Rosenberg

Paul Rosenberg & Co. 20 E. 79th St., New York, NY 10021
(212) 472-1134 Monday-Friday: 10-5

First established in Paris in 1878, the gallery originally showed the noted French Impressionist and Post-Impressionist artists. For three generations the Rosenberg family has continued this tradition, featuring Auguste Renoir, Claude Monet, Edouard Manet, Edgar Degas, Paul Cezanne, Paul Gauguin, Vincent van Gogh and other artists. Now the focus of the gallery is on high quality painting, drawing and sculpture by selected European masters, primarily Italian and French artists from the 1400s to the early twentieth century.

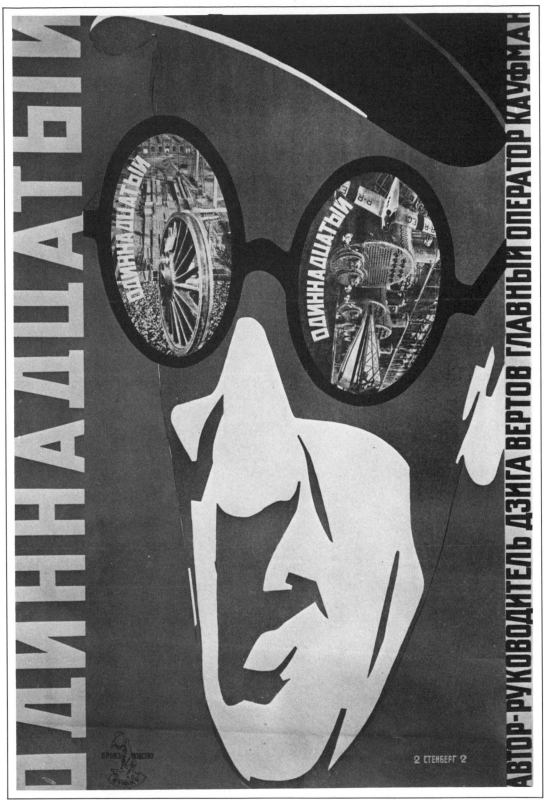

Vladimir and Gyorgy Stenberg, *The 11th* (1928), 40" x 28", lithograph and photomontage.
Rheinhold Brown Gallery.

Among more than two dozen artists whose works are presently on display are seventeenth-century artists Antoine Coypel and J. B. Rude, late baroque-rococo Italian artist Sebastiano Ricci, eighteenth-century Italian rococo artist Giambattista Tiepolo, and eighteenth-century French artist Pierre-Paul Prud'hon. Also exhibited are nineteenth-century French artists including Jean Auguste Dominique Ingres and Impressionists Edgar Degas, Eva Gonzalez, Georges Seurat and Edouard Vuillard. Works by Henri Matisse and Picasso are also available.

Saidenberg

Saidenberg Gallery 1018 Madison Ave., New York, NY 10021
(212) 288-3387 Tuesday-Saturday: 10-5 August: closed

The gallery specializes in twentieth-century European masters. Since 1955, it has been the representative of the Galerie Louise Leiris, Paris, and has exhibited oil paintings and works on paper by Picasso, as well as graphics by Juan Gris, Fernand Leger, Georges Braque and Andre Masson. Also featured are Paul Klee and Wassily Kandinsky, in addition to a few American artists.

Since it opened in 1950, the gallery has held many exhibitions, which include "An American Tribute to Picasso" and "An American Tribute to Braque." It also organized the first one-person shows in New York of works by Lynn Chadwick and Viera da Silva. The gallery held the American exhibitions of Balcomb Greene, David Hare, Gyorgy Kepes and other European artists.

Among other artists that the gallery presently features are Herbert Bayer, Georgy Kepes and Robert Braczyk, the sculptor.

Serge Sabarsky

Serge Sabarsky Gallery 987 Madison Ave., New York, NY 10021
(212) 628-6281 Tuesday-Saturday: 12-6

The gallery is devoted exclusively to German and Austrian Expressionism. The owner is a recognized authority on the work of Egon Schiele.

One-person and group exhibitions have featured Max Beckmann, Otto Dix, Lyonel Feininger, George Grosz, Erich Heckel, Alexej Jawlensky, Ernst-Ludwig Kirchner, Otto Mueller, Paul Klee, Gustav Klimt, Oskar Kokoschka, Emil Nolde, Max Pechstein, Egon Schiele, Oskar Schliemer, and Karl Schmidt-Rottluff.

In addition to staging exhibitions in New York the gallery has organized numerous shows of German and Austrian Expressionism in the United States, Europe and Japan.

Robert Schoelkopf

Robert Schoelkopf Gallery 825 Madison Ave., New York, NY 10021
Tuesday-Saturday: 10-5

For a gallery which is relatively small in its physical size, a large number of artists are shown who represent a variety of art styles. Schoelkopf, who has been dealing in twentieth century American modernist painting for twenty-five years, takes in works which represent a good cross-section of realist painting of the century. Some small-scale sculpture is also shown.

Paintings from the early part of the century are shown regularly. Works of some of the best known artists of this period are found including some hard to find paintings of Joseph Stella, Gaston Lachaise and John Storrs. Elie Nadelman, whose best known work of art is the figures on the famed Fuller Building, also has some work represented in the gallery's exhibitions. Others from this period include James Daugherty, Gertrude Fiske, Miklos Suba and William Fellini.

Contemporary painters take up the largest part of the gallery's changing exhibitions. Almost all of them are realists, many working in figurative veins. The list of artists is extremely long. Some of the artists are well known and others are just beginning to gain recognition. Best known of the gallery's contemporary painters are William Bailey who

Milet Andrejivic, *The Fountain,* 36" x 50", egg oil tempera on canvas. Robert Schoelkopf Gallery.

George Inness, *The Meeting at the Edge of the Wood* (1882), 30" x 45", oil on canvas. Ira Spanierman Gallery.

209

executes metaphysical still lifes, colorist Leland Bell, Gabriel Laderman and Chicago School painter Martha Myer Erlebacher whose current works are figurative, painted in a neo-renaissance vein. Others frequently shown are Milet Andrejevic, Natalie Charow, Daniel Dallman, Philip Grausman, Walter Hatke, Langdon Quin and Paul Wiesenfeld. Other gallery artists include: Barbara Cushing, Bruno Civitico, Raymond Han, DeWitt Hardy, Keith Jacobshagen, Louisa Matthiasdottir, Isabel McIlvain, Richard Piccolo, Edward Schmidt and Bonnie Sklarski.

Sindin

Sindin Galleries 1035 Madison Ave., New York, NY 10021 (212) 282-7902 Tuesday-Saturday: 10-5:30

The interior of this ground-level gallery is plushly laid out, somewhat resembling a small museum. Works are shown by a large number of artists from Europe and Latin America as well as a few Americans and Japanese artists.

Some of the gallery's best offerings are works by major forces of the twentieth century which include Picasso, Miro, Chagall, Giacometti and Henry Moore. The paintings and sculptures Sindin shows tend to be important works by these artists although some drawings and graphics may be found.

Among Latin Americans are a number of major artists including Francisco Zuniga and Giacomo Manzu. Zuniga's drawings and paintings depict rural life in his native Mexico. Some of his figurative sculpture may also be found. Manzu's sculptures are also frequently figurative. Working in bronze, and other mediums, his works often tend to be large scale. Works are also found of Giuliano Vangi, Luis Caballero, Guido Razzi and Benjamin Canas.

Most of Sindin's other artists work in a variety of styles and media. Carol Jean Feuerman's colorful, figurative sculpture is often highlighted among the gallery's exhibitions. Others in the changing shows are Paul Rahilly, Marshall Arisman, Murray Zimiles and Shozo Nagano.

Smith

Smith Gallery 1045 Madison Ave., New York, NY 10021 (212) 744-6171 Monday-Saturday: 11-6 July: Monday-Friday: 10-5; August: closed

This large gallery concentrates in several areas. It specialized in marine paintings of the nineteenth and early twentieth centuries, primarily American. These oil portraits of ships, notable for their historical value, are expertly painted by well-known artists James Butt, C. S. Raleigh, Fred Pansing, James Bard and W. P. Stubbs, among others.

Contemporary artists Albert Nemethy and Keith Miller also paint marine subjects, which are carefully researched for historical accuracy. Miller's large watercolors portray America's Cup Race prior to 1910 and New York port scenes. Nemethy depicts in muted colors the Hudson River as it existed in the nineteenth century, complete with sidewheelers and scenery.

The gallery also features contemporary Western painters and sculptors. Among the painters is Don Troianni, a founding member of The Society of American Historical Artists (SAHA), whose military and historical figures from the 1840s to the 1880s are done with painstaking historical accuracy. Gregory Sumida, a protege of Andrew Wyeth, works in gouache, painting Indian encampments with a delicate touch. The gallery is the only East Coast representative of Harry Jackson, a foremost contemporary Western sculptor, whose standing figures and equestrian monuments in patinated and painted bronze are well known.

Unusual American folk sculpture from the nineteenth century is often featured. Weathervanes, tobacconist figures and ship models can be seen.

The gallery's calendar of exhibits reflects its various areas of specialization. The gallery features Western art in the fall, marine subjects from January through March, and a potpourri of exhibits, including folk sculpture, during the rest of the year.

Luis Caballero, *Quest*, 77″ x 51″, charcoal on paper. Sindin Galleries.

Ira Spanierman

Ira Spanierman, Inc. 50 E. 78th St., New York, NY 10021 (212) 879-7085 Monday-Friday: 9:30-5:30 Summers: Monday-Thursday: 9-5:30; Friday: 9-3

In business for over thirty years, the gallery shows paintings and drawings ranging from works by old masters to early twentieth century artists. Some small sculpture is also available. The gallery's concentration is nineteenth-century American and European art.

Works include paintings by important American Impressionists, such as William Merritt Chase, Theodore Robinson, John Henry Twachtman, John Singer Sargent and Edward Potthast. Also available are works by Hudson River school artists, such as Jasper Cropsey and John Frederick Kensett, as well as seascapes by noted nineteenth-century marine artists, such as Alfred Thompson Bricher and William Trost Richards.

The gallery also specializes in Western art of the nineteenth- and early twentieth-centuries. A special exhibition was recently held of paintings of Indians by Henry Farny. The gallery also handles works by Frederic Remington and Charles Marion Russell, and the Taos school artists, such as Joseph H. Sharp and Ernest Blumenschien among others.

Staempfli

Staempfli Gallery 47 E. 77th St., New York, NY 10021 (212) 535-1919 Tuesday-Saturday: 10-5:30 June-mid-July: Monday-Friday: 10-5:30; mid-July-Labor Day: closed

The gallery specializes in contemporary American, European and Japanese painting and sculpture in a variety of modes.

There are delicate small-scale collages by American artist William Dole, in which passages of watercolor are integrated with varied paper elements. Mixed-media works by Enrico Donati incorporate stone and landscape-like subjects with high-relief surfaces that approach sculptural treatment.

Among paintings shown are works by British artist Anthony Green, whose figurative imagery reflects biographical references; and the romantic botanical watercolors by Rory McEwen, who is also British.

The gallery has recently placed emphasis on realistic painting, particularly of the Spanish school. Among painters in this group are Antonio Lopez-Garcia, Claudio Bravo and Cristobal Toral. Equally important is the Durer-like realism of pebbles and stones in the paintings and drawings of Alan Magee; and the precisionistic still-life drawings and paintings by Akira Arita.

Sculpture on display includes the monumental stone works by Japanese artist Masayuki Nagare, as well as the "sounding sculptures" by American Harry Bertoia. The Bachet Brothers from France exhibit kinetic steel works. The gallery also focuses on architectural sculpture, such as works by Michio Ihara.

The gallery has organized exhibitions which have circulated among museums and other galleries throughout the United States. They include a show of sculpture by Masayuki Nagare and Fritz Koenig; a retrospective of William Dole's collages; and an exhibit of Cuna Indian art.

Allan Stone

Allan Stone Gallery, Inc. 48 E. 86th St., New York, NY 10028 (212) 988-6870 Tuesday-Friday: 10-6; Saturday: 10-5 July-August: closed

Established in the early 1960s, the gallery offers a wide range of styles and modes of expression. Emphasis is placed on paintings by internationally renowned artists as well as some newer talents. Artists such as Willem de Kooning, Franz Kline, Joseph Cornell, John Graham and Arshile Gorky head the roster of gallery artists. Recent exhbitions of young contemporary artists included the realist paintings of English artist John Parks and the abstract paintings of Robert Baribeau. Richard Estes, a pioneer of New Realism, and Wayne Thiebaud were given their first one-person exhibitions in New York at the gallery, which continues to represent their work. Current works being shown include the large

John Kensett, *Sunset Over Lake George,* 28" x 46", oil on canvas. Ira Spanierman Gallery.

Theodore Robinson, *Girl Sewing Among Trees* (1891), 18" x 22", oil on canvas. Ira Spanierman Gallery.

abstract canvases of New York painter Ed Strautmanis, David Beck, Richard Hickam, Dominick Turturro and Dennis Clive.

A collection of Pre-Columbian, African, early American and Oceanic art is also available. Unique cabinet pieces are located throughout the gallery and old apothecary chests, wooden desks, and other more recent antiquities are displayed and at times offered for sale.

Vanderwoude Tananbaum

Vanderwoude Tananbaum Gallery 24 E. 81st St., New York, NY 10028 (212) 879-8200 Tuesday-Saturday: 10-5 Summer: Monday-Friday: 10-5

The gallery opened in 1982 under the directorship of two persons whose experience and knowledge of the art world gives credence to a year of interesting and provocative exhibitions. It will specialize in twentieth-century and contemporary American art. The inventory of available works includes many of the best known artists and sculptors among the New York school, the Pop artists movement, color-field painters and many others whose works predate these schools. Included will be Milton Avery, John Graham, Marsden Hartley, John Marin, Alfred Maurer, Gaston Lachaise and Elie Nadelman in addition to others.

During the coming season the gallery will schedule regular monthly exhibitions in the main gallery space. A private showroom, located in the rear of the gallery, is also the exhibition area for selections from their inventory.

Joe Neill, a contemporary sculptor whose work is considered global and cosmic in scope, will have a one-person exhibition. Another solo show will be of works by William Taylor, recently included in the exhibition of Black folk art at the Corcoran Gallery in Washington, D.C.

This gallery is the exclusive representative of the estates of artists George Ault, a precisionist; Bob Thompson, a visionary painter whose most recent retrospective was held at the National Collection of Fine Arts; and Maurice Sievan, an expressionist in both landscapes and figures, whose latest retrospective was held at the Queens Museum in New York City.

Joe Neill, *World Line Piece* (1981), 47″ x 47″ x 15″, wood and painted plastic. Vanderwoude Tananbaum Gallery.

Theo Waddington & Co., Inc. 1044 Madison Ave., New York, NY 10021
(212) 861-0600 Tuesday-Saturday: 10-5:30 Summer: Monday-
Friday: 10-5:30

The gallery recently opened as a branch of the Theo Waddington
galleries in Toronto and Montreal, Canada. The focus is on con-
temporary British and Canadian art as well as works by modern masters.
 Works by both established and emerging contemporary artists from
Canada may be viewed at the gallery. Dorothy Knowles, one of the
leading Canadian landscape painters, shows regularly. William
Perehudoff, a color-field minimalist, is also one of the gallery's more
important artists. Emerging, young artists, such as Margaret Priest,
Russell Gordon and Rose Lindjon, are also exhibited.
 Important contemporary British artists exhibiting at the gallery include
Elizabeth Frink, who does figurative sculpture, and William Turnbull,
who creates primitive masks and figurines.
 Another area of concentration is art by modern masters. The gallery
has major collections of works by artists such as Andre Derain, Raoul
Dufy, Henri Matisse and Paul Signac. The gallery, which recently
organized an exhibition of works by Derain from many periods of his
career, also plans other exhibitions of art by modern masters.
 An additional feature of the gallery is its collection of Eskimo soap-
stone sculpture, prints and drawings.

Weintraub Gallery 992 Madison Ave., New York, NY 10021
(212) 879-1195 Tuesday-Saturday: 10-5

The gallery handles art in all media by major twentieth-century masters.
One of New York's leading sculpture galleries, it specializes in the work
of Alexander Archipenko, Hans Jean Arp, Alexander Calder, Joseph
Cornell, Alberto Giacometti, Aristide Maillol, Marino Marini, Henry
Moore and other well-known sculptors. A recent exhibition featured
small works of Henry Moore. Located on the corner of intersecting
streets, the gallery, with its huge glass windows, gives the illusion of
open space surrounding the works on display.

Weyhe Gallery 794 Lexington Ave., New York, NY 10021 (212)
838-5478 October-May: Tuesday-Saturday: 9:30-5 June, July,
September: Monday-Friday: 9:30-5 August: closed

Located since 1923 on the upper floor of a bookshop filled with many rare
and out-of-print books on the arts, this modest gallery specializes in
graphics and prints of the 1920s and 1930s. One can find works by Peggy
Bacon, Mabel Dwight and Wanda Gag, in addition to etchings by John
Marin and drawings by Emil Ganso. Rockwell Kent's original drawings
from *Moby Dick* and Louis Lozowick's lithographs of New York City can
also be viewed. Other contemporary works include the bold woodcuts of
Antonio Frasconi and the watercolors of Sally Spofford. The gallery
continues to represent the expressionist portraits and landscapes of
Alfred Maurer, who had his first one-person show at the gallery in 1924.
 Graphics of European artists include works by Picasso, Max
Beckmann and Kaethe Kollwitz. Prints of well-known Mexican artists,
namely Jose Clemente Orozco, Diego Rivera, David Siqueiros and
Rufino Tamayo may also be found. Drawings by Gaston Lachaise and
George Grosz are also available. The gallery's small collection of
sculpture contains works by French artist Aristide Maillol and American
artist John B. Flannagan.
 The owner is the first American to have exhibited the photographs of
Eugene Atget. In addition, he published in 1930 a book of Atget's work,
now out of print, of which a copy is available in the owner's private
collection.

Wildenstein

Wildenstein and Company 19 E. 64th St., New York, NY 10021
(212) 879-0500 Monday-Friday: 9:30-5:30

Founded in Paris in 1875, the gallery was established in New York in
1902. The structure in which it is presently located was designed in the
style of Louis XVI and built for the Wildenstein family in 1930 as an art
gallery. With its many private viewing rooms and elegant, spacious
public exhibition rooms, the gallery provides a magnificent setting for its
paintings, drawings and sculpture.

The gallery's collection of art is broad in scope, encompassing works of
the Western cultural tradition ranging from the twelfth to the early
twentieth century. Works by major artists of the Renaissance, the En-
lightenment, the Romantic Age and the late nineteenth century are
exhibited. The gallery specializes in old masters; eighteenth-century
French artists, such as Jean Honore Fragonard and Antoine Watteau;
and French Impressionists and Post-Impressionists, including Claude
Monet, Auguste Renoir, Mary Cassatt, Edouard Vuillard and Pierre
Bonnard. English sculptor Henry Moore is the only contemporary artist
associated with the gallery.

To benefit a number of New York's philanthropic programs, the gallery
presents many important public exhibitions. Shows have featured works
by Rembrandt, Francisco de Goya, Edouard Manet, Camille Pissarro,
Camille Corot and Claude Monet among many other renowned artists. In
addition, the gallery has exhibited selections from great American and
foreign museum collections, which have been landmarks in exhibition
history and a major force in the art education of the community.

Willard

Willard Gallery 29 E. 72nd St., New York, NY 10021 (212) 744-2925
Tuesday-Friday: 10-6; Saturday: 10-5 August: closed

Since 1936, the gallery has exhibited contemporary painting and
sculpture. Almost all works shown are by American artists, most of whom
live in New York City.

For many decades the gallery has represented abstract sculptor David
Smith and abstract painters Mark Tobey and Morris Graves. Ralph
Humphrey has progressed from Minimalist paintings to abstract, poly-
chrome constructions recently exhibited at the gallery. Sculptor Ken
Price, a principal figure in the "renaissance of clay" in fine art, has
shown his small-scale abstract sculpture in polychrome glaze and paint.

Of the younger and lesser-known artists represented, Lois Lane and
Susan Rothenberg are New Image painters. Most works by gallery artists
are grounded in the tradition of abstraction; although some works
include an element of figuration, none is purely representational. Barry
Ledoux and Robert Lobe sculpt from sheet metal. Daisy Youngblood
works in clay and Barbara Schwartz works with shaped and painted
paper. Judith Shea uses a wide range of sewn and painted fabrics.
Harriet Korman and Joan Thorne create primarily abstract oil paintings
in vivid, saturated colors. Tod Wizon paints highly colored and imagina-
tive landscapes in acrylic on wood.

Richard York

Richard York Gallery 21 E. 65th St., New York, NY 10021 (212)
772-9155 Tuesday-Saturday: 10-5:30; Memorial Day-Labor Day:
10-5:30

York recently opened the gallery, however, his background is extensive
in dealing in works of American painters. The gallery shows an extensive
array of nineteenth and earlier twentieth-century painters with a range
as broad as Thomas Doughty landscapes from the 1830s to modernist
paintings of Ralston Crawford from the 1960s.

In addition to representative works from *trompe l'oeil* and some
paintings of the Western genre, works may be found by American
Impressionists and some members of the Stieglitz Group including
Charles Demuth, Georgia O'Keeffe and Arthur Dove. Some paintings by

Oscar Bluemner, Elsie Driggs and Charles Sheeler also find their way into the gallery.

The Hudson River School painters are an important part of the gallery's dealings in twentieth century painting. Most prominent among the gallery's offerings are paintings by Albert Bierstadt, Jasper Cropsey, Sanford Gifford and Martin J. Heade. Works from the Ash Can School are often available including those by John Sloan, William Glackens, Everett Shinn and George Luks.

Another area of attention is art by women artists. The gallery recently showed works by Ellen Day Hale, a Bostonian Impressionist painter who earlier exhibited in the Paris Salon. An exhibition is planned of works by Jean MacLane, a New York artist who specialized in portraits of women and children.

Ralph A. Blakelock, *The Old Mill,* 27" x 21½", oil on canvas. Richard York Gallery.

Index